Prints & Photographs

Understanding · Appreciating · Collecting

Prints & Photographs

Understanding · Appreciating · Collecting

EDITED BY
MARY JEAN MADIGAN AND SUSAN COLGAN

An Art & Antiques Book

Edited by Mary Jean Madigan and Susan Colgan
Designed by Jerry Demoney
Production: Hector Campbell
Composed in ten point Caledonia

First published in 1983 in the United States by *Art & Antiques* Magazine,
a division of Billboard Publications, Inc.
1515 Broadway, New York, New York 10036

Art & Antiques: The American Magazine for Connoisseurs and Collectors
is a trademark of Billboard Publications, Inc.

Library of Congress Cataloging in Publication Data
Main entry under title:
Prints & photographs.
 "An Art & Antiques book."
 Bibliography: p.
 Includes index.
 1. Prints. 2. Prints—Collectors and
collecting. 3. Photographs. 4. Photographs—
Collectors and collecting. I. Madigan,
Mary Jean Smith. II. Colgan, Susan, 1946-
III. Title: Prints and photographs.
NE400.P76 1983 760'.075 83-2565
ISBN 0-8230-8006-4

Distributed in the United Kingdom by Phaidon Press Ltd., Littlegate
House, St. Ebbe's St., Oxford

Manufactured in U.S.A.

1 2 3 4 5 6 7 8 9/87 86 85 84 83

Contents

Introduction

Created to capture a passing event, or to express an aesthetic perception, the print and the photograph have instructed, exhorted, informed, and delighted many generations of humankind. Whether limned in ink or photochemically produced, these images have the power to transcend ethnic, cultural, and time barriers to strike the deepest chords of feeling shared by people everywhere. That is just one reason why both antique and contemporary prints and photographs are enjoying a period of enormous popularity among collectors today. In their infinite variety, these images—produced in large editions or small—can appeal to virtually every taste; and their cost, ranging from the minimal to the monumental, can satisfy the requirements of nearly every purse.

So rich and diverse are the choices open to the collector or aspiring collector that no single volume can hope to illuminate them all. It is the aim of *Prints and Photographs*, therefore, to offer a carefully selected sampling of the wide range of documentary and artistic possibilities made manifest in the printmaker's and photographer's art, with particular attention to those works either made in America or of special interest to American collectors. Each of this book's 18 chapters has been published within the last five years as a feature article in the pages of *Art & Antiques* magazine.

To facilitate reference, the chapters on printmaking and on photography are arranged in consecutive sections, ordered as chronologically as possible. Each of the two major sections is introduced by a primer chapter, addressing issues of particular concern to the beginning collector. The notion of "infinite reproduction" of prints and photographs, and its presumed effect on value, for example, is something that troubles many

aspiring collectors. In explaining the terminology of prints, Diane Cochrane stresses the importance of understanding what is meant by "impressions, states, editions, restrikes, and posthumous prints"—and how these classifications, involving considerations of rarity and quality, are important determinants of value. Similary, Bonnie Barrett Stretch allays the fear—common to new collectors—that a photograph can be infinitely reproduced from a single negative by explaining that the concept of "limited editions" in photography, borrowed from the printmaker's lexicon, can actually result in the production of *more* prints than would normally be the case. Meticulous photographers, she points out, often spend hours trying to achieve a specific effect in any single print; they are not especially motivated to produce multiples.

Collectors, of course, are drawn to different types of prints or photographs for different reasons. Some respond to the seduction of technique, acquiring only daguerrotypes or drypoint etchings or whatever; others are moved purely by aesthetic considerations. Some are fascinated by didactic or documentary qualities; and still others are caught by some combination of all these elements.

In the 19th century and throughout much of the 20th—the major period of time addressed by this book—printmakers

Stieglitz and Kitty, photographed by Edward J. Steichen in 1904. Steichen is best-remembered for his moody, soft-focus portrait and landscape compositions. He was a leading member of the photo-secession, a movement that had as its object the elevation of photography to the status of serious art. Stieglitz himself was the founder and most influential member of this early 20th century movement. Courtesy The Metropolitan Museum of Art, gift of Alfred Stieglitz.

6

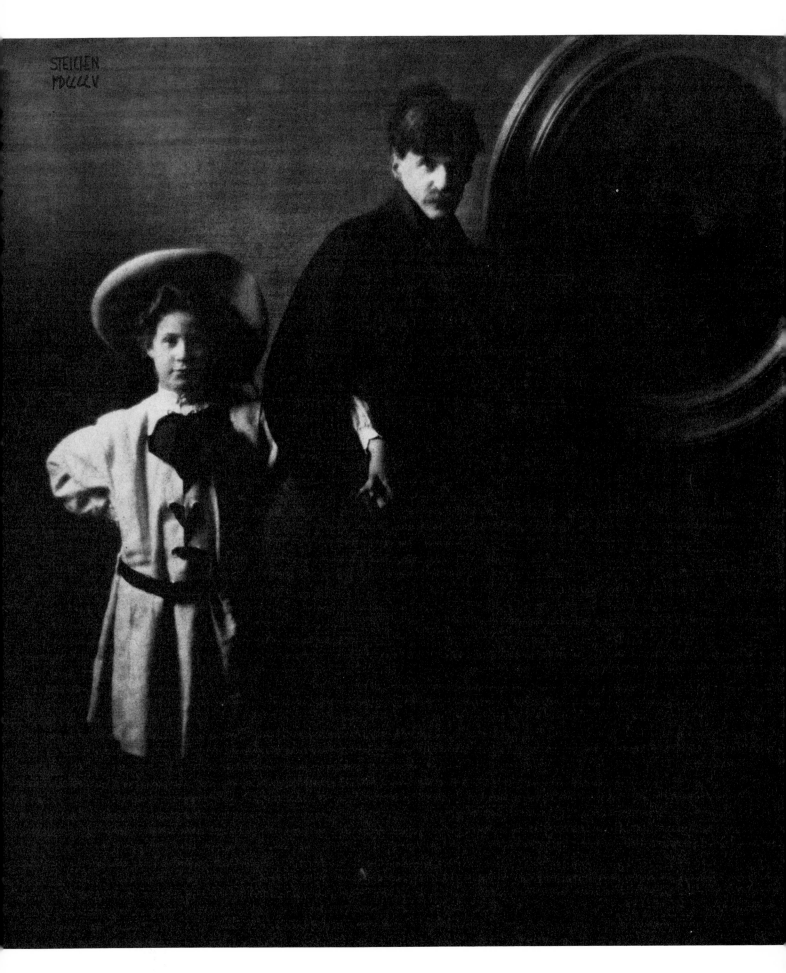

and photographers alike tend to aspire to either of two primary goals: the creation of "true art," or the documenation of a place, a person, an event, or some other fleeting moment in time.

There is an important exception to this general rule. In Far Eastern cultures, where aesthetic considerations are integral to every aspect of daily life, essentially documentary works like those of the Ukiyo-e woodcut masters of the 17th and 18th centuries are also consummately and unselfconsciously "artistic." Alexandra Holubowich notes that such prints not only recorded the carefree "floating world" of Japan's courtesans, kabuki actors, and nobility, but their compositional techniques also exerted an enormous influence on such later American artists as Mary Cassatt.

In the western cultures of the 19th century, however, the distinctions between images made to record and those made "for art's sake" tend to be more clearly delineated. Reacting to technological advances in communication and travel that heightened their world awareness, middle class Victorians were hungry for images that recorded remote, romantic, or exotic places. During the period from 1830 to about 1880, these appetites were assuaged by a veritable feast of documentary prints and, after 1840, photographs.

In her study of American landscape prints, for example, Maybelle Mann explains that "a long line of artists and printmakers, primarily from Britain," painted America's landscape and city views for reproduction in bound volumes of engravings that were avidly collected both here and abroad. Similarly, as Lewis Wright observes, the German-born artist Edward Beyer spent two years traveling through Virginia, recording such natural and man-made attractions as spas, towns, and railroads. His impressions formed the 40-page *Album of Virginia*, a folio volume of lithographs printed in Europe but sold primarily to American subscribers.

In 1839, a whole new world of documentary possibility was revealed with Daguerre's announcement that he had discovered a means of recording reality by fixing images in light on a chemically treated copper plate. The resultant daguerreotypes achieved almost instant acceptance as the new medium of portraiture, but as Carla Davidson notes, today's collectors especially prize those examples that record such early landmarks as the nation's capitol and the California gold rush. Hard on Daguerre's discovery, rapid advances in photographic techniques pushed the frontiers of documentary image-making ever wider. William Fox Talbot's 1841 calotype process for reproducing multiple images from a single paper negative made the broad dissemination of specific pictures a reality.

But calotypes, or "salt prints," tended to be fuzzy. Diane Cochrane points out that "the intrinsic ability of the camera to delineate and describe" was best realized with the perfection of the wet-plate process during the 1850s, resulting in a glass-plate negative for contact printing. Trundling their wet plates and other cumbersome equipment, British topographic and architectural photographers set out to record the world's wonders for the armchair traveler. "The power and importance of the topographic photograph" made by such greats as

Francis Frith and Roger Fenton, Cochrane observes, "lay in its literalness."

On this side of the Atlantic, American photographers—no less intrepid than their British counterparts, and with equal dedication to literalness—traveled through the daunting western wilderness between 1860 and 1885. Bonnie Stretch describes the work of such pioneer landscape photographers as Timothy O'Sullivan, William Henry Jackson, and Carleton Watkins, whose pictures are among those most highly valued by today's collectors.

The idea of making reproducible images as art, not just for purposes of documentation, was encouraged by the American Art-Union in 1839, the same year Daguerre announced his revolutionary discovery. Maybelle Mann explains that this organization "stimulated American painting, encouraged the portrayal of local subjects, and helped popularize art in America" by commissioning some 2,000 paintings over the course of 12 years. Prints made from works by such famous artists as Thomas Cole, William Sidney Mount, and Richard Caton Woodville were distributed to as many as 18,000 members a year.

However, the line-engraving methods employed by the American Art-Union were both relatively expensive and time consuming. It remained for the commercial printmaking firm of Currier & Ives, organized in the 1850s, to exploit the cheaper and faster process of lithography as a medium for reproducing original artworks. These prints were distributed to millions—not just thousands—of American households, satisfying the demand for images that were decorative as well as merely didactic. Harold Holzer points out that Currier & Ives fulfilled quite another documentary role: their ever-optimistic, often saccharine, prints recorded a highly idealized version of American life, not as it actually was, but as it existed in the popular imagination.

In the decades following the Civil War, the technology of photography and printmaking grew more sophisticated, and so did the greater portion of the American public. Their hunger for literal images of landscapes, remote cities, and architectural wonders had been largely satisfied. By 1890, the age of landscape prints and photographs was over. Pictorial photography was coming into its own.

During the 1890s, the development of the hand-held camera and flexible film brought photography literally within reach of everyone. As the simple act of recording an image lost its mystique, both amateur and professional photographers looked for other challenges—and pictorialism, a movement "to transform photography into a significant medium of fine art," was born. Bonnie Stretch reveals that by 1904, pictorial photography "referred specifically to the period's dominant aesthetic, which was characterized by broad painterly effects achieved through soft-focus techniques, matte-surface papers, and a variety of expressive printmaking processes."

Among the most charismatic of the pictorialists was Alfred Stieglitz, whose goal, according to Helen Gee, was "to advance photography as applied to pictorial expression." In 1902, he organized many of the most talented pictorialists

into an exclusive group, the Photo-secession, dedicated to "seceding from the sterile and bland attitudes that dominated artistic photography." Stieglitz published their pictures in his periodical *Camera Work*; these images are now collected in their own right.

Stieglitz himself refused to manipulate a photographic negative to produce painterly effects, but many members of his group used such techniques to good advantage. Among them, as William Homer notes, was Gertrude Kasebier, preeminent in portraiture from 1910 to 1920, who was also renowned for the romantic imagery of her pictorialist compositions characterized by informal poses and natural light.

The bitter realities of World War I brought an end to such romantic idealism in photography. Frances Benjamin Johnston, whose career spanned the decades from 1890 to 1940, was one of the few working during this period whose photographs remained impervious to the pictorialist influence. Johnston's greatest achievements came in the 1920s and 30s, when she devoted herself to documenting southern architecture, according to Marian Page.

Just as photography underwent a major shift in emphasis during the 1890s, printmaking was greatly influenced by "The Golden Age of Illustration" that spanned the turn of the century. The popularity of the illustrator's art coincided with the development of printing technologies that elevated the lowly poster into the realm of high art between 1890 and 1900, according to Robert Mehlman. Edward Penfield, William H. Bradley, and Louis John Rhead were among the period's most lauded illustrators. Posters they created for such magazines as *Harper's*, *Lippincott's*, and *The Century*, highly attractive to collectors of their own day, are once again avidly sought.

One of the period's best-known illustrators, Charles Dana Gibson, acheived wealth and fame through his singular creation, "a woman who seemed to typify the charms of her era,"

the so-called Gibson Girl. Frederick Platt observes that when photoengraving supplanted wood engraving as the favored method for printing such illustrations, Gibson's style grew perceptibly more linear.

Experimentation in printmaking techniques continued throughout the first half of the 20th century. During the 1920s, particularly in France, the *pochoir* method—involving the layering of many colored stencils to produce prints that mimicked the appearance of paintings—was in great vogue. Maybelle Mann explains how this fashionable printmaking process was selected to produce a striking edition of 750 *Kiowa Indian Art* portfolios after the watercolors of six native Americans trained at the University of Oklahoma in 1929. Technique, as well, was the focus of Atelier 17, an experimental printmaking studio established by the Englishman Stanley Hayter in New York City in 1940. Diane Cochrane notes that until that year, American printmaking was "dominated almost totally by printmakers executing black-and-white etchings in a realistic manner." Hayter and his students, dedicated to exploring all facets of the intaglio technique, changed the look of the American print with color and by experimental methods of manipulating the plate and print.

Today, the documentary function of prints and photographs has been largely usurped by the instantaneous electronic transmission, storage, and retrieval of images. But the art of printmaking and photography is no less challenging, nor any less satisfying to the collector, than it has been in times past. It is hoped that the reader of *Prints and Photographs* will be inspired to a more thorough exploration of these rewarding arts.

Print Collecting: A Primer

Before buying a print it is crucial for a beginner to have certain basic information about technique, editions, signatures, states, and the terminology of print collecting.

BY DIANE COCHRANE

"In this business, book learning helps, but seeing is knowing." The man who made this comment, Sinclair Hitchings, might have been referring to any visual art form, but as curator of the Boston Library Print Collection he knows it is particularly appropriate to print collecting. Not only must the collector sharpen his skills in judging the esthetic merits of an image, he must also ascertain what specific characteristics make one print more highly prized than another. Why, for example, did New York City's Kennedy Galleries in a recent catalogue offer one version of James A. McNeill Whistler's *Rotherhithe* for $5,000 and another for only $2,500?

Here's where book learning can help. The novice collector, besides looking, must also understand the technology and terminology of printmaking before identifying and judging the quality or condition of a print. Therefore, the purpose of this article is to describe briefly how prints are made, to define the terms associated with them, and to explain how this knowledge helps the collector evaluate them.

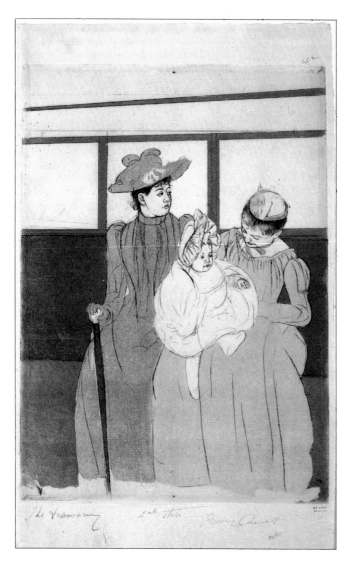

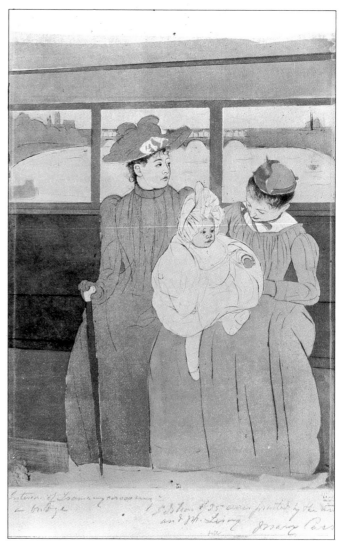

10

The four types of prints

The technology of printmaking has evolved from the primitive techniques of the earliest artists using knives and blocks of wood to the elaborate and complex methods of modern printmakers who sometimes employ computers and photomechanical processes to assist them in their work. Despite technical advances, however, the processes described below are still the four basic methods.

The relief print

Woodcuts, wood engravings, and linocuts are all relief prints. To make a woodcut, an image is drawn on the surface of a plank of wood cut along the length of a tree. The artist, using a knife and/or chisel, cuts away those parts of the wood that he doesn't want to print (some artists don't bother drawing, but set right in with their cutting tools). The raised surface (relief) design which remains is then rolled with a thin layer of ink. Paper is placed over the inked block and it is either run through a press or rubbed with the back of a spoon.

A wood engraving is a variant of a woodcut. In this process the end grain of the wood is carved with metal engraving tools. Unlike the woodcut, with its strongly contrasting areas of black and white, the wood engraving can achieve considerable shadings of black, white, and gray. A linocut is simply a method using linoleum blocks instead of wood blocks.

After many printings, the block for both woodcuts and wood engravings may crack or the relief lines may become worn, broken, or splintered. In addition, worms may bore into the block. Prints made from such damaged blocks lose their clarity. Lines become blurred; areas lose definition.

The intaglio print

Just the opposite of a relief surface that prints the image from the raised surface, intaglio techniques print lines cut into the matrix or printing plate. An intaglio surface contains recessed areas in which the ink is deposited. The surface is wiped clean of ink, and the incised line holds the ink. Impressions are printed by placing a dampened paper on the plate, and both are run through the press under enough pressure to force the

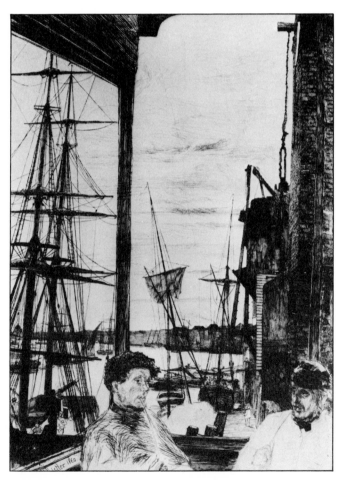 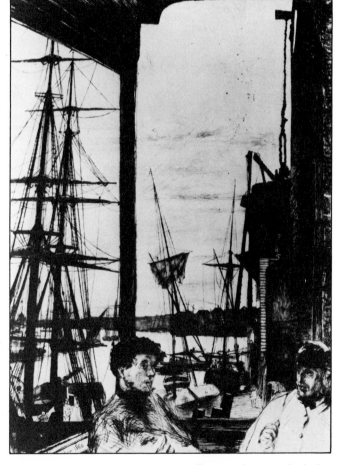

Opposite: *In the Omnibus* or *The Tramway*, Mary Cassatt, 1891. Color print with drypoint, soft ground, and aquatint; 14¼″ x 10½″. In the two states here the development of the artist's idea can be seen. The second state (left) shows figures drawn in drypoint and colored. By the fourth and final state (right), the view, the ceiling, and floor lines have been

added. New York Public Library Print Collection. Above: *Rotherhithe*, James A. McNeil Whistler, 1860. Etching with drypoint, 10¾″ x 7¾″. The rare first state (left) was pulled by Whistler himself. In the third and final state (right), printed after Whistler's death by Delâtre, the boat hull has been drawn in. Courtesy Kennedy Galleries, Inc., New York.

12

paper into the inked areas. That's the general process, but there are numerous types of intaglio processes, each with its own technical variation. Here's a rundown on common print-making intaglio techniques.

Briefly, to make an *engraving* (the first of the intaglio processes, invented in 1446), the line is cut into the metal plate by hand with a burin, or sharp engraving tool. Minute pieces of metal—burrs—forced to the surface by the gouging of the burin are wiped off before printing takes place.

To make a *drypoint*, the printmaker incises the line with a sharpened needle. Once again burrs are forced onto the surface, but this time they are allowed to remain, catching more ink than the engraved line itself and creating a rich, furry line rather than the crisp, hard line of an engraving. Since the raised burr is vulnerable to the great pressures of the press, it quickly wears down.

To make an *etching*, the incised lines are produced by acid rather than by hand. The metal plate is covered with a "ground"—an acid-resistant, waxy substance. An image is then drawn on the ground with a sharp tool that cuts through the ground, exposing the metal underneath. Next, the plate is immersed in a bath of acid that bites into the metal where the drawing was made. After inking the plate and wiping it clean, ink remains only in the incised lines.

To make an *aquatint*, the printmaker sprinkles a fine film of powdered resin on the plate and melts the resin to create a porous ground. He then coats those areas that are not to be bitten with a "stopping-out" varnish and immerses the plate in acid. The acid pits the areas of the plate not stopped out, creating a "grain"; and the printmaker can create tonal variations by continuing to stop out and expose specific areas of the plate. The linear elements of the design are achieved in a previous step, usually by an etching process.

Intaglio prints are made from zinc or, more commonly, copper plates. The latter are more durable and yield more acceptable impressions. Furthermore, the life of a copper plate can be extended by steel-facing, a process that electroplates a thin layer of steel over the plate. Steel-facing, however, tends to dull rich tones and eliminate subtle contrasts, so many artists reject its use.

The quality of intaglio prints can vary significantly from the first of many inkings to the last. Crisp lines are clear in early impressions but lose their depth as plates wear down. And burrs can disappear altogether in later prints.

The lithograph

The two processes mentioned so far—relief and intaglio—work from a surface that is raised or recessed. In lithography, however, the printing surface is flat or planographic. The process works on a basic chemical principle: oil and water

don't mix. First an image is drawn on the stone with a greasy crayon to which greasy ink adheres. Then the printing surface, usually a piece of Bavarian limestone or finely grained zinc, is inked after a thin film of water is sponged over the surface. The water prevents the greasy ink from adhering to the undrawn surface while allowing the ink to adhere to the equally greasy image or texture. The image is set before printing with a mixture of dilute nitric acid and gum arabic to fix the greasy image firmly into the stone and to desensitize the plain areas from receiving ink.

The greasy drawing on a lithographic stone or plate—at first so clear, luminous, and delicate—will at some point during a long printing begin to disintegrate, demanding heavier and heavier inking which will seep into the untouched areas until the image loses resolution, becomes muddled, and finally resists any efforts to revive its pristine distinctness by resetting.

The serigraph

Serigraphy, screen print, or the screen stencil method has been used commercially for many centuries. However, it was adapted for artistic uses only about 40 years ago, and thus is one of the newer artistic techniques that collectors are likely to run into. Often, it is incorrectly called silk screen—a term that is inaccurate because not all screens are silk.

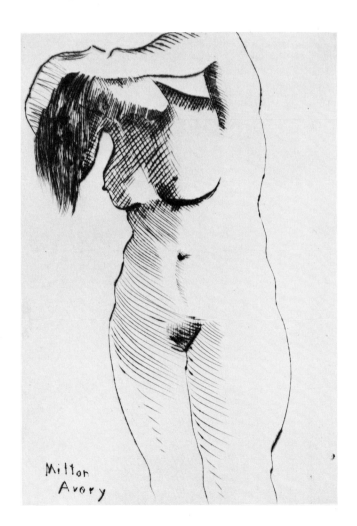

Opposite: *La Grande Execution de Robespierre*, Charles Klabunde, 1975. Etching and aquatint, 23¾″ x 7½″. The "pebbly" quality seen in the sky is frequently characteristic of aquatint. This "grain" can be too fine to see or, as it is here, clearly evident. Courtesy Associated American Artists, New York. Right: *Nude Combing Hair*, Milton Avery, 1950. Drypoint, 8½″ x 6⅛″. The drypoint burrs are obvious, imparting a "fuzzy" quality to the delineation of the figure. Courtesy Associated American Artists, New York.

To make a serigraph, the artist prepares a stretched screen (usually silk or synthetic mesh) and blocks out the areas *not to* be printed with glue, cut film, paper, photostencil, and the like. Ink is then squeegeed over the screen, forcing it through the open areas and onto the paper that has been placed beneath the screen.

Problems are minimal with this process. But a collector should look for clarity of image, absence of smudging, and perfect color registration (the placement of the paper for printing so that each color applied falls in the correct relationship with the ones that have gone before).

Printing

Technically, prints that come out of the ateliers of master printers are no better than those printed by the artist. (Not everyone agrees on this point, but the controversy itself is a subject of an article.) As Cecile Shapiro and Lauris Mason so aptly put it in *Fine Prints: Collecting, Buying & Selling:* "The difference between the two methods of producing prints might be compared to home cooking and restaurant meals—one, from menu planning, to marketing, to preparation, to serving, to cleaning up is done by an individual. The other depends upon a secondary staff at every step along the way. Some home cooks are dreadful, while others are superb; the same can be said of restaurants."

Whether dreadful or superb, prints made by a master printer are, as a rule, uniform in quality within an edition—all the prints made at one time. The printer works from a *bon à tirer*, a proof approved by the artist which serves as a standard against which all other prints must be measured within an edition. And this uniformity of impressions within an edition represents a plus to the collector. (An impression is a single pulling from the plate. An edition is made up of many impressions.) In developing connoisseurship for prints made in an atelier, such as the lithographs of Grant Wood, Thomas Hart Benton, Stuart Curry, Rockwell Kent, and others, collectors need only improve their perceptive powers regarding the esthetic quality of the image and the physical condition of the print.

For centuries, artists, with a few notable exceptions such as Rembrandt, turned over the job of printing to craftsmen after they placed an image on the matrix. Even today, most prints continue to come out of the ateliers of master printers. Most artists working in lithography have always used a master printer. More who did intaglio did it themselves—especially during the etching craze which lasted from the second half of the 19th century into the 1930s. As for drypoint, artists working in this technique generally did their own printing. But there is so much confusion between the term "print" and "original print" that you should find out what the seller means when using either term.

It is often very difficult to discern the difference between an artist-printed impression and a master-printed one. Art scholarship holds some answers: some artists never pulled their own prints, others did so only at certain periods in their career. When the difference is known, it can be important, because when artists were known to have pulled their own

prints, theirs are more highly prized. They conform more closely with the creator's intent. Artist-printed impressions are analogous to musical works played by their composers rather than by other performers; and a collector's visual acuity can sometimes point to this closer concordance between the artist's intent and the print's execution. Whistler's prints are a perfect case in point. Whistler made an art out of inking and wiping his etching plate. Unlike most etchers, who wipe the plate clean, he allowed some ink to remain to create the impressionistic effects he strove for, effects never quite duplicated by his printer, Eugene Delâtre, the superlative French master printer who also printed for Mary Cassatt and Edgar Degas.

When an artist does his own printing, his hand is a significant element. And nowhere is the hand of the artist more visible than in the prints of the late-19th-century and early-20th-century artist-etchers. Some of the printmakers constantly tinkered with their work so that at times they pulled only one impression from a plate, changed it, and then pulled another, making the task of the collector determined to find the best impressions infinitely more complicated.

Differences in quality between printings made by the artist

Both woodcuts and wood engravings are relief prints, but woodcuts use blocks cut along the grain while wood engravings are made on the end grain, which is more difficult to incise. Unlike the woodcut, with its strongly contrasting areas of black and white, the wood engraving can achieve considerable shadings of black, white, and grey. Below: *La Flute*, Felix Vallotton, 1896. Woodcut, 8⅞″ x 7″. Opposite: *Fair Wind*, Rockwell Kent, 1931. Wood engraving, 5½″ x 7″. Kent has used metal engraving tools here to achieve the fine lines. Both courtesy Associated American Artists, New York.

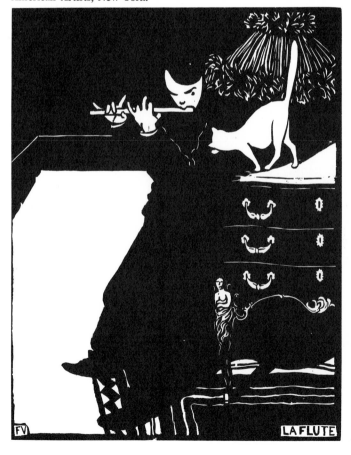

himself can be seen in Childe Hassam's prints. Hassam realized that the salability of his prints came from the extremes of light and shadow that he achieved by combining drypoint and etching. Since the burrs wear down easily in drypoint, the rich, velvety black quality he sought after gradually disappeared. When this occurred, Hassam would get out his drypoint needle again and rework the plate, meaning that some impressions, although printed later, outshine earlier ones.

Training one's eye to recognize differences in quality between impressions is both time-consuming and pleasurable. The would-be connoisseur must visit as many museum print collections and galleries as possible and talk to reputable dealers and, if possible, to print curators, about the distinguishing characteristics of individual prints. With enough exposure to prints in categories of interest, the connoisseur's eye will begin to make comparisons and ultimately learn to reject impressions that are inferior.

Terms

States
A state is any group of impressions made in the continuing process of developing the idea for a print. As their name implies, trial or working proofs are states used by the artist to arrive at a *bon á tirer* (literally, okay to print). After the *bon á tirer*—the first good, ideal impression—any changes made on the plate or stone are to preserve the approved image. An artist may print an edition and then decide that he wants to rework the plate and make new impressions from the altered plate. The impressions made in arriving at the new edition would be another state. Muirhead Bone probably holds the world's record for revisions. One of his drypoints passed through 29 states, a number only slighty less than the total number of impressions pulled.

States are usually indicated by lower-case Roman numerals. For example, i/iv means the first of four states. Recognizing the different states of an artist's work is a fascinating and rewarding chore, one occasionally made exceedingly difficult because some artists such as Hassam did not always record their changes.

The signed print
Originally, prints were either unsigned or signed in the plate or stone. Hand-signing each print in pencil is a fairly recent marketing device. First used by Seymour Haden and his

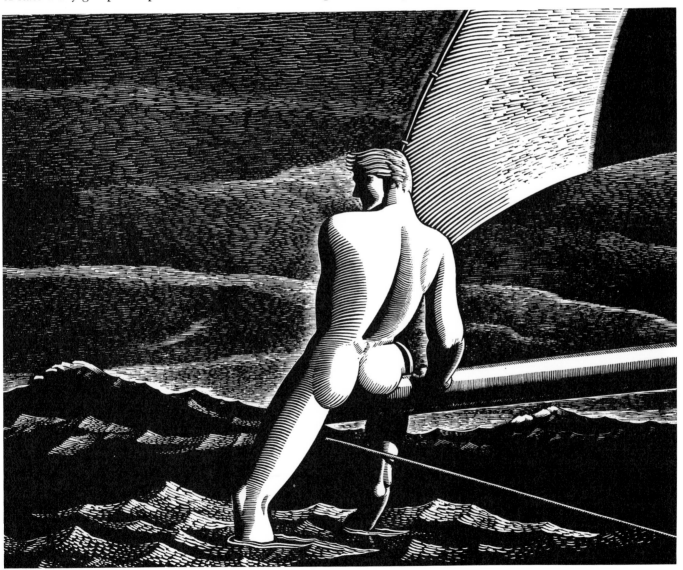

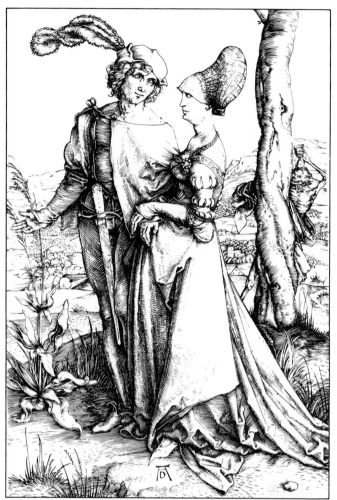

Above: *The Promenade*, **Albrecht Durer, 1498. Engraving, 7″ x 4¾″. The precision and force required to cut a metal engraving are revealed by close examination of tapered lines—thin, thick, thin—particularly evident in the skirt folds. Associated American Artists, New York.**

brother-in-law Whistler (who popularized it with his butterfly mark), the manual signature was developed to connote rarity. Whistler put the concept to the test in 1887 when he introduced a new group of prints wherein he charged twice as much for a set of signed prints as for a set of unsigned ones. It worked so well that today the difference in price for these and for much other hand-signed work is many times greater.

Today the penciled signature has come to mean, as Carl Zigrosser put it in *A Guide to the Collecting and Care of Original Prints*, "Among other things, a guarantee of printing quality, a stamp of good workmanship, similar to the hallmark on silver." The advantages to the collector of owning a signed, original print after it has been printed are obvious. The signature *presumably* attests to the quality, which may vary from one impression to another especially with prints made by hand. But alas, since signed prints are more valuable than unsigned prints, there are those who have abused the practice. Dealers have passed off signatures in the stone or plate as hand-penciled signatures; artists, Salvador Dali among them, have been known to sign blank papers before they are printed on; and of course, others have simply forged signatures on unsigned prints.

Chop marks

A mark embossed on paper which indicates who the printer was is called a chop mark. It may be the embossed symbol of the artist, if he printed the work, or that of the master printer or atelier out of which the print has come.

The numbered print

When a print bears a number, the number supposedly indicates the order in which that particular impression was pulled. Collectors often assume that the earliest numbers are best. For example, a print marked 2/15 seems to indicate that it was the second print made in an edition of 15, and therefore more valuable than one marked 15/15.

But this isn't necessarily so. Contemporary printmakers, particularly those making multiple color prints, often don't keep track of the order in which they print an edition. First, they print all impressions with one color and then hang them up to dry. When dry, the papers are taken down, probably at random, and the next color applied. It would be the rare printmaker indeed who would be so meticulous as to maintain the proper sequence when making a 3-color print, much less one of 10 or 15 colors.

Furthermore, even if the numbers correspond to the actual printing sequence, numbering may still have little significance. If an edition of lithographs, serigraphs, or relief prints is small, all impressions may be of equal quality. It is only with drypoints and other intaglio prints made from plates easily worn down that numbers (providing they represent the proper sequence) may help the collector to select the more valuable print. However, since numbering is a modern practice, most 19th-century and many early-20th-century artists such as John Marin, Martin Lewis, and Edward Hopper did not number their prints.

The limited edition

A limited edition is one in which the artist promises to make just so many impressions and no more. To ensure that the edition remains limited, the plate or stone is destroyed or altered in such a way that no more impressions can be pulled. Limited editions are yet another product of the 20th century. Historically, editions, if one could call them that, were not limited; impressions were pulled as long as the block, plate, or stone held up. Records show, for example, that 73,000 impressions of a single Currier and Ives lithograph were sold.

With the introduction of the limited edition came certain deceptive practices. As a general rule, the smaller the edition the more valuable the print. So what could be more tempting on the part of the unscrupulous than to offer a small edition while actually padding it so that more prints are available. Just one way of stretching an edition is to make separate editions of the same image from the same plate or stone by using two different types of paper; other ways to pad also exist.

The restrike

Restrikes, sometimes called *reprints*, are prints generally made without the artist's permission from a plate or stone after the original edition has been issued. Frequently, they are of inferior quality, but as long as they are identified as restrikes, they are perfectly legitimate. (Often, restrikes have small changes in the plate that indicate what they are. Cata-

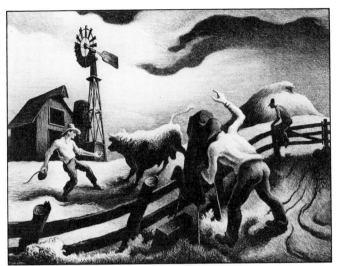

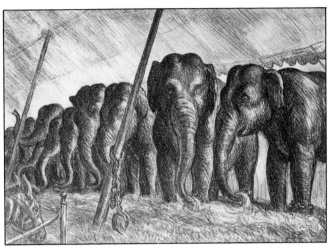

Above left: *Photographing the Bull*, Thomas Hart Benton, 1950. Lithograph, 12″ x 16″. Above right: *Circus Elephants*, John Stuart Curry, 1936. Lithograph, 9″ x 12½″. Lines in a lithograph can be much freer than those in an engraving because of the waxy crayon used. In these prints the crayon quality of the lines is clearly evident, but this is not always so. Both Associated American Artists, New York.

logues raisonnés frequently describe these changes.) The problem with restrikes is that they are sometimes passed off as prints from the original edition, a potentially illegal act.

Fraud is not always the intent behind restrikes, however. No less a personage than Mary Cassatt authorized the printing of editions which she refused to call restrikes. In 1923, when Cassatt was 78 and blind, her housekeeper discovered 25 plates from which she believed no editions had been made. Cassatt agreed, had them printed and sent some off to William Ivins, curator of prints at The Metropolitan Museum of Art, for exhibition or possible purchase. Ivins, knowing that previous editions existed, asked her to sign all impressions with the date 1923 to acknowledge that they were restrikes. Unwilling to admit that she might be wrong or forgetful, Cassatt refused.

The result was unfortunate. As Adelyn D. Breeskin says in *The Graphic Works of Mary Cassatt*, "the quality of prints is not equal to that of Miss Cassatt's best work. She was very particular about the printing of her plates and would accept only clear rich impressions. Certainly if she had retained her sight she would have been the first to criticize the lack of sharpness and evenness of line in the reprints."

The posthumous print

Posthumous prints are impressions made after an artist's death. They may be, but are not necessarily, restrikes. Some artists made prints only for their own amusement and not for the public. They would etch a plate or pull an impression or two. Later, after their death, relatives or publishers issue editions of the artist's work from the original plates and sign them with their own initials or names.

A case in point would be the etchings of Julian Alden Weir and John Henry Twachtman. Close friends and neighbors, they enjoyed working outdoors in the Connecticut countryside, but rather than encumber themselves with easels and paintboxes, they took along small etching plates on their rambles. When they returned home, they would pull a few impressions on Weir's press, but the results were regarded as casual exercises. Later, after their deaths, several series of impressions were made from the plates. In 1921 the printer Frederick Keppel published 19 editions of Twachtman's prints, all approved and initialed by Julian Alden Twachtman, the artist's son; many of Weir's prints were printed and signed posthumously by his daughter.

Penciled initials or signatures by relatives or others are not always proof that prints were posthumously printed, but only that they bear estate signatures. George Bellows, for example, had the curious habit of signing prints only when they left his workshop for sale. Thus, when he died, the prints had been made but they now bear the various signatures of his wife, his daughter, and his printer, the lithographer Bolton Brown.

Like restrikes, there's nothing wrong with selling posthumous prints as long as the collector knows what he is buying. Since the artist cannot bestow his stamp of approval on these prints, either literally or figuratively, they are generally less valuable. But as one would suspect, in order to raise prices there are plenty of cases of posthumous prints being fobbed off as prints that had been authorized during the artist's lifetime.

Cancelled plates

Prints from cancelled plates could fit either the restrike or posthumous print categories. The cancellation mark on prints pulled from Picasso's cancelled plates is an obvious heavy diagonal line. However, Susan Teller of Associated American Artists in New York warns that the cancellation mark on some prints can be very hard to see.

Facsimile prints

So far we've mentioned deceptive practices which may or may not be fraudulent. But there is little question about the criminal intent of facsimile prints priced high, and made to fool the purchaser into thinking he is buying the real McCoy. These prints are made either by a photomechanical process or by a hand copyist. The best way to avoid spurious prints is to deal only with reputable dealers and to research works by looking them up in catalogues raisonnés.

"The trained eye and catalogues raisonnés are the two most valuable tools possessed by the connoisseur."

Catalogues raisonnés
These books list, among other data: the title of each of the artist's prints up to the time of publication; the technique used; the number of impressions in the complete edition, if known; the size of the image area and overall sheet; the number of states and any pertinent data known about them; the paper used; the watermark; if signed, how; and if the plate was cancelled. Better ones also include photographs.

The trained eye and catalogues raisonnés are the two most valuable tools possessed by the connoisseur. Remember, however, that the simple line drawings of such 20th-century artists as Matisse, Picasso, and Modigliani are particularly easy to fake—a tricky business for the collector, since the image itself could quite legitimately appear in a catalogue raisonné. But in general, experience in looking will enable the collector to judge the quality of the print, while the information contained in a catalogue raisonné helps determine whether the print is a restrike, a posthumous print, a facsimile, or whatever. If a facsimile is suspected, for example, the print should be measured for comparison with the dimensions mentioned in the catalogue raisonné. In addition, a magnifying glass is helpful in determining whether a print was signed in the stone or hand-signed by pencil, or whether it was made by a photomechanical process. If the latter is true, a pattern of dots made by the halftone screen used in the production of most photomechanical reproductions will appear. (You cannot always see dots in photomechanical processes. For example, there are no dots on line cuts such as those used to reproduce Rembrandt designs on Christmas cards.) Any such examinations must take place when the print is out of the frame.

Now, going back to the question of the two Whistler prints mentioned at the beginning of this article. The $5,000 print is from a rare first state and was printed by Whistler himself. The $2,500 print belongs to the third and final state and, although superbly printed and an altogether exciting print, fails to arouse the enthusiasm of collectors as much because it is a posthumous print made by Delâtre. Lacking is that certain something that only Whistler could inject into his work, and something connoisseurs can know only by looking. ■

An etcher's point glides with perfect ease over the grounded plate. Left: *Lion Gardner House*, Childe Hassam, 1928. Etching, 9¾″ x 14″. Note the nervous tremor, one of the most recognizable characteristics of the etched line. Associated American Artists, New York.

Ten basic questions you should ask before buying a print:

1. What type of print is it: relief, intaglio, lithograph, or serigraph?
2. Did the artist or a master printer actually pull the print?
3. Is it hand-signed in pencil, signed in the stone or plate, or unsigned?
4. Do the print's dimensions and the watermark correspond with those given in the catalogue raisonné?
5. Is the print numbered and part of a limited edition?
6. Is it one of a series of states?
7. Is it a restrike?
8. Is it a posthumous print?
9. What is the physical condition of the print?
10. Are there other copies of the same print available for comparison?

Ukiyo·e Prints

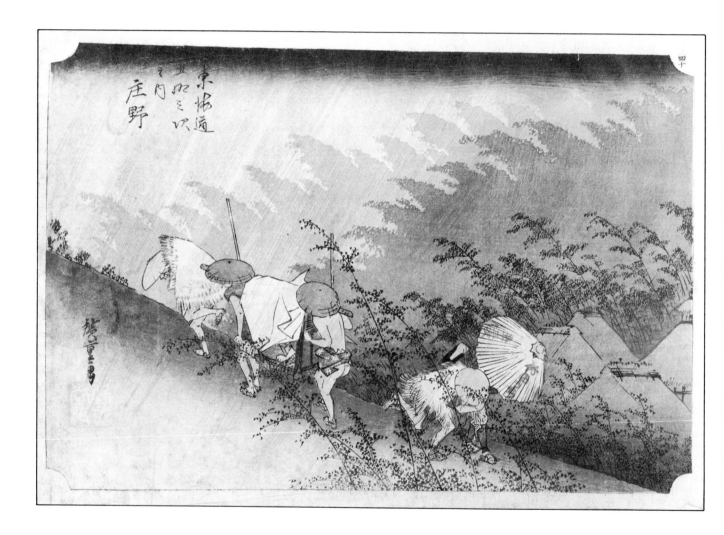

From the 17th through the 19th centuries, uk-
iyo-e printmakers captured the imagination of
the Japanese bourgeoisie with scenes of courtesans,
kabuki theater, leisure activities, and tourist attrac-
tions.

BY ALEXANDRA HOLUBOWICH

"Living only for the moment, turning our full attention to the
pleasures of the moon, the snow, the cherry-blossoms and the
maple leaves, singing songs, drinking wine and diverting our-
selves just in floating, floating, caring not a whit for the pau-
perism staring us in the face, refusing to be disheartened, like
a gourd floating along with the river current; this is what we
call ukiyo-e," wrote Asar Ryoi in 1661.

Ukiyo-e prints—a most exuberantly sensual art form—were
spawned in Edo, Japan, about 300 years ago. The term *ukiyo*,
or "floating world," refers to the society that created the
prints and patronized the printmakers. It was the demimonde
of newly rich merchants and boisterous samurai (who were
somewhat analogous to English knights of the feudal pe-
riod). Most ukiyo-e prints—pictures of the floating world—
portrayed the courtesans, wrestlers, actors, and tourist attrac-

tions that sated the appetites of these bourgeois. While serious, religious, intellectual art was patronized by the cultured Japanese, light ukiyo themes were produced for popular consumption. Ukiyo subjects appeared not only in prints but in paintings, on screens, and in literature—novels and short stories—as well.

ard Lane writes: "Ukiyo-e was always concerned with genre representations of ordinary scenes from daily life, leisure, and entertainment. But it was soon to choose as its special domain the amusement quarters of Edo, the courtesan district and the kabuki theatre. These themes were to provide the basis for at least two-thirds of ukiyo-e art in the 17th and 18th century. Early in the 19th century when ukiyo-e was dying out through lack of new subjects and themes, Hokusai and Hiroshige renewed it with their fresh approach to landscape, a subject hitherto exploited only by transitional painters and hardly ever by the artists of the floating world."

By some strange alchemy, the mundane and frequently bawdy prints transcended their limited subject matter and have over the years fascinated some of the most creative minds in the Western world. "The prints choose whom they love and there is no salvation but surrender," asserted Frank Lloyd Wright in *The Japanese Print: An Interpretation* (Horizon Press, 1967). Endeavoring to explain the allure of the fading polychrome impressions, Wright draws a parallel with Plato's concept of "the eternal idea of the thing." The prints are designs, patterns that are beautiful in themselves, he notes, but these are merely incidental and interesting by-products. The first principal of Japanese esthetics is simplification by elimination of the insignificant and therefore the emphasis of reality. When the Japanese artist lays stress on a simple element, he "touches the soul of the subject so surely and intimately that while less would have failed of the intended effect, more would have been profane," Wright explains.

Ukiyo-e printmaking

The earliest ukiyo-e prints, made in the first part of the 17th century, were printed from one block of wood and were black and white. They are called *sumizuri-e*. Soon color was applied to these prints by brush. One of the colors first used was

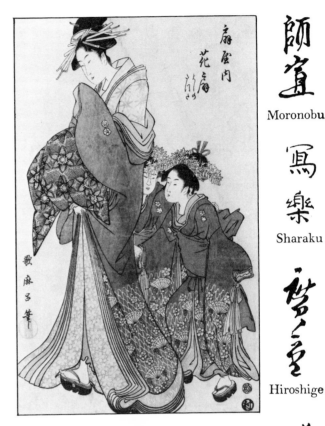

Moronobu

Sharaku

Hiroshige

Hokusai

Utamaro

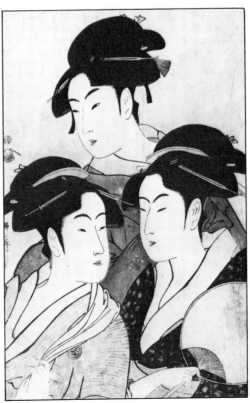

Ukiyo-e prints were first created in Edo about 300 years ago, and the style was perfected by several great artists. Utagawa Hiroshige (1797-1858) was a master of mood and poetic atmosphere in the landscape print. He was known for his treatment of rain, as in the example opposite: *White Rain*. Courtesy Christie's New York. This page: Kitagawa Utamaro (1753-1806) was said to have an intuitive grasp of female psychology. His women display a frankly sensual beauty: there is a sense of the "eternal female" in his finest works. Top: *The Famed Courtesan Hanaōgi of Ogi-Ya With Her Two Kumuro, Yoshino and Tatsuta*, 1793-1796. Hanaōgi, known for her beauty and grace, was also skilled in calligraphy. Bottom: *Three Modern Beauties: Okita, Toyohina, and Ohisa*, 1790-1792. Each of these famous beauties of the floating world displays the symbol of her house. The woman on the right is from a tea house; the woman in the center, from a greenhouse; and on the left is Ohisa, shop assistant in a rice cracker store. At first they look alike, but Utamaro has given each her own subtle identity by varying the shapes of faces, noses, and mouths. Both courtesy Ronin Gallery, New York. Far right: Signatures of five ukiyo-e masters.

21

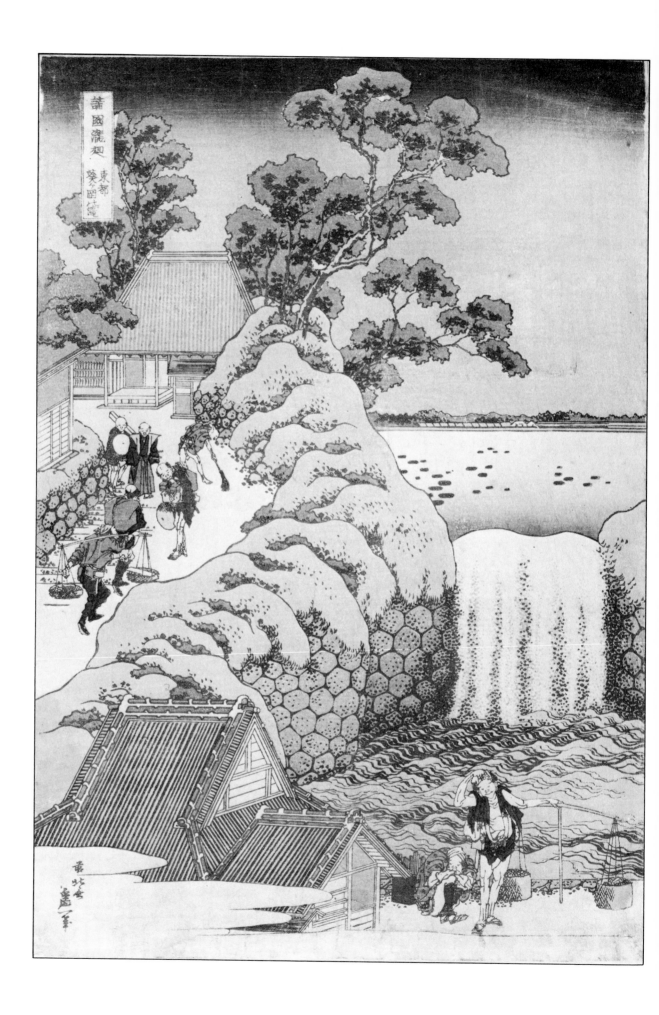

a red or orange; prints with this color were called *tan-e*. Somewhat later a more sophisticated form of hand coloring was adopted with *beni* (a pinkish red) as the dominant color. Other colors used were greenish yellow, light brown, low-toned blues, and purples.

Some painters added lacquer (*urushi*) to one or more of their pigments to give them a glossy look. Occasionally gold dust was sprinkled or dusted on some of the colors of the prints to give them a spectacular effect. About 1741, color prints employing two-color blocks appeared—usually *beni* and green. These prints were called *benizuri-e*.

The artist supplied the drawing for the print on transparent paper and indicated the colors. The engraver pasted the drawing face-down on a block of hard wood, cut around the lines with a knife, and by clearing the wood between the lines, left them in high relief. Once the ink was rubbed onto the raised lines, proofing paper was placed over the block, pressure was applied by rubbing a twist of hemp over the paper, and a proof of the engraver's facsimile of the artist's design was secured. Separate blocks had to be cut for each color to be printed. In a print of complex tints, as many as 10 or more such blocks might be required.

Moronobu, early printmaker

The essence of the subject caught in a few master strokes was evident even in the earliest great master of the ukiyo-e print, Hishikawa Moronobu (1618–1703). Because of a fire that destroyed most of the city of Edo in 1657, the earliest known signed and dated work of his is *Buke Hyakunin Isshu*—"100 Warrior Poets," 1672. According to Japanese print specialist Howard A. Link in *Orientations Magazine* (May 1972), this relatively undeveloped work of Moronobu contains many clues to his best style. "We can already catch a glimpse of his ability to distill the essence of a given portrait in the simplest of terms," writes Link, who is associate curator at the Honolulu Academy of Arts. Despite the simplicity of his linear configuration, Moronobu makes all his figure studies very much a living thing, notes Link.

Moronobu's prints have often been criticized for their cluttered backgrounds, obscured focal points, and rather undistinguished design. In *The Floating World* (Random House, 1954), James Michener writes that Moronobu's faces seem as if each had a harelip and that his men stand and walk with both knees bent. But these faults seem unimportant when you

Katsushika Hokusai's long life (1760-1849) embraced much of the ukiyo-e period. He began with figures of actors, wrestlers, and women, but by 1810 he had perfected his skill as a painter of nature and landscape. He was passionately interested in all living things: plants, trees, animals, and—most of all—people. *The Waterfall at Aoigaoka*, opposite, is from Hokusai's series *Shokoku Taki Meguri.* Courtesy Christie's New York. This page, top: *The Lovers Umegawa and Chubei Under an Umbrella,* 1797-1800. Here Utamaro depicts star-crossed lovers from the kabuki play *Love's Messenger on the Yamato Road.* He has ransomed her with stolen funds; knowing that their crime will bring death, they flee to allow themselves some time together before they are discovered. Right: Hiroshige's interpretation of the story of Umegawa and Chubei, 1847. Both courtesy Ronin Gallery.

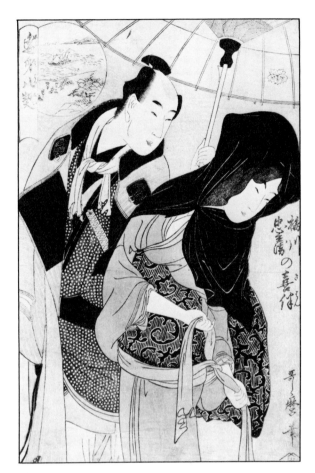

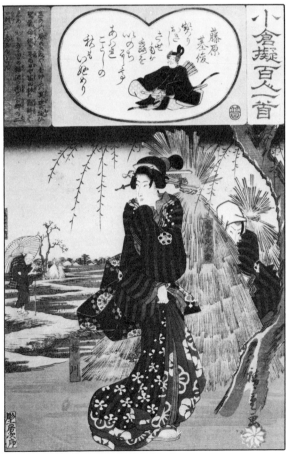

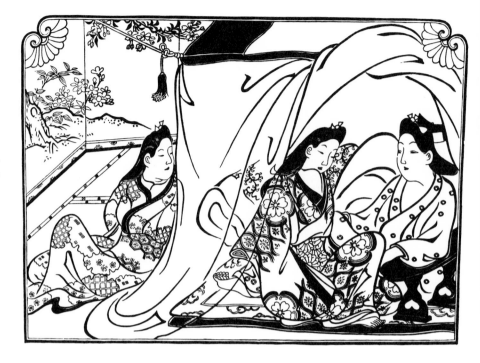

Hishikawa Moronobu was the first to consolidate the ukiyo-e style. He worked from the early 1670s until shortly before his death in 1694. Right: *Lovers With Attendant*, early 1680s. This is an example of Moronobu's dynamic early work; his soaring line is the soul of ukiyo-e. Such relatively sedate pieces were often used as cover illustrations or frontispieces for erotic print series. A lover is shown reclining beside his paramour—probably a courtesan—with her attendant at left. The mosquito netting above them indicates that the season is summer. The Honolulu Academy of Arts.

consider Moronobu's strengths—his unique ability to infuse each figure with the maximum psychological drama, and above all his ability to convey the essence of a portrait in the simplest terms. Whether it is the brute vitality of the warrior or the languid gentleness of a beautiful woman, each figure in a Moronobu print is a highly dramatic, compressed personality. By way of countering the detractors, Michener notes, "It's almost as if Moronobu's tremendous vitality of lines and ebullience prevented him from keeping the various parts of his prints related."

Utamaro and ukiyo-e's golden age

The ukiyo-e print reached its height during the last half of the 18th century. The foremost artist during this period was Kitagawa Utamaro (1754–1806). The unique Japanese ability to capture the soul of the subject is nowhere more evident than in his depictions of the courtesans who inhabited the *yoshiwara* ("joyful quarter"), Edo's brothels. To understand the poignancy of these women, it is vital to acknowledge the sadness of their life in the brothels. As the prints show, every night as dusk descended over the city the teen-age girls, beautifully dressed and elaborately coiffed, would assume their places in little cages on the first floor of the houses that lined the streets of the quarter. At the front gate to the *yoshiwara* a guard stood duty 24 hours a day to prevent the courtesans from escaping. As the young girls waited for clients, they sipped tea and chatted with companions behind the bars. How did these women come to the brothels? They might have been sold to the keepers by their parents or husbands. Or they might have been orphans or kidnapped as children. As courtesans they were trained from early childhood in the tricks of pleasing men. While young they enjoyed their few heady

years as the heroines of Edo society—but they were still kept locked up and constantly guarded. In their late 20s most were thrown into the streets to fend for themselves. A few were cared for by their patrons as lifelong mistresses, while others who had saved wealth were able to sustain themselves.

Drawing upon this milieu of unfortunate beautiful women, Utamaro created what was to become the universal symbol for Japanese womanhood. In a nation where most people are short, tend to be stocky, and have snub noses, Utamaro drew elongated creatures with long necks and straight noses. These emaciated beauties were reminiscent of the figures portrayed in the west by El Greco, William Blake, and Amedeo Modigliani.

Utamaro understood well the plight of the ephemeral beauties, for he wrote: "To the woman of the street, dark is the road of love; in the dusk she stands a lonely figure draped in black. Oh how heartbreaking to her that she must stand there with her face exposed." Utamaro also explained that while most artists copy what they see, what he wanted to do in his portraits was "to get at the soul of the sitter and then paint her so that all men will love her."

Ironically Utamaro himself was a very ugly man. A picture of him painted after his death shows him to have been fat, flabby, and somewhat dissipated. This has led critics such as Ernest Fenollosa, Waldmar von Seidlitz, and Arthur Davison Ficke to assert that he "created out of the living woman a disturbing symbol of impossible desire." They felt that his unnaturally tall beauties were the product of a perverted passion. But these critics currently are acknowledged to have been in error in their judgment of this most popular printmaker.

In the last half of the 18th century, excellent artists such as Torii Kiyonaga also portrayed women of the *yoshiwara*. The women who occupied a leading position in all their work

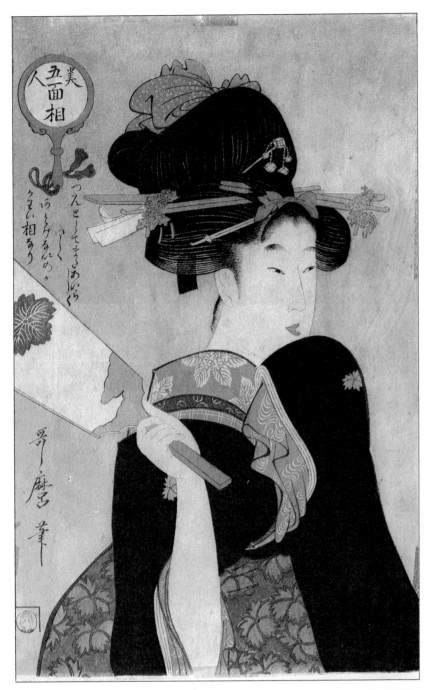

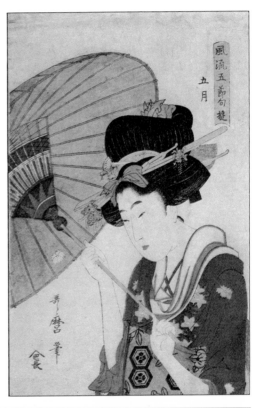

"Ukiyo-e prints were a most exuberantly sensual art form."

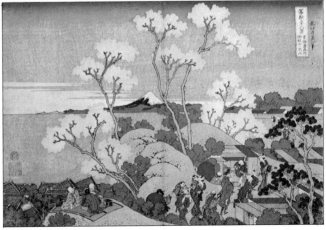

Above: *A Woman Holds a Hagoita*, by Utamaro, 1801-1803. This print, from the series *Faces of Five Beautiful Women*, is inscribed: "She looks cool, lovely, and young; she has a lovely face." Top right: *The Fifth Month (May): Young Beauty Under an Umbrella*, by Utamaro, 1804-1806. From the series *Enjoying Five Elegant Festivals*. Right: *Viewing Mt. Fuji from Gotemyama in Shinagawa on Tokaido* is from Hokusai's series *36 Views of Mt. Fuji*, considered by many to be his masterpiece. This set of 46 prints (10 were later added to the original group) displays Hokusai's consummate mastery of color, composition, and atmosphere, as well as his faithful rendition of the existing scene. All courtesy Ronin Gallery. All the prints in this article are *oban*, a standard Japanese print size measuring 10″ x 15″.

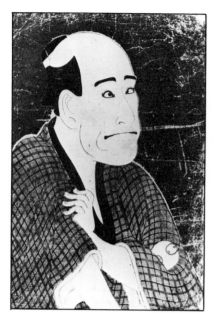 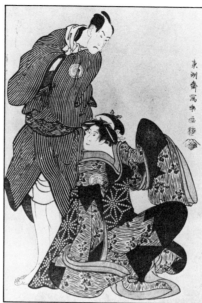

Far left: Toshusai Sharaku's work dates from a brief 10-month period in 1794-1795. It was not popular at the time, due perhaps to its sharp realism and psychological caricatures. His earliest prints were among his greatest and most original. This portrait of *Arashi Ryuzo* shows the actor as a money-lender in the play *Hanaayame Bunroku Soga*. The Honolulu Academy of Arts. Left: Scene from *Recollections of the Moon at the Katsura River*, by Sharaku, 1794-1795. From *The Surviving Works of Sharaku* by Harold Henderson and Louis V. Ledoux (E. Weyhe for the Society for Japanese Studies, 1939).

were usually drawn full-length and beautifully dressed. However, for the first time in ukiyo-e history, Utamaro began to paint only the upper torso of his sitters, so he could focus attention on the beauty of a courtesan's face and skin. While it had been fashionable to feature clothing and background in meticulous detail, Utamaro de-emphasized all the nonessentials to bring out the full beauty of the face.

Perhaps to make his courtesans even more sensual and alluring, Utamaro often portrayed them in a casual attitude that they might assume before intimate friends and lovers. He also delighted in depicting the tender and intimate relationship between a mother and child. This facet of Utamaro's work was carefully studied and copied by the young American artist Mary Cassatt.

Shunga—spring pictures

One aspect of the Japanese ukiyo-e print that has been largely misunderstood (because their display or reproduction has been largely taboo) is the *shunga*, or "spring pictures." These are quite simply sex pictures that depict men and women, men and men, even *ménages à trois* engaged in various acts of intercourse, lovemaking, and pederasty. Where do these prints fit into the ukiyo-e universe? To answer this question, it is vital that we understand the role of sex in the Japanese society of the time. To the Japanese mind of the 17th century, sex was not a romantic ideal, nor was it a sacred rite to be entered into with reverent care. It was simply a joyful union of the sexes, a natural activity that was among man's greatest pleasures, and as such it naturally belonged with the other leisure activities depicted in the ukiyo-e print. And in much the same way as the nude has been used by Western artists for esthetic rather than erotic purposes, the *shunga* is just another branch of the Japanese artist's oeuvre.

Erotica were "an integral part of the classical Japanese artist's recognized work," according to Richard Lane in *Images From the Floating World*. They were no more degrading than

the painting of a nude or a classical love scene would have seemed to a contemporary Western artist. The *shunga* books, prints, and albums provided an ideal way to educate a prospective virgin bride and therefore were in great demand even among the most aristocratic families, where they were handed down from mother to daughter. In the West, it is only in the present century that we find detailed drawings of sexual positions. In a sense, the Japanese several centuries ago were far ahead of the West in substituting creative works by major artists for the usual cold scientific diagrams in sex manuals.

Lane further points out that most of the "presentable" prints by early masters such as Moronobu that are shown in museums and art galleries today were probably the cover sheets to erotic albums. These less explicit prints were usually interspersed through most of the *shunga* books for variety's sake. The artists themselves, Lane continues, felt no need to apologize for their work in erotica. On the contrary, from the late 17th century on, artists often signed their erotica while sometimes neglecting to affix their names to much of their more ordinary work. Such masters as Utamaro even publicly disdained production of kabuki actor prints, but took great pride in their *shunga* work. They produced some of their finest achievements in this genre, according to Lane.

Sharaku, prolific kabuki portraitist

One of the most enigmatic figures among ukiyo-e artists was Sharaku, who burst on the scene, seemingly out of nowhere, in the spring of 1794. He worked in Edo for ten months. Within that period he turned out a stupendous series of more than 160 prints, the likes of which have never been seen in terms of originality and daring. Then Sharaku disappeared, never to be heard from again. While Sharaku took as his models the same famous kabuki actors of his day as did other artists, his portraits caricatured the role that the actors played. Indeed, they were so profound and passionate, so unconventional, that the audiences of 18th-century Japan found

them a bit too strong, and the prints remained unsold. (Kabuki-actor prints were always produced by ukiyo-e artists, just as landscapes were. Prints of women, however, were always a more popular subject with artists—except for Sharaku.) Later connoisseurs, however, have vindicated this enigmatic genius. And today his works command among the very highest prices at auction. Despite this contemporary popularity, almost a century and a half of painstaking research has failed to resolve the riddle of who Sharaku was, how he was able to achieve these masterpieces in so short a time, and why he disappeared.

Most of Sharaku's polychrome prints are portraits of actors, but he also did a few wrestler and warrior portraits. His work developed in the reverse direction of that of most artists. His first prints are his best, and his more ordinary prints came later. Furthermore, most Japanese artists went from a comprehensive treatment of whole figures against a background to full-length treatment of isolated figures without background and then to the half-length figure. They also began with a small print, working up to a large one—from technical simplicity to technical complexity. But Sharaku worked precisely in the opposite way in these technical and visual areas, according to Howard A. Link.

The scholar Suzuki Juzo wrote of Sharaku's first and best series of portraits, "The accuracy and economy with which the line captures only what is essential, dispensing with all unnecessary detail; the way in which the eyes, mouth and hands are used to suggest the spirit within, and in particular the consummate skill with which the fragment of gesture is made to suggest the whole unseen figures are all worthy of the highest admiration." The lines that "at first glance appear to be freakishly distorted—prove on closer inspection to constitute what one might describe as quintessential units of form which are produced by paring away everything but the absolutely indispensable."

Hokusai, ubiquitous printmaker

The subject matter of the color print was further enlarged by Katsushika Hokusai (1760–1849), one of the last great ukiyo-e printmakers, who drew everything that could be drawn: men, women, animals, plants, landscape, warriors, monsters, and ghosts. Hokusai produced over 30,000 prints in his 89 years of life and was fond of signing his works "The Art-Crazy Old Man." While most artists are content to select one or two subjects and develop them in depth, Hokusai attempted to capture the rhythm of waves in the sea, the force of the wind on flowers, the movement of roosters, as well as man within nature. Hokusai was one of the first to feature the landscape as the subject of a print, with man as the adornment enhancing the magnificence of the scene. And in the Fuji prints, Hokusai was among the first to take the courageous step of omitting the human figure altogether.

Hokusai had a lamentable sense of anatomy, and his deficiencies and inaccuracies in this area are glaring. However, his vivacity and biting observations of the comédie humaine rank him alongside his Western contemporary Francisco Goya. In *Hokusai Sketchbooks* (Charles E. Tuttle, 1958), James Michener notes that when The Metropolitan Museum of Art for the first time displayed Hokusai next to masters of the anatomy such as Dürer, Leonardo da Vinci, and others, Hokusai's anatomical drawings were ludicrous from a scientific viewpoint. Nevertheless, repeatedly during the exhibition, visitors were apt to linger longest before the Hokusai plates, reports Michener. In these drawings of homely, twisted little beings there was something universal. They represented not anatomy but mankind, Michener says.

The originality of Hokusai's thinking perhaps can best be demonstrated by an anecdote that is said to be about him. In a painting competition, Hokusai's subject was maple leaves floating on the Tatsuta River. To produce this effect, he took a long sheet of paper and with a broad brush painted a line to symbolize a river. Then he took a rooster, dipped its feet in red paint and let it walk across the painting. The shape of the rooster's tracks corresponded with those of maple leaves, and they won the prize for Hokusai.

Hokusai's own appraisal of his life's work was best summarized when he wrote: "Ever since the age of six, I have had a mania for drawing the forms of objects. Towards the age of fifty I published a very large number of drawings, but I am dissatisfied with everything which I produced before the age of seventy. It was at the age of seventy-three that I nearly mastered the real nature and form of birds, fish, plants, etc. Consequently, at the age of eighty, I shall have gotten to the bottom of things; at one hundred I shall have attained a decidedly higher level which I cannot define, and at the age of one hundred and ten every dot and every line from my brush will be alive."

Cultivated Japanese scorned these popular prints as vulgar, but the impressionists seized upon them and studied them carefully in the 19th century. The Japanese print burst upon Parisian society at a time when the art world was moving away from representational art. The prints, which by the end of the 19th century had become brightly colored, had arbitrary color schemes and nonnaturalistic outlines. They were frankly two-dimensional and adopted unusual above- or below-eye-level perspectives. But because of their greater freedom, they achieved designs in line and color that were beautiful or significant in themselves, independent of subject matter—a novelty in Paris then.

Yet the subject matter of the ukiyo-e print was one of its primary attractions. By the end of the 19th century, Europe had become obsessed by a cult of decadence, enabling the artists to see close parallels between their world and the Japanese "floating world." The bohemian attitude of the *fin de siècle* was kindred to many of the prints' "frank immorality" and "perversion"—as interpreted by Western standards.

Ukiyo-e prints today are more popular than ever. As the Japanese have come belatedly to appreciate this native art form, they have become active bidders at auctions, and it is common for a select Japanese print to command as much as $50,000. Why do ukiyo-e prints still continue to attract after all these centuries? Perhaps it is their spirit, and the fantasies they evoke of the floating world. ∎

The American Art·Union

From 1839 to 1851 this novel organization was responsible for circulating several hundred thousand engravings, purchasing over 2,000 original paintings, and conducting large exhibitions to which nearly 3,000,000 Americans ventured.

BY MAYBELLE MANN

It was a remarkable organization. During its 13-year existence (1839–1851) the American Art-Union promoted American art with a missionary spirit, giving 19th-century artists and their work an unprecedented boost in this country. The organization stimulated American painting, encouraged the portrayal of local subjects, and helped popularize art in America. Through the activities of the AA-U engravings were distributed to thousands of subscribers nationwide, bringing art into the homes of approximately 75,000 people in its last five years alone. In 12 years, furthermore, the AA-U purchased more than 2,000 original paintings! The result of the Union's brief existence is a remarkable pool of art for today's collector. We have been handed down not only original paintings of the period, but also engravings and bronze and silver medals.

The American Art-Union began its life as the Apollo Association for the Promotion of the Fine Arts in the United States. (It held this name for the first five years.) The idea came from James Herring, editor, publisher, portrait painter, and owner of the Apollo Gallery in New York City. He presented the original proposal for the organization—as well as a permanent place to exhibit art—in 1838. Herring was undaunted by the failure of the first show. It was clear that the poor attendance was due in part to the country's severe finan-

cial depression. In addition, the exhibit consisted largely of portraits and copies of old masters, which did not draw a significant crowd.

Not long afterward Herring received a report about a successful art union in Edinburgh, Scotland, an association based on a concept that had originated in Germany in 1825 and had spread rapidly across Europe. It worked essentially the same way everywhere: Each subscriber paid a small fee to join the association. This revenue was used by the association to defray expenses, to produce engravings, and to purchase original works of art. Each member received one engraving and was given the opportunity to obtain a bonus as well, an original painting. At an annual lottery, a member could win an original painting if his name was drawn.

The Early Years of the Apollo Association

When the first full meeting of the association was called by Herring on January 16, 1839, there were already 200 subscribers. That day the association elected officers and formed a management committee. Their intention was clearly affirmed: to promote American art and artists, and to elevate the public's taste in art.

The first year 814 members paid a five-dollar fee, and 36 works of art were distributed by lot in December. During that year, however, there wasn't time to distribute the premium.

Caius Marius on the Ruins of Carthage, **John Vanderlyn, 1842, oil, 87"x68½". The painting on the opposite page was considered to be Vanderlyn's best work. It was distributed to 1,120 Apollo Association members as a print (above) engraved by Stephen Alonzo Schoff. The print was the first fine engraving offered by the Association in its then-four-year existence. Vanderlyn was born in Kingston, New York, and died there in poverty in 1852. Courtesy H.M. de Young Memorial Museum, San Francisco, California.

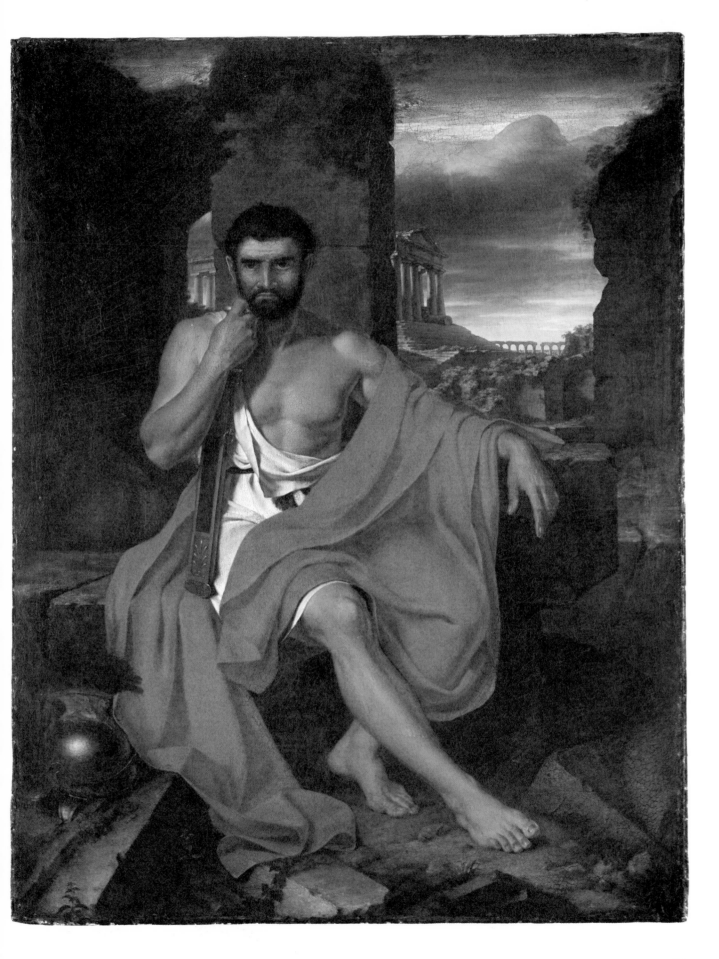

The following pages display the 36 prints distributed to the Apollo Association and American Art-Union members from 1840 to 1851. Note that the size indicated for each print refers to image—it does not account for the size of the borders.

1. *General Marion Inviting a British Officer to Dinner* by John Blake White, engraved by John Sartain 1840. 16⅞″x20½″.

2. *The Artist's Dream* by George H. Comegys, engraved by John Sartain 1841. 16⅞″x20⅝″.

6. *Escape of Captain Wharton* from Cooper's *Spy* by T.F. Hoopin, etched by F.F.E. Prudhomme 1844. 10″x12″.

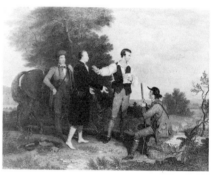

7. *The Capture of Major Andre* by Asher B. Durand, engraved by Alfred Jones (figures); James Smillie and Hinshelwood (landscape) 1845. 13¼″x18″.

8. *Sir Walter Raleigh Parting with His Wife* by Emanuel Leutze, engraved by Charles Burt 1846. 20″x15″.

12. *Illustrations of Rip Van Winkle* by Felix O.C. Darley, designer and etcher 1848. 6 plates. 8⅝″x11¼″—PLATE I.

13. PLATE II

14. PLATE III

18. *The Voyage of Life—Youth* by Thomas Cole, engraved by John Smillie 1849. 15¼″x22¾″.

19. *Illustrations of the Legend of Sleepy Hollow* by Felix O.C. Darley, designer and etcher 1849. 6 plates. 8½″x11⅛

20. PLATE II

3. *Caius Marius on the Ruins of Carthage* by John Vanderlyn, engraved by S.A. Schoff 1842. 13¼"x9⅞".

4. *Farmers Nooning* by William Sidney Mount, engraved by Alfred Jones 1843. 12⅝"x16".

5. *Sparking* by Francis William Edmonds, engraved by Alfred Jones 1844. 12⅞"x16⅞".

9. *The Jolly Flat Boat Men* by George Caleb Bingham, engraved by Thomas Doney 1847. 19"x24".

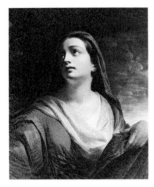

10. *A Sibyl* by Daniel Huntington, engraved by John Casilear, 1847. 9¼"x7⅞".

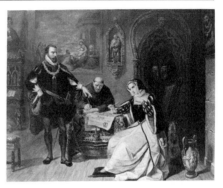

11. *The Signing of the Death Warrant of Lady Jane Gray* by Daniel Huntington, engraved by Charles Burt 1848. 17¼"x21¾".

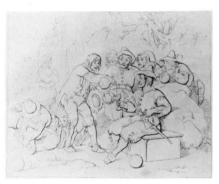

15. PLATE IV

16. PLATE V

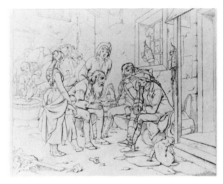

17. PLATE VI

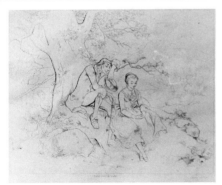

21. PLATE III

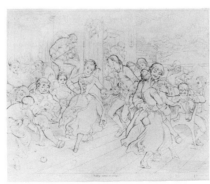

22. PLATE IV

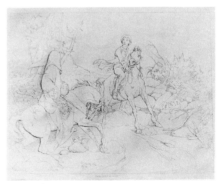

23. PLATE V

31

24. PLATE VI

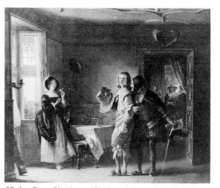

25. *Ann Page, Slender and Shallow. A Scene From the Merry Wives of Windsor* by Charles R. Leslie, engraved by Charles Burt 1850. 16¼"x20⅜".

26. *The Card Players* by Richard Caton Woodville, engraved by Charles Burt 1850. 7¼"x10".

27. *Dover Plains* by Asher B. Durand, engraved by John Smillie 1850. 6⅞"x10⅜".

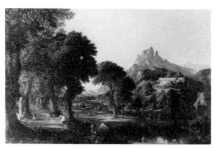

28. *Dream of Arcadia* by Thomas Cole, engraved by John Smillie 1850. 6¼"x10½".

29. *The Image Breaker* by Emanuel Leutze, engraved by Alfred Jones 1850. 9¼"x7¾".

30. *The New Scholar* by Francis William Edmonds, engraved by Alfred Jones 1850. 7¼"x9¼".

31. *Mexican News* by Richard Caton Woodville, engraved by Alfred Jones 1851. 20½"x18⅜".

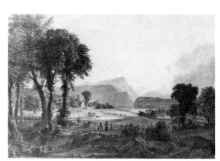

32. *American Harvesting* by Jasper Francis Cropsey, engraved by John Smillie 1851. 7¼"x10⅜".

33. *Bargaining for a Horse* by William Sidney Mount, engraved by Charles Burt 1851. 7¾"x10".

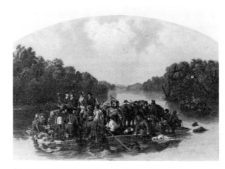

34. *Marion Crossing the Pedee* by William Ranney, engraved by Charles Burt 1851. 8"x11⅞".

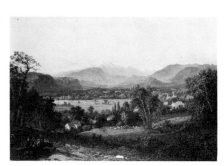

35. *Mount Washington From the Valley of Conway* by John F. Kensett, engraved by James Smillie 1851. 7"x10⅜".

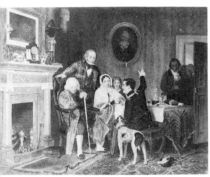

The AA-U regarded itself as a new kind of patron with a special mission: to awaken a wide public to the value of contemporary American art.

36. *Old '76 and Young '48* by Richard Caton Woodville, engraved by Joseph I. Pease 1851. 7½"x9⅝".

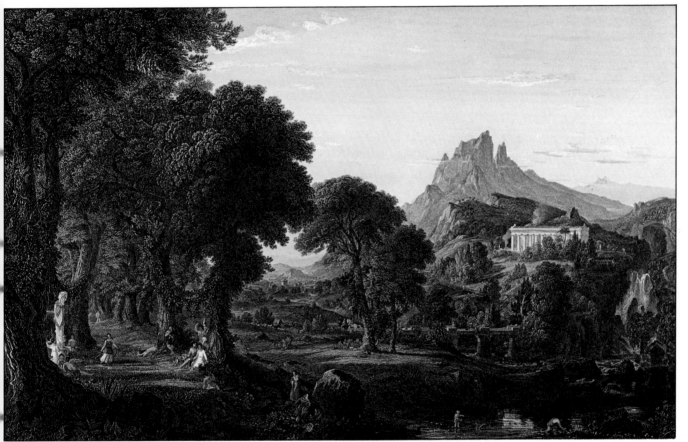

Dream of Arcadia, Thomas Cole, engraved by John Smillie, 1850, 6¼x10½. K.M. Newman, Old Print Shop.

It required months—often as long as a year and half—to engrave and print the steel engravings, so that the first subscribers did not receive their engravings until the following year. By 1840, each member received a print and from that year on the union kept its promise that every subscriber would receive something in exchange for the membership fee.

The first three years of the association's existence were beset with difficulties. Herring was forced to withdraw early in 1840 because the Apollo Association was unable to compensate him for his expenses. And even though the National Academy of Design granted AA-U the free use of its exhibi-

tion hall for the October and December shows, the receipts were still small. Only 58 paintings were purchased for the annual distributions between 1839 and 1841, despite the fact that almost all services were donated and only a few employees were salaried. Members were admitted free to the galleries, but the poor displays did not attract enough outsiders to defray expenses. Simply to fill the walls, the Association was obliged to borrow works from collectors and allow artists to exhibit without selling their paintings.

Prospects improved in 1842. The number of subscribers increased steadily. By 1847 there were almost 10,000 members. Only two years later, in 1849, the AA-U reached its peak

membership: 18,960 subscribers!

The romance between the National Academy of Design and the Apollo Association did not endure for long. Feeling threatened by the competition, the NAD tried to control the fledgling association. As a result, the association decided to keep the NAD at arm's length by holding its own exhibitions at a different time from the academy's exhibition. Its first show was held in May 1843, after the NAD had already closed its annual spring exhibit. The association eliminated its admission charge, set up a "perpetual free gallery," and mounted a new and expanded show each year. These changes soon attracted thousands of viewers.

In 13 years, approximately 3,000,000 visitors saw the exhibitions, an enormous attendance for those days, (and good even by today's standards). At a time when the population of New York City averaged about 400,000 (from 1839 to 1851), the average annual attendance to the AA-U exhibits reached 250,000.

Two thirds of the membership came from outside of New York City. At first, these members were solicited by a traveling agent who was dropped after 1845. After that, honorary secretaries handled all transactions with out-of-town members, retaining 10 percent of each subscription as their commission.

Early on, the Apollo Association changed its policy about the pricing of art. When the association had just formed, an artist could establish his own prices. But it soon became evident that artists held unrealistically high expectations of the worth of their work, so that practice had to be discontinued.

Thereafter, the association determined the price. While artists may not have been happy with that development, they could not deny the single major benefit of being exhibited at the gallery: widespread visibility. And this opportunity was available to all artists who chose to send in their work. According to the November 1848 issue of *Knickerbocker*, "Every poor struggling artist, no matter how narrow his circumstances, how remote his residence, can send his work hither with a certainty of its being examined by unprejudiced eyes, and receiving a fair judgement."

At the lottery, every precaution was taken to preserve openness and honesty. The members present nominated gentlemen—military officers, for example—to supervise the drawing. Later, in 1849, the acting mayor of the City of New York and the mayor of the City of Brooklyn presided over the drawing—evidence of the importance the AA-U had attained.

The lottery worked this way: There were two wheels—one held the titles of the paintings and the other the names of subscribers. A young woman posted at each wheel drew one from each, matching painting to the lucky subscriber, and continuing until all paintings had been won.

At the end of 1843, the association changed its name to the American Art-Union which better described its function and constituency. The group also became more democratic when the committee of management grew to 21 from 15 members, 7 of whom were elected each year.

The success of the AA-U stimulated competition—the growth of other art unions. Once on its feet, the AA-U felt secure enough not only to tolerate but to *support* similar organi-

Opposite: *Farmers Nooning*, William Sidney Mount, 1836. Oil, 20⅛"x24 3/16" and right: *Sparking*, Francis William Edmonds, 1844, 12⅞"x16⅞", were both engraved by Alfred Jones. Compare Mount's painting to the print taken from it, shown earlier. Five of Mount's paintings were given to the AA-U yearly lottery. The engraving from the painting was the first of two by Mount that the Union published. Courtesy Museum of Stony Brook, New York, Gift of Frederick Sturges, Jr., 1954. The print, right, was originally distributed in black and white (see Number 5, previous page). It was later colored. Edmonds was both a banker and artist. He was elected in 1840 as an Academician of the then rival artist organization, the National Academy of Design. Courtesy Kenneth M. Newman, Old Print Shop, New York.

zations. The exception was Goupil and Vibert's International Art Union, which the AA-U described as "A private enterprise owned and managed by foreign capital for profit," according to an essay by Charles E. Baker in *The American Academy of Fine Arts and American Art-Union* by Mary Bartlett Cowdrey.

Union with a Mission

The association's annual report to its members represents an early illustrated magazine of American art, a precursor of many art magazines to follow. It was initially called *Transactions* and was retitled the *Bulletin* in 1847. The report of 1842 described the domestic art scene as follows:

> We have no public galleries; our highways are ornamented with neither monuments nor statues; the men of wealth and taste among us, who possess works of art shut them up within the walls of their houses, there they are as much lost to the world as though they had never existed. . . . Our churches are now the last places where an artist would look for encouragement, and the state hardly acknowledges the existence of Art among us.

The AA-U regarded itself as a new kind of patron with a special mission: to awaken a wide public to the value of contemporary American art. The means by which they could accomplish this end was through the creation of engravings. At first they produced mezzotints, an arduous etching technique, but in their third year they created their first line engraving, a process which was described by one of the members as follows:

> Line engraving . . . at this period of art development (was) the sole means by which the inaccessible works of a painter . . . could be made widely known. Through the cunning of its technical process, a line engraving displays the principal elements of a painting—composition, drawing, form, gradations of light and shade, and the subtleties of effect—everything but colour. In competent hands the mechanical processes employed, like delicate sculpture, become a fine art. . . . Sometimes his art equals, and occasionally surpasses, that of the painter whose work he copies [from *The Life and Times of A. B. Durand* by John Durand.]

Choices for the engravings were made by the association's standing committees. Its members also contracted with the engravers and supervised the engravings and printing. The engravings were made from original paintings. Originally the association borrowed the paintings until it could afford to choose from among its purchases. An artist never received a fee for the use of his painting in the engraving process, but it was agreed that several works would be commissioned.

The prints and medals issued in the AA-U's brief but active years trace the organization's development and provide a valuable record of the evolution of 19th-century art. The first engravings were stilted and static, illustrating management's early view of what constituted serious art.

The subject William Sidney Mount chose for the offering of 1843 (*Farmers Nooning*) was a first for the Union. It influenced the artists after him to depict similar typical American scenes.

The AA-U's rising fortunes permitted it to distribute two prints to the members, instead of one, each year. From 1847 on, the organization always gave more than one print—generally a large and some smaller ones. With at least two choices, the selection committee could please members siding with either camp in a split that had occurred between supporters of allegorical and historical subjects from those who preferred genre subjects. Both sides of this debate were represented in the AA-U's publication, the *Bulletin*.

At the annual meeting in 1847, William J. Hoppin, editor of the *Bulletin*, made the following resolution in reference to Daniel Huntington's *The Sibyl*. "It is the duty of this Association to use its influence to elevate and purify public taste, and to extend among the people the knowledge and admiration of the productions of 'HIGH ART'."

The other side of the discussion is covered in the October 1849 issue of the *Bulletin*. George Caleb Bingham felt strongly that he could not have succeeded in his career without the support of those who admired genre painting. His debt to the AA-U was acknowledged in the *Bulletin*:

> . . . these works are thoroughly American in their subjects, . . . It was this striking nationality of character, combined with considerable power in form and expression, which first interested the Art-Union . . . according to his own statement, if it had not been bestowed, he would never perhaps have attempted that peculiar class of subjects which have given him all his reputation.

Engraving was not the only contribution the American Art-

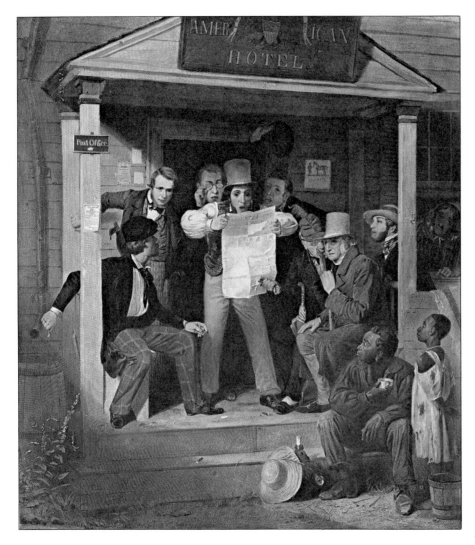

Mexican News, Richard Caton Woodville, 1851, 20½"x18⅜". Just when the original black and white print (above) was painted in watercolor (left) is uncertain. Today the color prints such as this example can cost as much as two or three times more than the originals. This Woodville print, engraved by Alfred Jones, pictures men in front of a Southern tavern receiving news of the Mexican war—a contemporary topic demonstrating the popularity of genre presentation. Woodville was the only artist to have three pictures engraved for distribution by the AA-U. His career as an artist was launched in effect by the Union which opened its doors to this young, unknown artist. Jones executed five engravings for the AA-U and participated in a sixth before he died in New York City in 1872. He excelled in engraving figures. Color print courtesy Kennedy Galleries, New York. Original print, private collection.

Union made to the development of multiple art in those days. In the April 1851 issue of the *Bulletin*, the AA-U maintained that it was responsible for introducing to America the art of "medallurgy." It produced three medals honoring deceased American artists: Washington Allston (in 1847), Gilbert Stuart (in 1848), and John Trumbull (in 1849). Each medal presented the portrait on one side and the AA-U seal on the other. (Prints, incidentally, also displayed the seal of either the Apollo Association or the American Art-Union). Although the medals were not given to each member, between 200 and 400 were distributed in lotteries each of the three years. Additional copies of all the medals were given away in the lottery of 1850.

The AA-U, proud of its accomplishments, commissioned a drawing by Thompkins H. Matteson, *Distribution of the American Art-Union Prizes at the Tabernacle-Broadway, New York; 24th Dec. 1847*. It was lithographed in 1848 and distributed by the honorary secretaries to help them solicit additional subscribers.

As the AA-U matured, it developed new ways of "packaging" art. For example, it commissioned Felix O. C. Darley's illustrations of Washington Irving's popular stories—*Rip Van Winkle* and *The Legend of Sleepy Hollow*. Darley drew them on stone and lithographed them. They were distributed to the members in 1848 and 1849 in pamphlet form with text. (Darley was just 21 when his work came to the AA-U manager's attention.)

The AA-U also distributed a series of engravings in a folder, which it called "A Gallery of Art." The idea was new in 1850. That year, the collection consisted of five small engravings representing a mixture of what Hoppin had called "high art," and genre subjects. By the next year, not a single piece of the so-called high art was selected for the gallery.

The AA-U's Demise

The downfall of the AA-U was brought about by a disgruntled artist with a bent for journalism (who was described by some of his contemporaries as an Englishman by birth but of little talent). Thomas Whitley had three of his paintings accepted by the AA-U only because William Cullen Bryant, ex-president of the AA-U, had interceded on his behalf. His later offerings were all rejected.

Embittered by these rejections, Whitley attacked the Union. His accusations were published by James Gordon Bennett, editor and owner of *The New World Herald*. Other journals, which had supported the AA-U when it was young and

struggling joined the *Herald* in the assault. The barrage of hostile publicity began to create an adverse effect on the public.

During those Victorian times, the issue of the lottery had been the Achilles heel of the AA-U from the start. After legal actions snapped back and forth, the AA-U seemed to have won the battle. Ironically, the District Attorney—who was a friend of the AA-U—decided to take the matter to the Supreme Court for final victory. Instead, the Court found the American Art-Union lottery illegal and unconstitutional.

The task of keeping the organization going by other means proved impossible. The entire inventory of art in the possession of the AA-U, including the engraving plates themselves, was liquidated in a final sale in December 1852. Records, left-over engravings, some paintings, remaining funds, and anything else that was unclaimed were all turned over to the New-York Historical Society, where they remain to this day.

The Legacy of the AA-U

John Durand in his book, *The Life and Times of A. B. Durand*, described the changes the AA-U had caused in the American art scene:

> In 1836 [artists] could be counted on one's fingers, in 1851 when the Art-Union fell under the hand of the law, American artists formed a large body. . . . The institution, if not the creator of taste for art in the community, disseminated a knowledge of it and largely stimulated its growth. Through it the people awoke to the fact that art was one of the forces of society.

The American Art-Union was influential in promoting a radical change in the kind of art that was being done by the newer artists. Where portraits and historical paintings once led the way in the few galleries that held exhibits, the AA-U promoted landscapes and genre works.

With the advantage of hindsight, Worthington Whittredge wrote in an article, "The American Art-Union," in the February 1908 issue of *The Magazine of History:*

> . . . The class of work generally known as "genre," the most natural and expressive way of recording the manners and custom of a people, had been almost entirely neglected. It was the Union that gave impetus to this class of work, not so much by merely buying them . . . as by the encouragement it gave to native art, and the consequent spur to the artists to look for subjects at their own doors.

What caused the organization's phenomenal success? The lottery feature was crucial. The possibility for an average person to win an expensive, original oil was irresistible to many. For example, a major reason 7,000 new subscribers joined the AA-U in 1849 was one of the many prizes offered that year: four canvases composing Thomas Cole's *Voyage of Life* series.

For the rising middle class of the city, the free gallery became a fashionable place to see and in which to be seen. For the members scattered around the country, where there was no access to the free gallery, the engravings they received were enlightening. They had the opportunity to own art of a higher quality than they could normally buy or see.

With the demise of the AA-U, American artists lost a market for their work that would not redevelop for 100 years.

Hints for American Art-Union Print Collectors

1. All the prints—etchings and engravings—were initially distributed in black and white. At a later time—no one knows precisely when —dealers and possibly individual collectors water-colored some of the prints. According to one theory, these prints may have been painted right after the AA-U disbanded at just about the time chromolithography became widely used, a printing technique that made colored pictures extremely popular. Another theory suggests that the dealers of the late '20s were the first to color these engravings in order to make them more appealing to their clients. In fact, dealers continue to color them today. Oddly enough, for the less expensive etchings and engravings these "watercolor prints" can actually double or triple the price of the untouched originals. The price of the prints that sell for $1,000 or more generally do not increase at quite this rate.

2. The price of the print is determined by two important factors: the popularity of the artist and the rarity of the print. The most expensive prints are those of William Sidney Mount, George Caleb Bingham, or Richard Caton Woodville.

Because the earliest prints—such as *The Artist's Dream or Caius Marius on the Ruins of Carthage*—are rare, they demand higher prices than the later offerings. When they were originally distributed, the edition was probably as small as the membership (from 937 to 1,120). The precise number of each edition is not known. The AA-U continued to produce additional copies of its early offerings to accommodate special orders from later members who desired complete sets. However, we can be certain that printings of its early offerings were not as great as those printed from 1848 on—when the membership climbed over 16,000.

3. In an ideal engraving, the margins of the print should be untrimmed and should include the artist's name, the title, and any other information the AA-U originally printed at the bottom. The engraving should also carry the seal of either the Apollo Association or the American Art-Union. (After the AA-U disbanded, G. Appleton of Appleton Press reissued one print—William Sidney Mount's *Farmers Nooning*. This one is of poor quality which greatly distressed the artist. It can be easily distinguished from the others because it lacks the association's seal.)

4. For the prints having suffered excessive water damage a special bleaching process can be used to eradicate the brown spots. Bleaching does not alter the value of the print—on the contrary, it can enhance an otherwise spoiled etching or engraving. But it is an expensive process; a conservator does it.

5. The prints can be located at auction and through dealers nationwide because they were distributed to a membership through the country. The AA-U actually had an agent in London, so finding some of these prints overseas should not surprise the collector.

American Landscape Prints

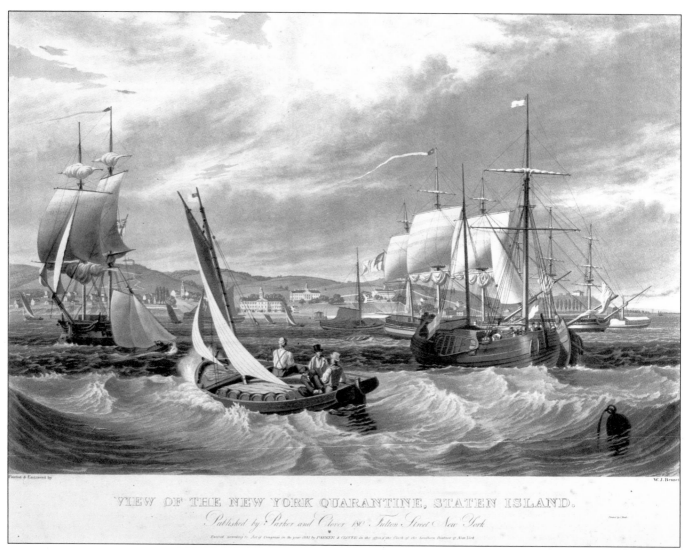

VIEW OF THE NEW YORK QUARANTINE, STATEN ISLAND.
Published by Parker and Clover 180 Fulton Street New York

The international fascination with American scenery attracted artist-engravers from Europe, who brought with them the most up-to-date printmaking techniques. Their romantic views recall a young nation full of vigor and promise.

BY MAYBELLE MANN

During the early years of the 19th century, romanticism, nationalism, and European fascination with the emergent American nation created a demand, both here and abroad, for "view books" or "annuals" of bound prints and engravings depicting sites along the Hudson River and other picturesque landmarks. Today, prints cut from such volumes, appreciated as works of art, are of great collecting interest, but the circumstances attending their original conception and publication often have been forgotten.

John Hill was first in a long line of artists and printmakers—primarily from Britain—who traveled to this country to record the landscape for such bound volumes of views, which were published well into the third quarter of the century.

The arrival of John Hill in Philadelphia in 1816 was a landmark for the graphic arts in America. The city where the emigrant Englishman chose to settle employed 60 engravers,

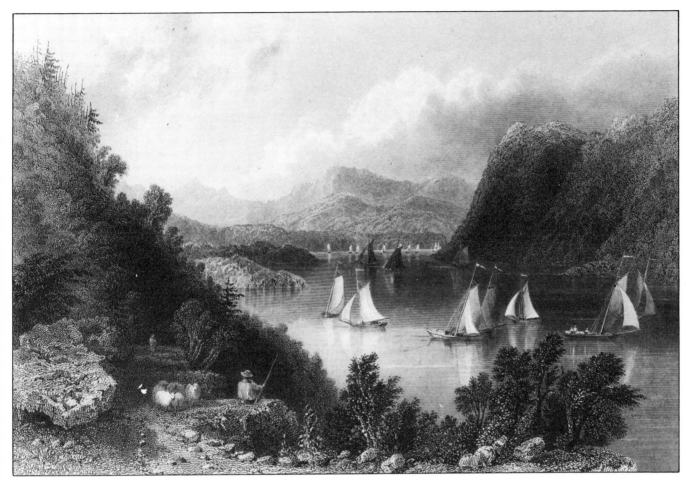

drawn by the presence of the banknote engraving business. None could match Hill's style and competence.

Hill came to America in his mid-forties because of the diminishing demand in England for his craft of aquatint. That he emigrated immediately after the Napoleonic wars indicates that he might have come sooner if it were possible. Apart from the engravings he produced, little is known of Hill's first three years in the United States, but by 1819 he found sufficient encouragement to bring his wife and four children from England.

Picturesque Views of American Scenery

In 1819 Hill began the plates for *Picturesque Views of American Scenery* after the works of Joshua Shaw. In the same year Shaw traveled throughout the country sketching and taking subscriptions for his projected publication. These folios seem to be the first "annuals"—prints bound into book form—published specifically to arrive in time for Christmas giving.

Shaw selected Hill to transpose his work to the print medium because aquatint, an etching process in tone, is particularly suited to the reproduction of watercolor-wash landscape drawings with delicacy, subtlety, and, where desired, bolder effects. During Hill's period of greatest activity, only the work of William J. Bennett could compare with the quality of Hill's prints.

The first printer/publisher for the project, Moses Thomas,

The extremely popular Bartlett prints were engraved by various printers after sketches made by Englishman Henry Bartlett during his travels around America between 1837 and 1852. On this page are two prints from Bartlett's *American Scenery or Land Lake and River Illustrations of Transatlantic Travel*: H. Adlard's engraving *View near Anthony's Nose Hudson Highlands*, 1840, at top; and *Valley of the Connecticut (from Mount Holyoke)*, 1834, by R. Brandard after Bartlett, below it. Both New-York Historical Society. William J. Bennett's 1833 *View of the New York Quarantine, Staten Island*, is on the page opposite. 15⅜″ x 22¼″. Hirschl and Adler Galleries, New York.

VIEW OF BOSTON IN 1848.

dropped out after completing only the title page, dated 1819, but Mathew Carey quickly took over. The ambitious plan initially included 36 hand-colored illustrations to be issued in six parts, but Carey stopped Hill in February 1821 after only 20 plates were finished, including the title page. Most of the illustrations—each with a letterpress description—were sketched in seven states by Shaw, but several were adapted from drawings by Capt. Joshua Rowley Watson of the Royal Navy.

Eschewing the English practice of trade specialization, Hill was responsible for the entire printing process from start to finish. *Picturesque Views of American Scenery* proved to be a milestone in American printmaking and was so appealing that it was reprinted in 1835 by Thomas T. Ash of Philadelphia.

"Picturesque" as an indication of what lay within a book or folio became a key word for American scenery. The "views" became the prototype for American colored-plate printing of large scenic landscapes. Untamed wilderness scenes, depicted in stormy and melancholy moods, foreshadowed the romantic Hudson River school of painters. Most important for Hill, the work called attention to him as a master of aquatint.

In 1821 Hill etched an instruction manual for landscape artists, entitled *Drawing Book of Landscape Scenery, Studies From Nature Executed by J. Hill*, published by Henry J. Megarey, who prepared the text. Hill and his daughters Caroline and Catherine hand-colored the prints. This popular book was reprinted in 1824 and 1825.

An earlier volume in which Hill is not identified as the printer carried the title *The Art of Drawing Landscapes; Being Plain and Easy Directions for the Acquirement of This Useful and Elegant Accomplishment. Embellished With Ten Engravings in Aquatint* (Baltimore: Fielding Lucas, Jr.,

1820). The scenes are all obviously foreign but done with such perfection that there is little doubt Hill made them. Reinforcing this assumption is the fact that in 1818 Hill had etched plates for a drawing book on flowers for Lucas.

The Hudson River Portfolio

The Hudson River Portfolio was begun by another English-born printmaker, John Rubens Smith, after the watercolors of a young Irish artist, William Guy Wall. Before Smith had finished the first four plates, the project was turned over to Hill, who worked on it for five years, from 1821 to 1825. Hill continued to strike prints until 1833. Although the prints were issued over a period of 12 years and numbered consecutively, they were not published in numerical sequence, which resulted in later confusion. Hill continued for many years to issue other individual views on various topics. In 1822 he moved with his family to New York's village of Greenwich, but spent his last years in Rockland County, New York, in the vicinity of Nanuet.

Richard J. Koke, curator of the New-York Historical Society, lists 181 prints in his definitive checklist of Hill's works.

Jacques Milbert

The fascination with American scenery was international. In the 1820s lithographs accompanied a book by Jacques Gerard Milbert, who also made his sketches on the site. Milbert's *Itinéraire Pittoresque du Fleuve Hudson* overlapped in subject matter with Hill's *The Hudson River Portfolio* and with later prints by William Bartlett, but Milbert's drawings take their perspectives from different lines of sight. Milbert's drawings, which date from 1823 and 1824, were published circa 1829 in four languages, including Latin.

After emigrating from England in 1837 artist Edwin Whitefield became an enthusiastic traveller, recording the American landscape in sketches and later in lithography, which he taught himself in 1842. Although many of Whitefield's lithographs were copied after his own watercolor and pencil sketches, his *View of Boston in 1848*, opposite page, was executed after a work by C. Burton. 19″ x 43″. Courtesy Kenneth Newman of The Old Print Shop. Whitefield's drawings are minutely de-

tailed, as in the two lithographs, above, from *North American Scenery*, 1846. On the left is *View of the Conestoga near Lancaster, Pennsylvania*. The house represented in *Country Seat, near Yonkers, Hudson River*, at right, was Thomas W. Ludlow's "Cottage Lawn." Both New-York Historical Society. Below, William Bennet's colored aquatint *West Point, from above Washington Valley*, 1834. 15¾″ x 22⅝″. Courtesy Hirschl and Adler, New York.

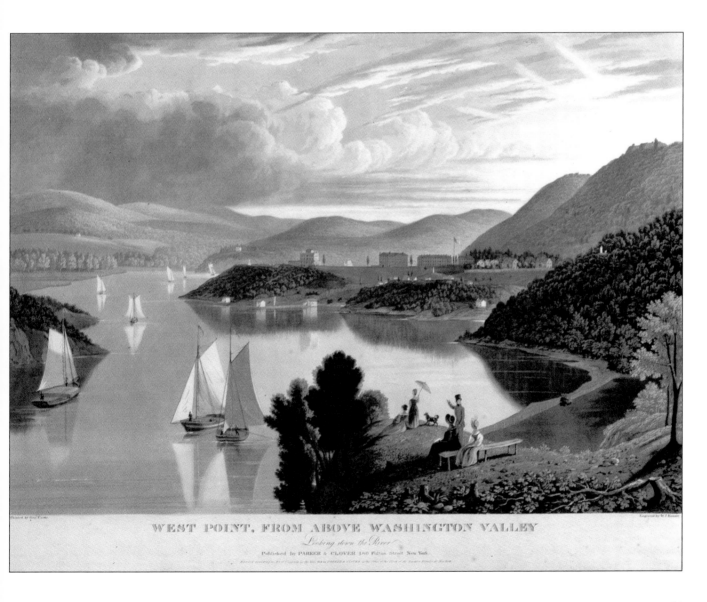

WEST POINT, FROM ABOVE WASHINGTON VALLEY
Looking down the River
Published by PARKER & CLOVER 180 Fulton Street New York.

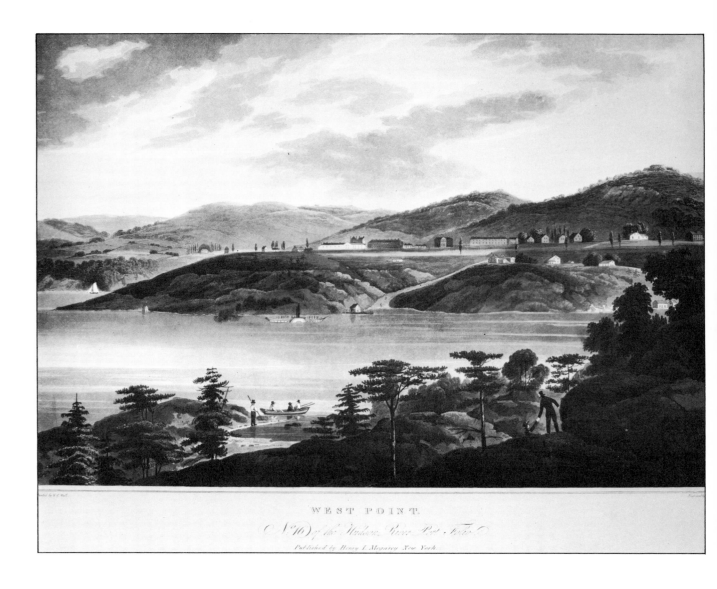

WEST POINT.

(*No. 10*) *of the Hudson River Port Folio.*

Published by Henry I. Megarey New York.

William J. Bennett

William J. Bennett, National Academy painter and engraver, migrated to New York City from England in 1816, the same year Hill arrived. Bennett is recognized as the only aquatint etcher of that era who surpassed Hill, although during his first ten years in the new country, he concentrated on painting. I. N. Phelps Stokes, the foremost authority on American prints, calls Bennett's city views "perhaps the finest collection of folio views of American cities in existence." Bennett went into the field of pictorial reporting, an area later cultivated by Currier and Ives. Despite the quality of his work, Bennett did not have as much impact as Hill on painting in the United States.

Durand and Wade: *American Landscape*

One of those artists, Asher B. Durand, attempted to publish his own gift annual, but he only completed the first book, *American Landscape, No. 1*, issued in New York by Elam Bliss in 1830. There were six plates by A. B. Durand and E. Wade, Jr., (whose name does not appear on the plates themselves but is on the title page). James Smillie prepared one of the plates and the rest carry Durand's name. In the preface William Cullen Bryant struck a patriotic note in justifying the publication of the Durand and Wade illustrations:

> The Embellishments of our "Annuals," and the avidity with which they, as well as similar foreign publications have been sought, for the Sake of the engravings they contain, are alone a sufficient proof, that there is no want of competent talent among our artists, nor of taste in the community, to ensure the most successful results . . .

Bartlett's *American Scenery*

Probably the most popular American landscape prints are the so-called Bartlett prints, named after William Henry Bartlett, who was born in a London suburb in 1809. At 13 he was apprenticed to a well-known British architect, John Britton, who soon recognized young Bartlett's ability as a draftsman. By the 1830s Bartlett provided the drawings for travel books written by Dr. William Beattie and published in England by George Virtue, who remained Bartlett's publisher for life.

Between 1836 and 1852 Bartlett made four extended trips to the United States to find the subject matter for his draw-

PROGRESSIVE
DRAWING BOOK.

BALTIMORE;
Published by Fielding Lucas, Junr.

John Hill was the first of many British engravers and etchers drawn to America. In 1819, three years after settling in Philadelphia, Hill made the first plates for *Picturesque Views of American Scenery*. This series became the prototype for a number of later "view books" or annuals of landscape prints. In 1821 Hill did the first etchings for *The Hudson River Portfolio* after the watercolors of a young Irish artist, William Guy Wall. *West Point*, shown opposite, ca 1824, is number 16 from this series of colored aquatints. Courtesy Kennedy Galleries. Prints from this portfolio, including both *Newburg*, above middle, and *Glenns Falls*, top, emphasize the great expanse of the American landscape that so impressed foreign and immigrant artists. Minute figures and tiny buildings are dwarfed by huge boulders, giant trees, and long stretches of water. Above: Front cover of John Hill's *The Progressive Drawing Book*. Illustrations on this page, New-York Historical Society.

ings. These are translated by 20 English engravers, but only four—R. Wallis, R. Brandard, J. Cousen, and H. Adlard—are mentioned on the title page of Bartlett's *American Scenery or Land Lake and River Illustrations of Transatlantic Travel*. Nathaniel P. Willis wrote the text for this set and three others. Beginning in 1837 the views were published in sets of four steel engravings with eight pages of text. The chronology of the early volumes is uncertain; although bound volumes are often dated, subscribers—not publishers—bound and dated the volumes. Thus, their order varies. By 1850, when Virtue published complete sets, dates of publication began to appear, although the earliest sets are presumed to have been finished in 1840. *Canadian Scenery* was issued in a similar manner, and the earliest versions date from 1842. *Letters From Under a Bridge* by Nathaniel Willis contains nine handsome views by Bartlett. Published by Virtue in 1840, this volume is not well known. The final collaboration between Bartlett and Willis was *The Scenery and Antiquities of Ireland*.

For many years the Bartlett books have been broken up and vandalized for their prints. Complete sets of Bartlett's American and Canadian views are becoming rare, but the individual prints taken from them are still avidly collected. (Not every print in *American Scenery* is after Bartlett. Two are after Thomas Doughty and six were redrawn by Thomas Creswick before engraving.) Although maps are included at the beginning of each set, no itinerary is outlined, nor can Bartlett's travel plan be deduced from the order of the prints.

The books were also issued in French, German, and Dutch. On some of the plates the name and address of the publisher accompanied by a date can be found, although numerous inconsistencies exist in wording of titles and a few proper names are misspelled. Nearly 30 different engravers produced the plates, accounting for variations in lettering.

These books were all issued in black and white. Any hand-coloring was done by others later on. The prints were extensively pirated in this country, because no copyright law existed at the time. Other engravers made new plates, some of which still carry Bartlett's name. So many of these were done that to sort them out could be the work of a lifetime.

Virtue issued many editions in the 19th century, and both the American and Canadian scenery volumes have recently been reprinted. *Canadian Scenery* was reprinted in facsimile in 1967 and *American Scenery* in 1971. A cursory inspection of the facsimiles by even an untutored eye will reveal, however, differences in the quality of the paper and the reproduction of the print.

Bartlett's posthumous work, *History of the United States of America*, edited by Bernard B. Woodward, was published in 1856. The plates are practically indistinguishable from those found in earlier works. A final reprinting of some of Bartlett's scenes was issued in 1883 by Estes and Lauriat of Boston in a volume called *Mountain, Lake and River: A Series of Twenty-five Steel Engravings From Designs by W. H. Bartlett and Others*. The pages are noticeably larger than those of the original *American Scenery*.

In 1968 a volume titled *Quebec* was issued in Canada in a limited edition of 1,500 on special paper with 75 more, on

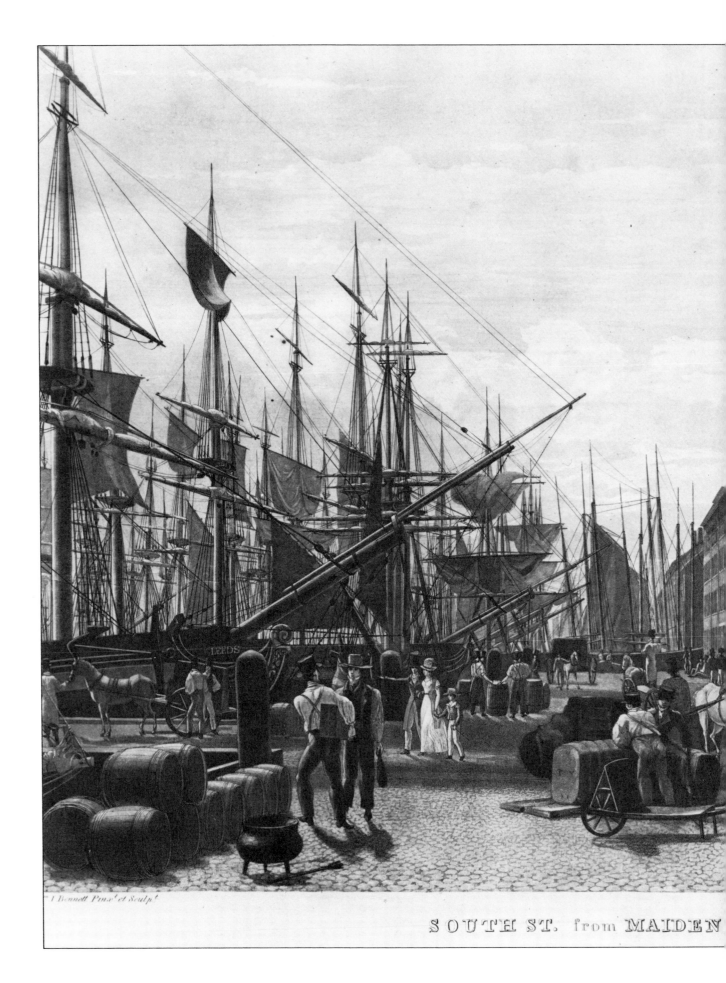

LEEDS

Bennett Pinx.t et Sculp.t

SOUTH ST. from MAIDEN

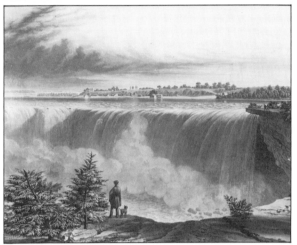

Most printers discussed in this article used intaglio printing techniques, cutting the lines of the picture into a copper or zinc plate, rubbing ink into the lines, wiping the surface clean, and pressing the print paper into the inked lines under the weight of a press. Although the term "engraver" is correctly applied only to the printer who incises his plate mechanically with a steel rod, or burin, all types of 19th-century printmakers in America called themselves "engravers," a more prestigious designation. Such was the case with etchers, who used acid to reinforce lines scratched into the plate—a chemical as well as mechanical process. Color was later applied by hand to many aquatints (etchings using a granular ground to protect portions of the plate from acid).

William J. Bennett was a National Academy painter and etcher before he left England in 1816, but he concentrated on painting during his first 10 years in the United States. Although many regard Bennett's colored aquatints as the finest of the period, those of his more prolific peer, John Hill, probably had more influence on the course of 19th-century American printmaking. Opposite: Bennett made the colored aquatint *South Street from Maiden Lane*, 9½″ x 13½″, after his own 1828 painting. It was published in 1834 in *Megarey's Street Views in the City of New York*. Above, top: One of Bennett's best-loved aquatints is *New York from Brooklyn Heights*. Both courtesy Kenneth Newman, The Old Print Shop. Above: Bennett's 1840 aquatint *Niagara Falls from the Table Rock*, 16¼″ x 23″. Kennedy Galleries, New York.

even finer paper, for private circulation. These are based on the Bartlett prints from the Canadian set. Perhaps the most interesting aspect of this book is the comparison the reader is able to make between an original sepia wash drawing by Bartlett and a replica by the English engraver. The romantic flare of the print is heightened by a twisting rooftop, accentuating trees and shrubs, and turning a simple rocky crag into an Alpine peak. The engraver has eliminated the mundane aspects of Bartlett's original faithful topographical drawing.

In his short lifetime Bartlett did the drawings for many travel books, ranging from Wales to the Near East, some of which carry his own text. Many oil paintings have come to light bearing a Bartlett signature, but there is no other supporting evidence that he painted in oil. It is known that Victor de Grailly, who never left his native France, copied Bartlett's prints in oil, and some of these paintings have appeared with fraudulent signatures.

Other publications

The interest aroused by the first volumes of American landscape engravings encouraged other publications. *Georgia Illustrated*, published in 1891, consisted of steel engravings after sketches drawn by Thomas Addison Richards. The banknote engraving firm of Rawdon, Wright, Hatch, and Smillie executed the engravings and published the first—and only—volume of a projected "Series of Views Embracing Natural Scenery and Public Edifices" in 1841.

The English artist Edwin Whitefield had many landscapes published in the United States. Whitefield came to the United States about 1837, settling first in Albany. He moved around a good deal, and his travels can be followed through the titles of his books and prints.

In 1842 Whitefield learned to make lithographs based on his own pencil and watercolor sketches. He was essentially self-taught, producing work that belongs to no school but accurately depicts the landscape he observed. His work is direct, spontaneous, and lively. Some of his early sketches indicate that he was a stickler for detail on major architectural and topographical features. The 12 volumes of his diaries preserved by his granddaughter, which cover his life from 1842 to 1892, reveal that Whitefield was his own publisher and promoter—and, most of all, his own man.

Some of Whitefield's better-known publications are *North American Scenery, Faithfully Delineated* (28 views), 1847; *Whitefield's Original Views of (North) American Cities (Scenery)* (39 views), 1845–1857; *Minnesota Scenery* (4 known views of an intended 8), 1858; *Whitefield's Views of Chicago* (7 views), 1860–1863; *Homes of Our Forefathers* (five hardcover books with lithograph illustrations), 1879–1892.

Whitefield's Patent Combination Drawing Cards, First Series Views on the Upper Mississippi (eight cards), 1861, was an innovative approach to teaching drawing. He produced many watercolors and individual scenic prints. All of these are much in demand by collectors.

The Home Book of the Picturesque (New York: Putnam, 1851), a handsome volume with a gilt-embossed hard cover and gilt-edged pages, contains 188 pages of letterpress by the leading writers of New York. Under the impact of rising nationalism, this book asserts the excellence of all things American. The book is dedicated to Asher B. Durand, then president of the National Academy of Design and a leading landscape artist. Its fine engravings were after some of the best landscape artists of the era: H. Beckwith, J. Talbot, D. Huntington, John F. Kensett, Asher B. Durand, Jasper Francis Cropsey, T. A. Richards, Frederic E. Church, R. W. Weir, Régis Gignoux, and Thomas Cole. The engravers were Beckwith, Hunt, Halpin, and Kirk.

Picturesque America: the end of a tradition

Picturesque America marked the end of the era for landscape "view books" illustrated with engraving on steel. Edited by William Cullen Bryant, and published in several editions from 1872 to 1874, the bulky two-volume gift set was the first landscape publication to treat the entire United States. Each book of the two-volume folio-size set has over 550 pages. The covers are embossed with gilt and the pages are giltedged. It contains hundreds of excellent wood and steel engravings. The steel engravings are listed by place, artist, and engraver in each volume and printed on better-quality paper than the many wood-engraved illustrations found on every page.

Many of the contributing artists were illustrators; some were both artists and illustrators. Some of the better known are R. Swain Gifford, Homer Martin, Thomas Moran, Granville Perkins, James and William Hart, James D. Smillie, David Johnson, Felix O. C. Darley, J. W. Casilear, John F. Kensett, and Worthington Whittredge.

There were many more "view books" published than can be described in this short article. In the period before the Civil War, when national pride was at its height, there seemed to be no end to the means used to celebrate the American heritage and its romantic landscape. But after 1875 the mood of the country changed and the demand for landscape illustrations diminished. Railroads brought the once exotic and seldom-seen Western frontier within the reach of all. Nostalgia for the land was giving way to industrialism, with its new hopes and problems. The trend-setting *nouveau riche* and middle classes began to turn away from things American and look toward Europe for "real" art. Expensively bound "annual" books gave way to cheaper magazines and to books illustrated with photogravures rather than wood or steel engravings. The "golden age of illustrators" celebrated people, not scenery, ending an era of romantic interest in the American landscape.

Today, however, the remarkable prints that illustrated the great 19th-century view books and annuals are treasured by collectors, both for the quality of their artistic achievement and for the vision they evoke of a young country, full of promise and hope. ■

On the opposite page are two aquatint views of the South by William Bennett after works by George Cooke. Above: *City of Charleston, South Carolina Looking Across Cooper's River.* **Below:** *City of Richmond, Virginia from the Hill above the Waterworks.* **Both New-York Historical Society.**

PUBLISHED BY LEWIS P. CLOVER 180 FULTON St N York.

RICHMOND, Virginia

FROM THE HILL ABOVE THE WATERWORKS.

Edward Beyer's Album of Virginia

In a forty-page volume of lithographs, this German-born artist documented Virginia's rolling hills and country resorts of the mid-1800s.

BY R. LEWIS WRIGHT

Although a landscapist of exceptional ability, Edward Beyer is not widely known either in his native Germany or in America. This is probably due to the small number of his works that survive. Born in the Rhineland about 1820, he graduated from the prestigious Düsseldorf Academy, founded in 1767. When Beyer studied there, the school was still markedly influenced by Peter Cornelius who espoused combining classical and romantic styles with precise depiction of even minute details in a landscape. Beyer found merit in this approach for his works have a distinctly romantic quality sharpened by his acute eye for detail.

After leaving Düsseldorf Beyer worked for a period in Dresden. Only three of Beyer's works from this period are known: two copperplate engravings, *Oak Forest on the River* and *Village with Goats Tended by Children*, and an etching, *Cottage and Water Mill*.

Beyer's panorama

In 1848 or 1849 Edward Beyer came to America, settling first in Newark, New Jersey. In 1850 he was working in Philadelphia. Several of his drawings, including views of the *Friends Meeting House at Jordans* and the *Grave of William Penn*, were prepared as wood engravings by W. B. Gibon and published in 1851 in *Pictorial for the Million: A Supplement to the Commercial Intelligencer*. About this time he collaborated with French-born artist Leo Elliott in the preparation of an extensive panorama depicting wars in Italy and Hungary. The panorama was a popular form of art in early and mid-19th century Europe and America. Painted on a roll of canvas, the elongated scene was either arranged in a circle for exhibition or rolled from one reel to another in front of spectators to show various parts in succession. The Philadelphia *Public Ledger* of December 9, 1850, carried this advertisement:

> A BEAUTIFUL PANORAMA—In the course of this week, a most beautiful panorama, representing the WARS FOR LIBERTY in Hungary, Upper Italy and Rome, the pictures to which, about 90,000 figures, of three feet in height, are painted in an unequalled manner by the celebrated artists, Messrs. Leo Elliott and Edward Beyer, of this city, will be shown to the public.

In the spring of 1851 the panorama was exhibited in New York. Beyer presumably had purchased Elliott's interest in the work, for from this time onward Elliott was no longer mentioned in connection with the panorama. The New York *Herald* of April 13, 1851, noted that

> Beyer's splendid panorama of the Wars for Liberty in upper Italy, Rome, and Hungary is now on exhibition at Panorama Hall, corner Broadway and Walker Street. Admittance, 25 cents; children 12½ cents. Liberal arrangements made with

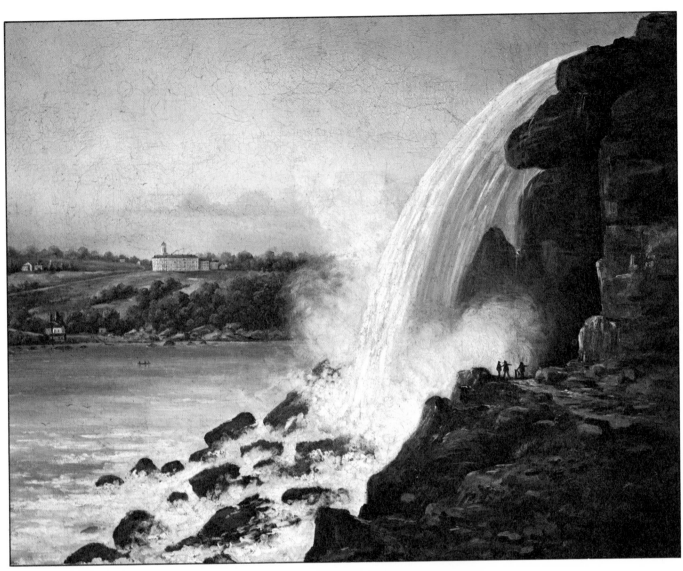

Above: Edward Beyer comments on nature's domination over man in *Niagara Falls*, 1853. Oil/canvas 16″x20″. The size and placement of figures and buildings (the factory on the hill suggests the industrial revolution) emphasize their vulnerability to the powerful waterfall. Courtesy Kenneth M. Newman, The Old Print Shop, New York; Photo Mysak/Studio Nine. Left: A more peaceful view of nature is seen in *Skating on the Passaic*, 1852. Oil/canvas, 12½″x18″. The German-born artist owes his careful attention to detail to the artistic traditions of northern Europe. The Newark Museum. Opposite: A carte-de-visite photograph of Beyer, ca 1850. The Valentine Museum, Richmond, Virginia.

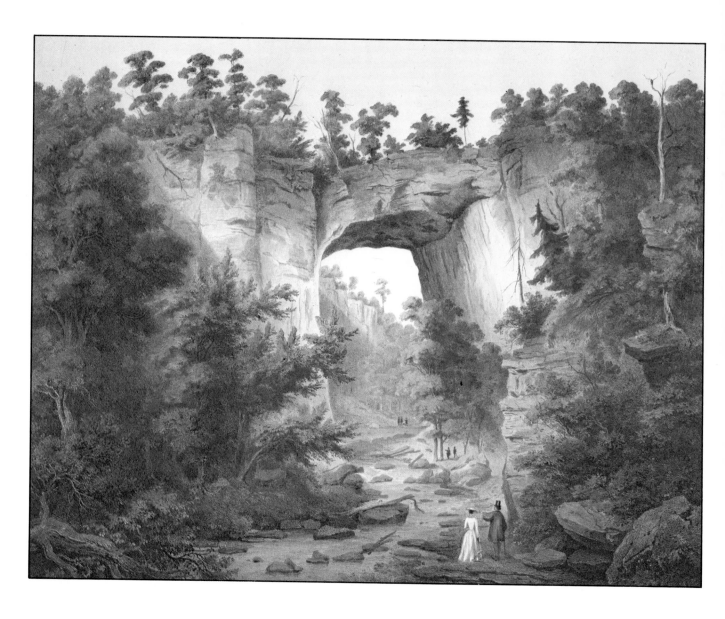

schools. Afternoon exhibitions, Wednesday and Saturday, at three o'clock. Doors open at 7 P.M., commencing at 8:00.

The panorama was last exhibited in Cincinnati, according to the Cincinnati *Gazette* of December 3, 1853:

> TO THE PUBLIC—I have a fine Panorama of Italy together with four magnificent oil paintings, one being a view of Cincinnati which I wish to dispose of, as business of importance requires me to be in Europe as soon as possible. . . E. BEYER

Album of Virginia

Edward Beyer did not return to Europe as predicted in his advertisement. Instead he came to Virginia early in 1854 and remained there for approximately two and a half years. He worked chiefly in the sparsely populated but mountainous western part of the state, including that portion which at the time of the Civil War became West Virginia.

Perhaps the natural scenery of the area reminded him of his native Rhineland. Most of his known surviving works, done at this time, record in meticulous detail and bright color the natural scenery and architectural details of the towns, farms, and fashionable spas then numerous in Virginia's mountains.

Beyer also carefully depicted the methods of transportation in the area—carriages, trains, and their tunnels through the mountains, covered bridges, and canal boats.

Many of his works from this period in Virginia were incorporated into the *Album of Virginia*. This forty-page, folio-size volume of lithographs devoted only two pages to scenes from the easternmost or tidewater portion of the state: one depicts two views around Hampton Roads—the great harbor in the Norfolk area—and the other shows Richmond from Oregon Hill. The remaining pages are devoted to scenes from the piedmont and mountainous areas of the state.

Beyer's scenes are essentially romantic, emphasizing unruly nature's dominance over man. Many views in the *Album* have a picturesque point such as *Natural Bridge* with its craggy outcroppings of rock, or *Weyer's Cave* with its grotesque rock formations being admired at a respectful distance by well-dressed travelers.

These top-hatted gentlemen and their hoop-skirted ladies would not be out of place on a grand tour of the Continent, and they form part of Beyer's preoccupation with the Virginia springs. Well over one-third, or fifteen of the forty

plates making up the *Album of Virginia*, picture lavish hotels at such watering spots as Red Sulphur Springs, Yellow Sulphur Springs, White Sulphur Springs, and others. One can imagine that he found the leisurely life of these resorts a congenial counterpart to the elegant German spas—Baden and Patersthal in the Black Forest, for example—that beckoned English and Continental tourists alike.

As much as he admired pristine rustic landscapes, Beyer seems to have accepted the necessity of industrial expansion. Apparently he did not think the construction of the railways was a hopeless degradation of natural scenery, for he pictures them many times. In his rather sentimental rendering of the tunnel at Shawsville, for example, it appears that the railway has disturbed nature as little as possible, paralleling the river's gentle curve. Moreover, the four corner vignettes on the *Album*'s title page juxtapose Jefferson's home at Monticello and Washington's Mt. Vernon residence with a railway and a factory.

Though the details of Beyer's life in America are sketchy, a letter he wrote from Lynchburg, Virginia, to his friend Mr. Karrmann, on December 20, 1854, relates that Mrs. Beyer accompanied him on the trip to America, and that they came to Virginia partly because of her poor health. Writing in German, Beyer notes:

> If we were both in Germany we would welcome both holidays, Christmas and the New Year, with jubilation and joy. But here we don't care. . . . Probably I would have forgotten all about Christmas if a Negro had not reminded me with a hint for a good trip.
> Rightfully we may say that Virginia is a state richly endowed by nature with beautiful places. A slave state but also a state of pigs. I wish I could show a kitchen to your wife. She would have to wear boots with iron nails, or she would sink in and lose her footing. . .
> I have seen many beautiful places on my trip since my last letter, such as the Falling Springs, an enormous waterfall higher than Niagara Falls. . . . So is the Natural Bridge a splendid sight. . .
> I was also on top of the Peaks of Otter. The outlook surpasses anything I have seen before. I was here for four days, and I have seen it in fog and rain, at sunrise and sunset. . .

In this same letter he mentions recently completed paintings of Lynchburg and Natural Bridge and states that his fee for a painting is fifty dollars plus room and board.

According to the *Daily Dispatch* of May 19, 1856, Beyer was in Richmond seeking subscriptions to his *Album*. Because the vistas to be incorporated into his *Album of Virginia* were prepared on lithographic plates and printed in Europe, he returned to Germany later that year to oversee preparation. Some plates were done by Rau and Son in Dresden; others by W. Loeillot in Berlin.

The *Album* is completed

The Richmond *Daily Dispatch* of May 25, 1857, announced the arrival from Germany of the first prints for the *Album of Virginia*. According to this account, Beyer returned to Richmond to deliver these. The *Album* was bound and copyrighted in Richmond. Some copies were issued in 1857 and some in 1858. The number issued is not known.

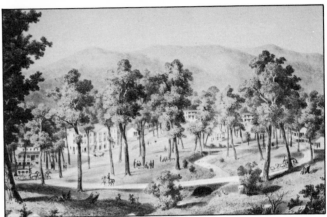

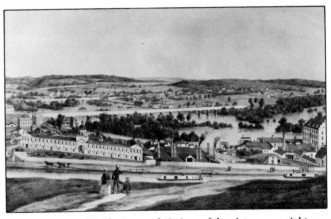

Opposite: *Natural Bridge* is one of 40 views of the picturesque sights and spas of Virginia that form Beyer's *Album of Virginia*, printed in Germany in 1857. Lithograph, 12¾" x 16¼". This page, top: *Stribling Springs* is one of the many fashionable spas Beyer visited, it is believed, for the benefit of his wife's ill health. Fifteen of the prints in the *Album* show the various spas Beyer frequented during his two and a half years in Virginia. Lithograph, 11" x 18". This page, center: In *Roanoke: Red Sulphur Springs*, Beyer typically represents a landscape with people seen from a distance. Lithograph, 11" x 17¾". Beyer's landscapes are not strictly pastoral; elements of industrialization and urbanization are often included, as in *View from Gambles Hill*, directly above. Social criticism is not, however, the intent. The railroad and the factory in this print blend easily with nature. Lithograph, 11" x 18". All courtesy The Old Print Shop.

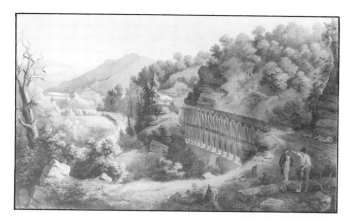

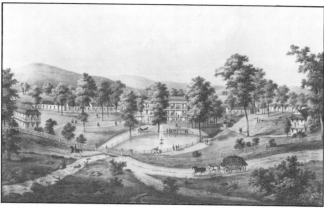

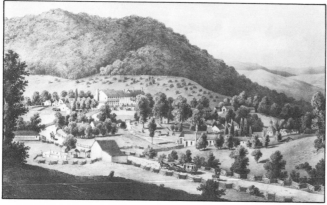

This page, top: Beyer's vision of Virginia is a foreigner's. In *Viaduct on Cheat River B & O R.R.* he portrays two stereotyped Americans conversing in the rugged terrain 19th-century Europeans thought typical of this country. Lithograph, 11″ x 17½″. Center, above: The architecture of the spa at *Yellow Sulphur Springs* is much simpler than that of the grand hotels—such as Baden and Petersthal—Beyer knew in his native Germany. Lithograph, 9¼″ x 15¾″. Above: The same is true of *Hot Springs*, where a stagecoach rides towards the large, but rustic spa. Lithograph, 11″ x 17½″. All lithographs from the *Album*. Courtesy The Old Print Shop.

A paperbound octavo-size booklet of 47 pages was published to accompany each volume of the *Album*. Entitled *Description of the Album or Virginia, or The Old Dominion Illustrated*, it was printed by the Enquirer Book and Job Printing Office at Richmond in 1857. Each of the 40 scenes depicted in the *Album* was described in detail, and directions for travel to some of the more remote areas were given. The author of the booklet is not known; it is signed "A Virginian, May 12, 1857."

After returning to his native Germany Beyer prepared another panorama: American views, including many of Virginia. He exhibited this in Meissen, Munich, and Berlin. The Richmond sculptor Edward V. Valentine, then a young man studying in Germany, wrote his sister, Sarah Benette Valentine, on April 7, 1863: "Professor Kiss was with me to see Mr. Beyer's panorama of Virginia. Mr. Beyer has made some 2,000 Thalers in Berlin by exhibiting his panorama of some parts of America." The present whereabouts of this panorama is not known, and it is unlikely that it survives.

Other Work

In addition to his *Album*, three landscapes of Virginia scenes, made from Beyer's drawings of this period, were issued as separate prints. These include views of the towns of Staunton and Lynchburg and of the resort White Sulphur Springs, which exists today as the Greenbrier. Lithographed by Nagel and Weingartner in New York, and published by August Heuser in Newbern, Virginia, these prints are now exceedingly rare.

Of Beyer's 20 known surviving paintings, 17 are scenes of Virginia. In private collections are three representations of the town of Liberty (now called Bedford); two each of Salem and Wytheville; views of Christiansburg and Charleston (now located in West Virginia); the farms Monteray, Bellview, and Edgehill in Roanoke County; a farm in Rockbridge County; and Grove Hill in Botetourt County. The painting of White Sulphur Springs presently is owned and displayed by the Greenbrier resort. A panoramic view of the town of Buchanan, owned by the Buchanan Town Improvement Association, is on exhibit in the Buchanan Community House. Several other paintings of American views are known to exist. Two versions of Beyer's *Skating on the Passaic* (1852) are in the collections of the Newark Museum and the New Jersey Historical Society. Paintings of an Ohio River Valley landscape and an unidentified waterfall are privately owned. The financial risk that Beyer took in America was considerable. Though his motive was profit, by tradition little profit was to be earned by landscape artists: in Virginia, as in the rest of America, the public supported portrait artists to a much greater extent.

Other Virginia landscape artists

By the time Beyer painted his views of Virginia, the few landscapes that had been done in the state were primarily of the Capitol in Richmond, Natural Bridge, or Mt. Vernon. Among those who painted series of Virginia views in the early 19th-century were architect Benjamin Henry Latrobe and his son

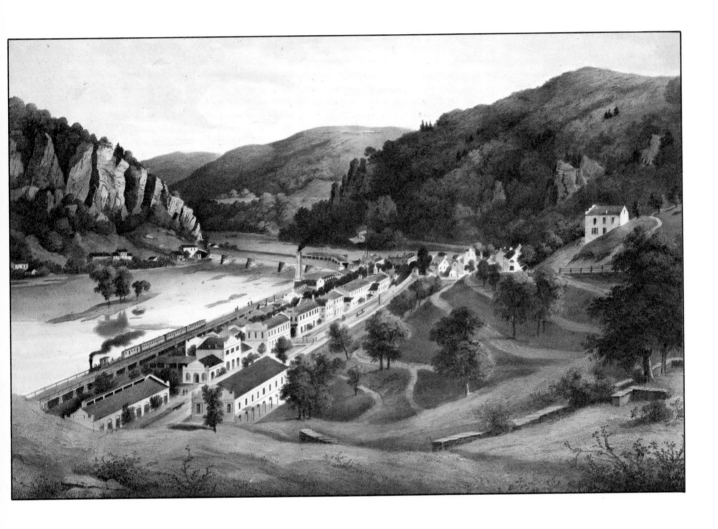

Above: Beyer contrasts the linear regularity of the houses, streets, and railroad in the *U.S. Armory in Harpers Ferry* with the untamed, surrounding countryside, where the undulating hills are dominant. Lithograph from the *Album*, 11¾″ x 17¾″. Courtesy The Old Print Shop.

John Hazelhurst Boneval Latrobe, who painted for their own pleasure. In the early 1840s Thomas Charles Millington was a lithographer. Lewis Miller, an itinerant folk artist, made numerous drawings throughout the state between 1846 and 1871. He too painted for his own pleasure. William Henry Bartlett drew about a half-dozen Virginia scenes from which steel engravings were made to illustrate *American Scenery* (1840). Henry Howe spent a period in Virginia in 1843 and sketched numerous landscapes which were used for wood engravings to illustrate his *Historical Collection of Virginia* (1845).

At the time Beyer was working in Virginia, three other landscape artists were active in the state. William Skinner Simpson and his son William Skinner, Jr., both of whom were talented amateur artists, earned their livings as insurance brokers, but executed many exceptionally fine watercolor views of central Virginia in the area of Petersburg. The third of these artists, David Hunter Strother, used the *nom de plume* Porte Crayon. From around 1853 to 1856 he drew numerous Virginia landscape and genre scenes to illustrate a series of magazine articles on Southern life. These drawings were also used in his book *Virginia Illustrated* (1857). Of these artists only Bartlett, Howe, and Strother worked with a profit-making motive—they hoped their views would sell as illustrations for books and periodicals.

Like other Virginia landscape artists, Edward Beyer is scarcely known to most historians of American art, but he painted some of the finest landscapes of 19th-century America. One can but hope more works survive. ■

Currier and Ives

I n terms of sheer volume, no other American printmakers surpassed Currier & Ives, whose 7000 titles provide enduring visual documentation of life in the mid-19th century.

BY HAROLD HOLZER

It really began for America's foremost printmakers on the frigid New York waterfront on a wind-whipped January afternoon in 1840. The launching that day of the steamboat "Lexington"—the first steamer reequipped to burn coal instead of wood—had generated incredible public excitement.

But that night, as she cruised off Eaton's Neck in Long Island Sound, the "Lexington" suddenly burst into flames. When it was all over, 123 passengers and crew had died; only four survived.

News traveled slowly in 1840. When, 36 hours later, a breathless messenger finally arrived at the offices of the *New York Sun* bearing the complete account of the disaster, a stroke of luck would turn a hundred men's disaster into a single man's triumph. It would dramatically alter the American media for all time and decisively propel the career of a young publisher of pictures—Nathaniel Currier.

Currier, a lithographer since his teens, was fortunate enough to be in the *Sun* city room when word of the nautical fire was received. Earlier in his career, he'd shown a keen, if under-appreciated news sense with timely pictorial records of such previous disasters as the New York Merchant's Exchange fire and the Planter's Hotel blaze in New Orleans.

Now the *Sun* editors had a new idea. They would issue an "extra" edition—believed the first ever published in America—featuring a prominent Currier lithograph portraying the "Lexington" fire. "The Extra Sun," as it was bannered, offering seven printed columns of grisly detail, sold out immedi-

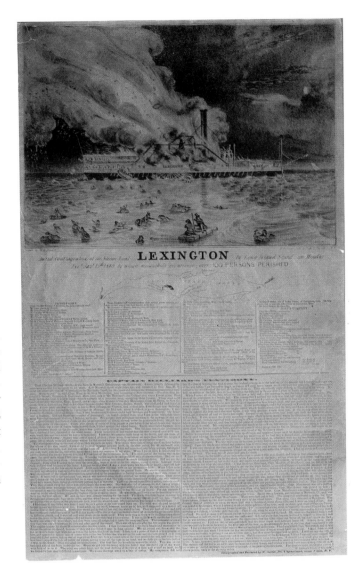

ately. Never before had a newspaper published so large and detailed an illustration. And before three more days had passed, a record for the era, Currier had issued a separate sheet lithograph drawn by W. K. Hewitt, *Awful Conflagration of the Steam Boat Lexington in Long Island Sound.* No one kept sales records, but it was reported that Currier's old drum press, which could yield 1,000 copies an hour, was kept busy night and day to meet the demand.

Overnight, Nathaniel Currier became the most famous printmaker in the U.S.—a title he has yet to yield to anyone.

Later, of course, he would become senior partner in the legendary firm of Currier & Ives of New York, for more than half a century the most successful, prolific, and imaginative picture publishers on earth. From 1835, when Currier started the business, on through 1852, when Ives joined him (he became a partner five years later), and then continuously (later under the management of their sons) until 1907—a span of 72 years—they published the astounding total of 7,000 different prints, retailing anywhere from 20 cents to five dollars each, in both small and large sizes, black-and-white and color. Experts believe that Currier & Ives sold more than ten million copies, more than those of all of their competitors combined.

Scholars differ today on the enduring value of their work. Currier & Ives have been praised as accurate chroniclers of America, but others have found their art cloying and mundane, their interpretation more personal than precise. There is no question, however, that they achieved a success unknown to any picture makers of their time. And even their harshest critics agree that for every maudlin or unrealistic scene, they issued a truly beautiful and evocative one. Sufficient quantities of each type appeared in their self-proclaimed "celebrated mammoth catalogue" to satisfy every taste and to dominate American interiors for decades.

Just as they advertised, they offered "The Best, the Cheapest, and the Most Popular Pictures in the World" in numbers so staggering they remain a force in today's art market, icons of a homespun style that influenced such successors as sculptor John Rogers and illustrator Norman Rockwell. Notably, the fashion for Currier & Ives has intensified even as the reputations of their followers have waned.

Nathaniel Currier, born in 1813, raised in New England, was at 15 apprenticed to William and John Pendleton, one of the first American printmakers then practicing the new art form developed by German Aloys Senefelder and introduced in America by Bass Otis: "the beautiful and highly useful art" of lithography, according to a period Pendleton ad. Cheaper and faster than the more exacting art of engraving, it promised a flood of pictures to the picture-hungry young nation, and a flood of profits to the enterprising publishers.

Currier remained with the Pendletons until 1833, moved on to Philadelphia where he worked briefly under another lithographer, and then arrived in New York where he struck out on his own. From surviving records it appears he entered into partnership with William Stodart, a music publisher (alliances between lithographers and sheet music makers were then becoming common). The pair published one important print, a view of *Dartmouth College.* Interestingly, despite the mind-boggling variety of subjects in which Currier would later specialize, one of the few staples of contemporary art in which he rarely again focused was the "college view," the subject of his earliest success.

By 1835 "N. Currier" was in business for himself, armed with two hand presses (some believe he *never* converted to steam presses) and orders to job-print pictures for established publishers like J. H. Bufford and J. Disturnell. And finally, Currier moved his shop to bustling Nassau Street in downtown Manhattan, where he would occupy space in a variety of commercial buildings up and down the street for the rest of his career, many of which are still in use today.

Currier & Ives, as we know them, would not join into for-

mal partnership for 15 years more. Meanwhile, Currier, working alone (even brother Charles, a printmaker in his own right and occasional occupant of the same headquarters as Nathaniel, did not share billing with his better-known sibling), issued hundreds of lithographs, earning a growing reputation as a printmaker. His 1840 success with the *Lexington* fire catapulted him to the very top of his profession.

James Merritt Ives finally joined the firm in 1852, when he was 38. At first, he was merely a bookkeeper, but he was also the fiancé of Charles Currier's sister-in-law. The plump Ives—physically the opposite of the tall, rangy Currier—soon proved a talent for more than keeping records: he knew popular art, sensed popular taste, and had titles to suggest to the artists. By 1857 he was a full partner: the firm of Currier & Ives began the first of its 50 years in business.

From then on, the firm's huge output and intensive marketing was all but overwhelming. The vast array of well-promoted indoor and outdoor scenes, portraits, cartoons, and trade cards—ranging from the "vulgar in subject and crude in execution," according to art historian Mantle Fielding, to "some very beautiful prints"—became giant sellers.

There was something for everyone in the Currier & Ives showroom—a crammed scene of confusion and hubbub frequented by such celebrities as Horace Greeley and P. T. Barnum—from the stacks of labeled prints that reached halfway to the ceiling, to the huge bins of overstock that crowded the floor, to the display trays kept outdoors on the street. And this, of course, was merely the retail operation. Early each morning, street peddlers arrived there with their wagons to pay cash (it was always cash, perhaps at bookkeeper Ives's insistence) for parcels of prints they would hawk on the river ferries, or on the streets of nearby Brooklyn and Hoboken. And then there was the large catalogue sales operation, a major wholesale network through which millions of Currier & Ives prints were shipped and sold to points north, west, and south—prints that often depicted the very regions to which they were exported, even though, in most cases, their artists had never cast eyes upon the places they commemorated.

Whatever the expertise behind it, the Currier & Ives catalogue was truly encyclopedic, and it was clever. The firm published 350 different views of farm, village, and country life (designed to appeal to the restless dwellers of congested cities) and hundreds of views of city life (no doubt to appeal to the restless dwellers of dull farms and villages). For foreign sales there were views of America's wonders. And for recent immigrants there were views of the lands they'd left behind.

There were 100 game and bird prints; 100 hunting and 30 fishing scenes; 60 prints of the Revolutionary War, 50 of the Mexican War, 100 of the Civil War.

There were 400 views of sports and games to titillate the nation's 16-hour-a-day work force, and dozens of depictions of our technological prowess lest these laborers forget their place and grow too fond of sports and games (there could be no technology without labor).

There was more: 400 pictures of ships of every description and 600 portraits of American celebrities (including 30 campaign prints). Some 500 Currier & Ives lithographs were comic in nature, and another 700 were sentimental, like the famous, maudlin, *The Lonely Adieu*.

Then there were 350 religious prints (often the most poorly drawn of the firm's portfolio), 350 pets, 60 music sheets, 30 freaks and 150 lampoons. Yes, Currier & Ives issued political cartoons (what is astounding is how few campaign prints the determinedly nonpartisan firm put out). But often they presented both sides of the same issue, as if to ensure that all potential customers could find a viewpoint to their liking. Abraham Lincoln, for example, was both savagely lampooned and pictorially extolled in Currier & Ives cartoon lithographs of the 1860 campaign.

Somehow, within this stunning diversity and noncommittal centrism, there were prints of undeniable artistic and historic value, images that traced the development of urban centers, commerce, and sport. Currier & Ives views of their native New York, for example, especially their six pictures of Central Park and early depictions of the Brooklyn Bridge, rank among their best efforts. Their fishing and hunting scenes were praised. And their 30 or so railroad prints, along with their better clipper ship and yachting pictures, are fine examples of period lithography. Mixed in, even among their 17 rather redundant views of contemporary fires, were superb scenes of firemen battling blazes, offering a closeup look at individual heroes that was far more riveting than the less demanding overviews of burning buildings.

But there was no overlooking the chaff. There were hundreds of prints of children; sometimes the same print was reissued over and over again, updated every few years to freshen hair and clothing styles. Among this bland series was, literally, an A-to-Z roster of some 180 "Little" darlings, from *Little Anna* to *The Littlest Zouave*, whose popularity no doubt confirmed the company's suspicion that even the lowest denominator of their efforts would find an audience.

Worst of all, perhaps, was the obvious absence of conviction—the determination to please, not polemicize—that marks the Currier & Ives *oeuvre*.

In the 1880s and 1890s, for example, the firm that had issued several Emancipation Proclamation prints published a series of 73 mortifyingly racist "Darktown" prints (like *The Darktown Slide*: "Golly! am dere an erfquake?") depicting blacks as hapless imbeciles. Only 30 years earlier, when the popular mood hovered at the opposite extreme, they had portrayed the controversial John Brown as a hero, and his abolitionist cause, a crusade.

AMERICAN HOMESTEAD WINTER.

AMERICAN HOMESTEAD SUMMER.

AMERICAN HOMESTEAD AUTUMN.

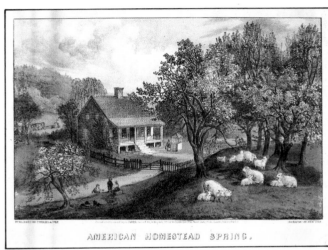

AMERICAN HOMESTEAD SPRING.

In the troubled decade following the Civil War, Currier & Ives discovered it was good business to assuage America's hunger for romantic images of an idealized agrarian society. The simple virtues of country life are nowhere better extolled than in the popular *American Homestead* series, which celebrated the changing of the seasons and the modest pleasures of home and family. Clockwise, starting top left: *American Homestead Winter* (1868), *American Homestead Summer* (1868), *American Homestead Spring* (1869), and *American Homestead Autumn* (1869). All, Museum of the City of New York, Peters Collection. Currier & Ives's winter scenes are among the most popular they produced, in part because many were the work of artist George Durrie, a landscape painter of considerable talent.

Yet as the Library of Congress' curator of historical prints, Bernard Reilly, points out, even the Brown print shows more about Currier & Ives as marketers than as political portraitists. He notes that the 1863 version of the Brown print, issued at the height of northern anti-Confederacy fervor (by which time the firm's southern market had been cut off), showed Brown being all but dragged to his execution by a pack of brutal-looking soldiers, with the arms of a nearby statue of Justice symbolically shattered—"the old flagellation of Christ theme re-worked," Reilly says. But an 1870 revision eliminated most of the soldiers and even deleted the metaphorical statue. The second John Brown lithograph was so bland its subject might have been en route to a personal appointment instead of his own execution. But the public mood had changed in those seven intervening years, and Currier & Ives almost always reflected—rather than led—public opinion.

When temperance became an important American theme, Currier & Ives even revised its 1848 N. Currier lithograph, *Washington's Farewell to the Officers of His Army,* a view that originally depicted the founding father toasting his men with wine. In an 1876 version, however, the decanter on the table was rubbed out and replaced by a cocked hat, and Washington's hand deprived of its glass and instead stuffed awkwardly, Napoleon-style, into his coat.

But the key to Currier & Ives success—especially as measured by volume—was this ability to revise and re-stock. Taking full advantage of an audience that proved both politically and aesthetically fickle (they changed their wall decorations nearly as often as they changed their minds), they moved with the social current, making sure their fans would always want to come back for more.

As they bragged in a letter to their salesmen written during

Here was the essential American view of itself in all its immodest diversity.

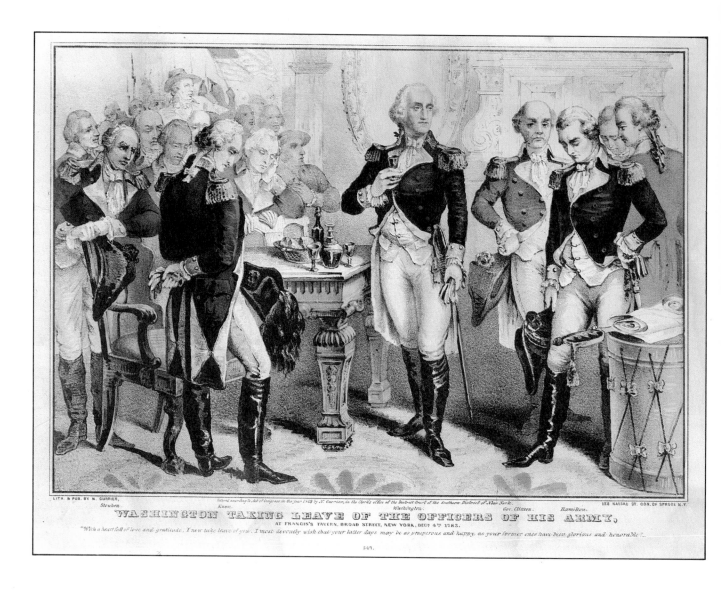

WASHINGTON TAKING LEAVE OF THE OFFICERS OF HIS ARMY,
AT FRANCIS'S TAVERN, BROAD STREET, NEW YORK, DEC? 4TH 1783.
"With a heart full of love and gratitude, I now take leave of you. I most devoutly wish that your latter days may be as prosperous and happy, as your former ones have been glorious and honorable."

the 1870s, "Our experience of over Thirty years in the Trade enables us to select for Publication, subjects best adapted to suit the popular taste, and to meet the wants of all sections . . . of the country." Who could argue that they didn't know best?

Certainly they had the best marketing approach of the period—a combination of both blatant and subtle reminders that their work was the epitome of mass appeal. That message was both trumpeted in their sloganeering and subliminally communicated in their captions. Observers have noted that no fewer than 90 Currier & Ives prints boasted the catchword "great" in their titles; 70 used "grand," and another 70 "celebrated." The word "America" cropped up 200 times, and such words as "magnificent," "champion," "splendid," "national" and—as one historian put it—"that magic word, 'home,'" were used again and again. The message was clear: here was the essential American view of itself (like *Home to*

Thanksgiving) in all its immodest diversity. A natural like *American Homestead* was issued in four different versions, one for each season, guaranteeing, according to one scholar, "a set that retained its popularity for one hundred years."

To their credit, Currier & Ives always employed a number of excellent artists. Louis Maurer specialized in horses, George Durrie in northeastern winter scenes, Charles Parsons in clipper ships and Thomas Wirth in comic views. George Catlin, Thomas Nast, George Innes, and Eastman Johnson also worked at one time or another for Currier & Ives.

Perhaps the artists were lured by the lithographic process itself, a compelling means of reaching a wider audience when practiced by ordinary printmakers, but potentially a window to untold millions under the auspices of Currier & Ives, master salesmen. How were the prints made? First, a large, thick limestone slab was cut to size, cleaned, and ground smooth. (A

plate of zinc or aluminum could also be used.) A drawing was then made in reverse, so it would print in obverse using a special greased crayon. The finished stone was then bathed in "etch," a gum arabic and nitric acid solution that rendered the noncrayoned portions more porous and fixed the greased areas more firmly to the stone. Then the stone was soaked in water and a greasy ink was applied with a roller. The ink would adhere only to the greased portions and not to the wet ones. Finally, paper was applied, pressed, and pulled. If no color was to be added, the work was ready for drying and sale.

But many Currier & Ives prints *were* colored, and by hand (though many others were produced by using several successive lithographic plates, inked in various colors). Prints to be hand-colored were passed along an assembly line of women, who each applied a different color. This early mass production method has its drawbacks: the girls were probably pressured into hurrying their work, and often, especially on small-folio prints, one can discern colors that flow over their margins. Large-folio prints—the cream of the firm's stock—were usually sent to outside art houses to be colored, where they were fussed over and highlighted with tempera and opaque hues. So it was that the firm's 7,000 titles, in innumerable multiples, were smoothly, quickly, and efficiently manufactured and marketed.

The sheer volume of their output helps in part to explain the endurance factor of Currier & Ives prints. But something else had to occur to ensure their preservation and it did. Currier himself retired in 1880 and died in 1888. Ives died in 1895. Edward West Currier and Chauncey Ives carried on until 1907, issuing only a handful of original images while reissuing dozens of existing scenes (and updating them as needed: the firm's old trotting horse series, for example, was revived with modern sulkies inserted to replace the more old-fashioned carriages after 1892). An 1898 portrait of *Col. Theodore Roosevelt, U.S.V./Commander of the Famous Rough Riders* would be one of the last original lithographs from the firm. By the first decade of the new century, their long vogue had come to an end. The advent of the photogravure process and the birth of sophisticated pictorial magazines had rendered single-sheet lithography all but obsolete.

But Currier & Ives's art was spared even as their business died—thanks largely to the vision of several pioneer collectors who surfaced in the 1920s to corner the market on surviving rarities and, importantly, publish critical appraisals and checklists that would inspire and guide curators and acquisitors for the next 50 years.

The first and greatest of these were Harry Twyford Peters, who published the first important volumes on Currier & Ives in 1929, and Frederic A. Conningham, who issued a scholarly checklist in 1930. In 1932, print dealer Harry Shaw Newman convinced the *New York Sun*—the same paper that had sparked Currier's career back in 1840—to publish the so-called "50 best" Currier & Ives large-folios, selected in a poll of experts, including Peters. The paper published one a day for 50 days, selling out every edition in which the nostalgic prints appeared (the best of the "best": *Husking*).

By the time Peters died, leaving his entire collection to the Museum of the City of New York, the American passion for

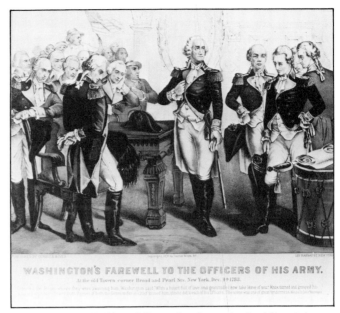

Because it was profitable to follow rather than to lead public opinion, Currier & Ives conformed to prevailing moral sensibilities and revised its prints to reflect changing values. For example, an 1848 version of *Washington's Farewell to the Officers of his Army* (facing page) depicts his final toast, but in deference to temperance advocates, the 1876 revision (above) eliminates decanter and wine glasses. 1848 print, Museum of the City of New York, Peters Collection. 1876 print, The Old Print Shop.

acquiring Currier & Ives prints had grown nearly as formidable as it was in the firm's heyday. The revival was in gear.

Through it all, the debate over the Currier & Ives's *oeuvre* has continued. Were they really great art publishers or merely great marketers whose product happened to be art? Was their technique archaic or merely homey? Did they perceive popular taste or merely mirror it?

To former Museum of the City of New York curator Albert Baragwanath, the issue was clear. "Although a general coating of sentimentality glossed almost all the work," he said, "there still remains a true documentation . . . a rich pageant interspersed with the morality and prejudice of the day."

But historian James Banner argued that their prints more accurately revealed "the image of themselves which 19th-century Americans esteemed"—reassurances, amidst times of unsettling social and economic change, "that America was a peaceful and virtuous land."

"In the end their prints don't tell you much about either social or political movements. They were such dogged generalists. Yet their dogged generalism made them rich. People didn't regard them as controversial or opinionated, so their works became acceptable parlor decorations of the period," says Bernard Riley. "In sum I see Currier & Ives' work less as windows *into* 19th century culture than reflections *of* 19th century culture."

Most modern iconographers concur: Currier & Ives chronicled Currier & Ives, not America. But however narrow their view of society and the individuals who contributed to it, their uncanny knack for giving people what they wanted made them a giant cultural force in their time. ■

Posters of the Nineties

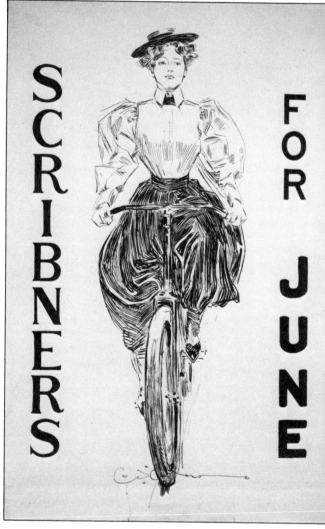

In one brief decade a revolution took place in American graphics: the poster advanced from an awkwardly composed placard to an eagerly collected work of art.

BY ROBERT MEHLMAN

They are "masters of the newest art—that of bill-posting," wrote the *New York Times* of the great European poster artists. It was November, 1890, and the opening of the first major poster exhibition in the United States. The exhibit at New York's fashionable Grolier Club was America's formal introduction both to the important recent poster developments in England and France, and to the poster as a work of art. What the enthusiastic critic did not foresee, however, was the development of postermaking in the United States that would

rival the Europeans in quality and surpass them in national enthusiasm. What he also didn't know was that Louis Rhead, a 33-year-old member of the Grolier Club, who was equally awed by the opening the night before, would be destined to become one of the greatest America poster artists.

The "American Poster Revolution" or "Golden Age" that followed the Grolier exhibition spanned a period of only about ten years. In the brief time between 1890 and 1900, the poster in this country advanced from a garish and awkwardly

*Above: **Scribner's** for July by Charles Dana Gibson, 1895, 22 x 14. Private Collection. Facing page: **Harper's Weekly** by Maxfield Parrish, 1896. Parrish has become a collector's favorite. Note the almost photographic realism of this poster. Courtesy the Exhumation, Princeton, New Jersey.*

NATIONAL AUTHORITY
ON AMATEUR SPORT

Left: *When Hearts Are Trumps* by William H. Bradley, ca 1890, 16½ x 13½. The flatness, delicate lines, and compressed faces of this poster illustrate Bradley's mastery of the English style, most notably that of Aubrey Beardsley. Above: *Lippincott's* May by J.J. Gould, 1896, 15¾ x 10¾. Gould's designs are often imitative; except for the signature and magazine, this poster could easily be mistaken for an Edward Penfield. Facing page: *Lippincott's* July and November by William L. Carqueville, 1895, 18½ x 12¼. Carqueville's posters are also derivative of Penfields. Private Collection. The Sun is by Louis John Rhead, 1894, 43½ x 25½. Courtesy Exhumation.

composed placard to an eagerly collected work of art and then suffered a decline almost as dramatic as its rise.

Particularly at the beginning of the decade, much of the style of the American postermakers was based upon the work of contemporary European masters of graphic art. In England, the work of William Morris, leader of the Arts and Crafts movement, and of Aubrey Beardsley, Art Nouveau illustrator, were a major stylistic influence on the American designers. Their graphics, along with William Nicholson and James Pryde's (whose joint compositions were signed as the "Beggarstaff brothers"), were frequently echoed in American poster designs of the nineties. In France, Jules Chèret (whose experimentation with multi-color lithography from about 1870 on made him the "founder" of the art poster according to many), Henri de Toulouse-Lautrec, Théophile Steinlen, Alphonse Mucha, and Pierre Bonnard inspired major international advances in lithographic design, including significant developments in American posters.

The poster was well known in America before 1890, but the placards that heralded the coming of the circus or the marvels of some patent medicine bore no resemblance whatever to the 100 pieces at the 1890 Grolier Club show. Despite the charm that we recognize now in the brightly colored, somewhat naive posters predating 1890, these advertising bills were viewed with disdain by the critics of the nineties. As noted in a *Scribner's* article in 1895, the earlier poster was considered "flashy and ill-executed" and "as hideous as cheap work could make it." The medicine bills in particular were criticized by sophisticated contemporary tastemakers. As the *Scribner's* piece put it, each was "constructed upon one of a few simple formulas—simple to the point of idiocy." The example under scrutiny was the typical "Before and After" ad which "involved the employment of two pictures, one which represented a lean and haggard wretch of advanced years, destitute of teeth, and but sparsely provided with hair." The second, the same man after two swills of the super-tonic, was "a sturdy, lusty person in the prime of his life, with well-slicked hair and as many teeth as the artist could crowd into his mouth." That type of primitive poster was the forerunner of innumerable television commercials.

The posters of the 1870s and 1880s in this country needn't have been as poor as they were. The United States was one of the two most industrialized nations in the world, and the technical potential for executing a quality print existed here. The impetus for it, however, did not. American industry didn't yet understand the principles of aesthetic advertising, and a great deal of talent that would develop as a result of its patronage still lay dormant.

The American poster before 1890 was attention-getting to be sure, but it was not memorable. The subtlety and beauty of the French and English "art" poster, on the other hand, created images that lingered. The European art poster was the marriage of art to commerce; it took place after the rapid advances in chromolithography, beginning in the middle of the century, first in England and then in France. The fine bills that were subsequently created, though primarily announcements, were respectable and *collectible* works of art, too.

The Grolier show was given a French name—"Exhibition d'Affiches" in recognition of French preeminence in the art of poster-making. The French name also helped identify the

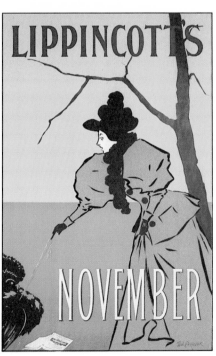

Above: *The Pocket Magazine* by Louis John Rhead, 1896, 16 x 12. Although the total composition falls short of much of Rhead's work, the figure, done in a "woodblock" style, is beautifully rendered. Private collection. Facing page: *The Chap-Book "Pan"* by William H. Bradley, 1895, 14 x 20. One of Bradley's many posters for the "little magazines." The Pan design shows his flat intricate style broken only by the color contrast of Pan's hair. Courtesy Phyllis Elliott Gallery, New York.

become "cultured" and "aware." Magazines competed feverishly for contributing talent in literature and illustration in the battle for readership and revenue. The periodicals brought that battle to another front by the nineties, with advances in printing technology, and an awareness of the advertising potential of the brilliantly designed European posters. With the poster as a weapon, they competed on fences, newsstands and in bookstores. Consequently, the focus of the poster shifted from entertainment and medicine to the publishing industry, where magazines and books inspired what is now being recognized as a vital contribution to American art of the period.

The aforementioned *Scribner's* article on American posters was the third in a three-part series published in 1895; the first on French posters appeared in May, the second on English posters in July, and the third on American posters in October. The "American" article was a glorification of poster development here since 1890, and there was undoubtedly a bit of self-approbation in its publication. Though frequently derivative at the beginning of the decade, by 1895 the American poster had become an inventive and internationally respected art form, exhibited and sold in the leading art centers of Europe. Popular books and mass magazines, *Scribner's* included, were not only the subject of most of the fine placards, but had fostered the American poster "renaissance" at the outset.

The poster "revolution" of the nineties did far more than sell a lot of extra magazines. The posters became more desirable than the periodicals themselves and were the object of a massive collecting craze among America's middle class. The magazines printed thousands of extra sheets each month simply to satisfy the needs of collectors. Though poster collecting was already long fashionable in Europe, it could not compete in intensity with the mania in the United States. Posters were sold in shops as well as through the magazines, and were also used as successful come-ons as "gifts" to attract new subscribers. Even institutions built important collections of poster art. Those at the Boston Public Library, The Currier Gallery of Art, in Manchester, New Hampshire, and Columbia University now constitute the most important poster archives in America.

Poster collecting became so popular that by 1896 special exhibitions were mounted, *The Modern Poster* and other books were published, and several magazines devoted solely to poster collecting were launched. *The Poster*, a periodical which ran six issues in 1896, reported a variety of spinoffs on the trend. The March issue, for example, hailed the growing popularity of the "poster party," where ladies came dressed as the beauties portrayed on current placards, with their escorts decked out in the guise of popular literary figures. At "guessing time" the source of each costume was identified by

contents of the show—not the ordinary placards of the past, but the new art poster. Newspaper reviewers also recognized the stylistic differences between the placards and the art posters, and even between the French and the English. More important, they were aware of both the shortcomings of the American poster and its potential. The *New York Post* said "Just at this time, when all the dead walls and fences in American cities are covered with gigantic theater posters, these more fitting and infinitely more artistic French bills may be pointed to in the hope that a lesson may be learned from them." The lesson was indeed learned, and the American publisher was the star pupil.

By the 1880's, the fiction and commentary of periodicals like *Harper's*, *McLure's*, *The Century*, *Lippincott's*, and the *Atlantic Monthly* had become the most important form of entertainment for increasingly affluent Americans striving to

best illustrators money could buy.

"those in the know." The same issue of this magazine claimed that "the possibilities of the poster are not yet exhausted. In Paris, poster dinner cards grace all smart culinary functions, and such well-known artists as Grasset, Chêret, and Willette bestow their time and talent upon them. It only waits for some bride with a touch of happy audacity to send out poster wedding cards!"

Throughout the nineties, American poster artists kept up with continued European developments in the medium first-hand and through the media. They saw European posters at exhibitions, during travels abroad, and in shops and stores where the best European work was available on the American market. The poster craze was not limited solely to the collection of American work. By the mid 1890s, Brentano's bookstore in New York sold European posters for under five dollars apiece. Indirectly, American artists learned about innovations in European poster making through the various international poster publications. The most important of these was *Les Mâitres de l'Affiche*. With the artists' authorization, the monthly French publication reproduced the best of what was current, in a reduced size on high-quality paper. *Les Mâitres de l'Affiche* was far more than a collectors' magazine. The more easily displayed miniatures were readily removable from their binding, and, on better paper than the originals (though some were on Japan paper), *Les Mâitres'* reproductions were collectibles themselves. From the standpoint of production and distribution expenses, it's understandable that issues of *Les Mâitres* (each containing four prints) were as costly as most single originals during the five years, from 1895 to 1900, that the publication was produced.

Though the accomplishments of the European poster artists continued to enlighten and influence the Americans throughout the decade, posters here were nonetheless inventive and distinctly American. To the art they added boldness in line and color and directness in composition. As time went on, American posters became less imitative of their European counterparts than exemplary of the forthrightness that American art and American society seemed to possess. Our finest postermakers owed obvious debts to the English and the French, but their work showed a style very much their own.

The most significant American poster artists of the nineties were probably Edward Penfield, William H. Bradley, and Louis John Rhead. Edward Penfield's posters were probably the most "typical" of the period. As art director for the various *Harper's* publications, and designer of all of Harper's monthly posters from 1893 through the remainder of the decade, Penfield was one of if not *the* most prolific and imitated designers of all. He virtually created the American art poster and, more than anyone else, was responsible for the poster revolution. All contemporary magazines competed to try to match *Har-*

per's and *Lippincott's* ads. Obvious Penfield imitators—J.J. Gould and William L. Carqueville—strove for the quality of Penfield's work.

Gould was a competent and consistent illustrator. But in many of his posters he emulated the detached elegance of Penfield's figures and settings, making it hard to distinguish between the two. Carqueville, while working in a similar style, managed to add humor and excitement to his posters that sometimes surpassed Penfield's in overall appeal.

For inventiveness and complexity of design, Will Bradley was the genius of the American poster movement. Often compared to Aubrey Beardsley, Bradley mastered the flat, boldly drawn and heavily contrasted designs of this English book illustrator. Several of his figures even resembled Beardsley's. Their British inspiration is hard to miss when his figures are surrounded by intertwined floral borders, reminiscent of William Morris's. But Bradley surpassed his sources. He designed posters for various magazines, including his own, *Bradley: His Book*, as well as posters for commercial corporations. In his Victor bicycle posters, Bradley wove his lines into intricate two-dimensional floral patterns that sometimes appeared as near total abstractions, while still clearly communi-

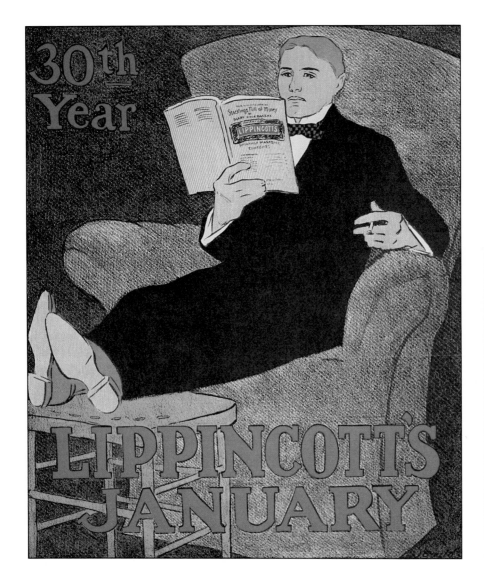

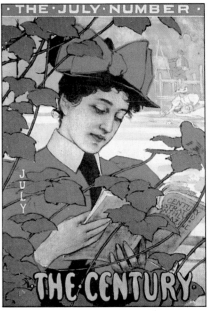

Left: *Lippincott's* January by J.J. Gould, 1897, 15¾ x 13¾. The detached sophistication of the subject is typical of Gould's style, as well as many other designers of the period, including Edward Penfield. Below: *The Century* July by Edward H. Potthast, 1896, 21¼ x 15½. This design, which won honorable mention in *The Century* contest of 1896, foreshadowed the look of Potthast's later paintings. Courtesy private collection.

cating their message. His preeminence in the period is unquestioned. Few graphic artists have come near rivaling him.

In style and technique, the work of Louis Rhead was similar to that of the French artist Eugene Grasset. Grasset was well represented at the Grolier Club show, and prior to 1890 he had designed at least one poster in this country. But the striking colors of Rhead's posters made them clearly distinguishable from Grasset's. If Art Nouveau was derived from both Japanese and medieval art, then Rhead and Grasset may be said to have led those who leaned more toward the second source. The work of both conveyed the feeling of the early manuscript woodcut. Because of the closeness of Rhead's posters to some of Grasset's, his importance has sometimes been questioned. Yet Rhead's significance is borne out by the sheer strength of his work. One would hardly be able to walk past a Rhead poster without noticing and admiring it more than most others.

Women never played a dominant role in the poster world, nor did they dominate any other area of American illustra-

tion, but their acceptance and contributions were nevertheless extremely significant. Eighty years ago, the female illustrators of the Brandywine School (founded by America's leading illustrator Howard Pyle, who trained such important illustrators as N.C. Wyeth, Elizabeth Shippen Green, Jessie Wilcox Smith, and Frank Schoonover) were acknowledged masters of the art. Several other women were in the ranks of the primary poster artists. Ethel Reed was most important in the group that included Florence Lundborg and Blanche McManus. Her simple Japanese-style compositions, broken into large areas of richly contrasting colors, were reminiscent of some of the English poster artists, such as William Nicholson. But her interpretations of the style were distinctly her own, and her poster for Albert Bagby's book, *Miss Träumerei*, is a classic of the era.

In 1896, at the height of the poster revolution, *The Century* conducted a competition for its midsummer issue. The winner's poster would advertise the issue. With the poster craze destined to last less than five more years, the young contest-

ants would have little opportunity to make any long-term major contribution to the art of poster lithography. Nevertheless, the judges' decisions had a farther reaching effect on American art than did the body of work of any postermaker. The winners of first and second prizes were J. Christian Leyendecker and Maxfield Parrish. Though briefly distinguished as poster artists, they became two of the most important illustrators of the next generation and idols of our current generation of collectors. With his Arrow Collar Man, Leyendecker created the debonaire male complement of the fashionable Gibson Girl. His later covers for the *Saturday Evening Post* became as familiar to Americans as Norman Rockwell's.

Parrish also emerged as an important commercial and cover illustrator. But it was the paintings for his books, with their unearthly luminescence, brilliant color, and photographic realism, that made his figures and landscapes more wondrous than the fantasies of the children and adults who beheld them.

The foresight of *The Century* judges went beyond recognizing Leyendecker's and Parrish's genius. Edward Henry Potthast won honorable mention in the contest. Though his beautiful design was perhaps more striking as a painting than a placard, the "Japanese" composition and startlingly brilliant color exemplified the qualities that would later distinguish Potthast as an important painter of the next quarter century.

There were other early 20th-century painters who designed at least one poster during the art poster heyday. Maurice Prendergast and John Henry Twachtman, the American Impressionist, each tried his hand, with results ranging from mediocre to awful. The vision and intent of the painter, and often the book illustrator, differs greatly from that of the poster artist. (Enough book illustrators succeeded as postermakers so the rule does not apply as consistently to them.) But few of America's great 20th-century painters succeeded in designing star billboards.

The most notable exception was John Sloan. The posters that Sloan created for the "little magazines" (small size literary periodicals that published more esoteric and "contemporary" literature than the mass monthlies) bear no resemblance to the facile "Ashcan" paintings of the following decade. Yet Sloan's success with both posters and paintings was due to his seriousness as an illustrator as well as the ability to respond to changing ideas in art. Sloan's mid-90s placards were done in an easy, flowing Art Nouveau style. They were closer to English sources than to the French, but were uniquely Sloan's. His realist style, developed after the poster craze and reflecting the influence of Théophile Steinlen and, more importantly, Robert Henri, was still as much a part of his illustration as his painting. In fact, much of the spontaneity of Sloan's paintings may be attributed to his brilliance as an illustrator.

By the end of the decade the poster craze had faded away. Several of the publishers that supported the poster movement had gone out of business, style was changing in America and abroad, and the poster-collecting craze was over. Critics in the mid-90s assailed the movement, calling it a fad that would pass as quickly as it had risen. It was not a fad, however, because it lasted too long and had an enduring impact on American graphic art. Unfortunately, the poster decline also meant the disappearance of those who would not or could not make the transition to the new styles and media. Some, like Leyendecker and Parrish, were only beginning their careers. Others, like Penfield, Bradley, and Rhead, continued to work but outside of the mainstream of illustration. Still others, like Ethel Reed, disappeared from view altogether.

The renewed interest in posters during World War I did not match that of the 1890s. Many posters were developed as propaganda pieces, therefore, they were not widely collected at the time. Later posters (except for some of the brilliant Art Deco pieces) reflected many of the changes in illustration. In general, the work of the artist was eclipsed by the print of the photographer. By 1900, America had "come of age." And the masterful, sophisticated posters of the preceding decade may have been the clearest announcement of that rite of passage. ■

Above: *The Northampton* by Edward Penfield, ca 1895, 28½ x 41¼. Here is an unusual design by one of the most widely imitated of the American poster artists. Courtesy Phyllis Elliott Gallery, New York.

The Gibson Girl

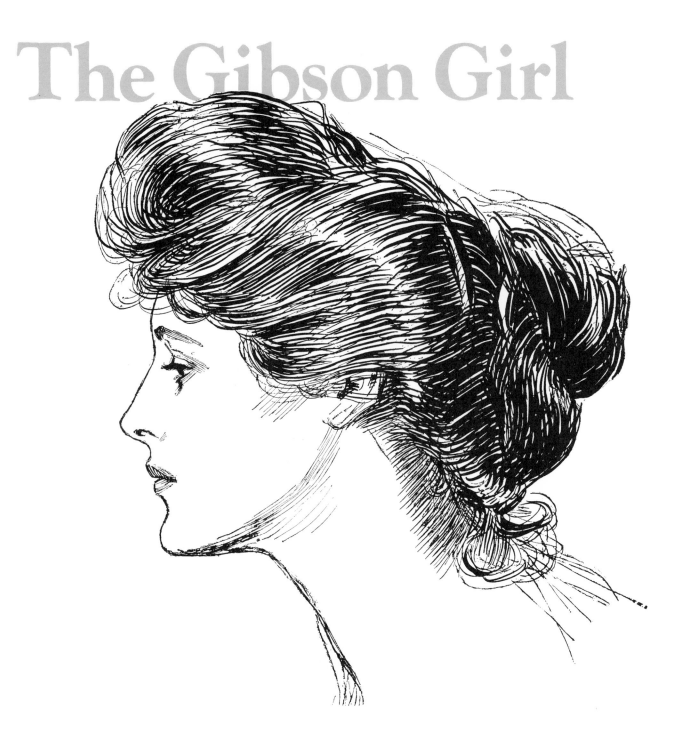

Photoengravings of Charles Dana Gibson's *wasp-waisted females appeared in* Life, *Tidbits,* and Punch. *His Girl became the symbol of an age.*

BY FREDERICK PLATT

She was the most popular woman of her era. Magazines vied for her likeness. Individual prints adorned stately homes and grass huts around the world. After the execution of the last czar of Russia, books depicting her exploits were discovered in the imperial palace. It did not seem to matter that she was not real.

To this day the Gibson Girl, as she is called, retains a wide

following among collectors, social historians, artists, and whoever appreciates a beautiful woman—a woman who seems to typify the female charms of an era. She was the creation of Charles Dana Gibson, thus her name: The Gibson Girl.

Generations of New Englanders on the sides of both his father, Charles De Wolf Gibson, and his mother, the former Josephine Elizabeth Lovett, led up to the birth on September 14, 1867 of Gibson, middle among three sons who would precede three daughters. Roxbury, Massachusetts, now part of Boston, was his birthplace, but Gibson's father, a prosperous salesman for the National Car Spring Company, moved the family to Chicago and Saint Louis, before settling them in Flushing, New York.

By the time he was five, his artistic ability revealed itself.

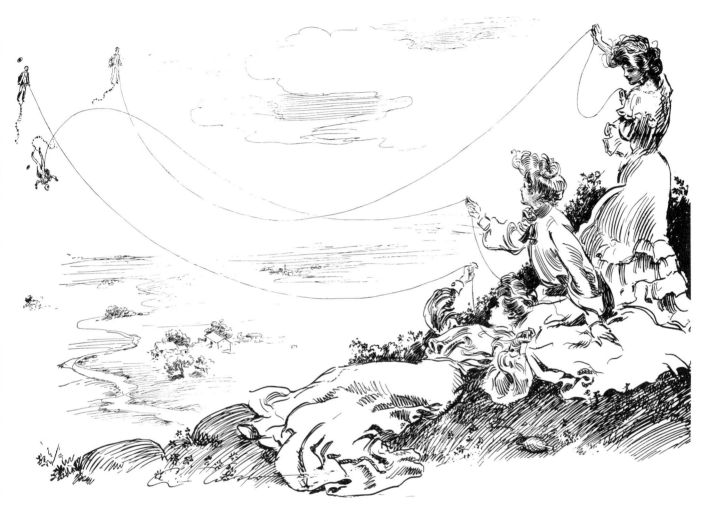

To amuse him during a childhood illness, his father cut animal silhouettes out of white paper. Soon the son had to try, and by the time he was eight, he was master of the scissors, creating scenes of pathos and humor that seemed the work of an adult. He did this without drawing, simply by snipping out episodes he witnessed or imagined. Among his products was a girl tending her garden, perhaps the earliest Gibson Girl.

As Gibson grew up, high society was coming of age. It was an artistic era; life itself became an art in which many worthwhile people found careers. Every activity—dining, listening, entertaining, descending a staircase—was to be done beautifully. But most men of wealth were too busy with (and too tired from) making money to delve deeply into graceful living. To the women fell these responsibilities. Marshaling the efforts of architects, dressmakers, florists, and platoons of servants, they turned the suffocating clutter that had lately afflicted the rich into an airy elegance that made their lives, like all the best works of art, appear effortless.

Victorian heaviness was giving away to a lithe classicism.

One leader of this conversion in the art world was American sculptor Augustus Saint-Gaudens. And it was to Saint-Gaudens that Dana at age 13 found himself apprenticed. Despite the evidence of his cutouts, any sculptural talent was swallowed up by inattentiveness. He soon left the august studio for the less reverential halls of Flushing High School. No more scholar than sculptor, he preferred local sports. His rugged build enabled him to row and swim and put, and in a boat of his own design he and his brother even sailed from their hometown to Rhode Island. Finally, his two years at the Art Students League in New York awakened the aptitude for drawing with which he would set out on his own in the summer of 1885.

"I think a position in society is a legitimate object of ambition," declared Henry James, and contemporaries agreed. Every woman wanted to appear a society woman, and the Gibson Girl became the most accessible example of a young socialite; every girl wanted to appear a Gibson Girl. Patterned after actual debutantes, she went on to be copied far

69

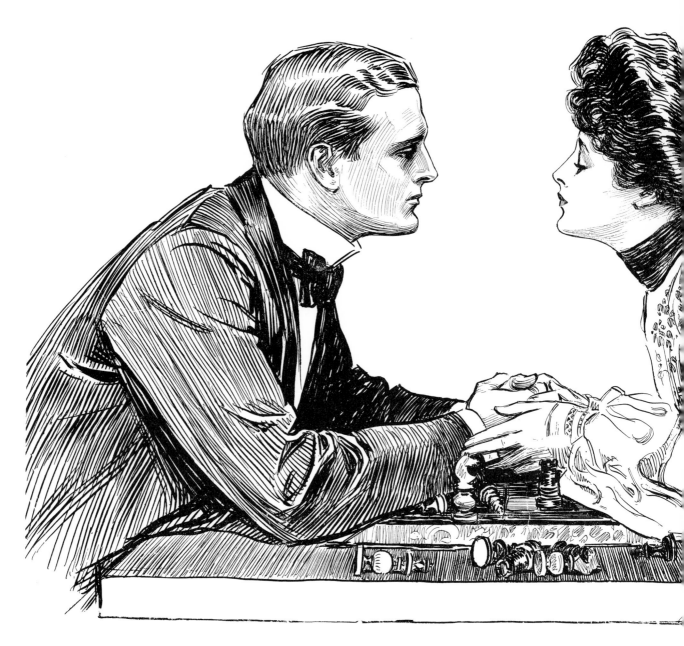

and wide by beauties of all stations. Gibson Girls could be seen at office typewriters or at tea tables, on streetcars or in carriages.

At eighteen, Gibson, making the weary rounds with sketches, finally arrived at the headquarters of *Life*. The magazine had been founded just three years before that winter, to publish humor. Editor John Ames Mitchell saw the potential in Gibson's drawings and paid four dollars for one of a little dog howling at the moon. Such other American humor journals as *Tid-Bits* and *Punch* accepted him soon after, and there were offers for advertisements. But *Life* remained his most faithful customer. Co-workers sometimes would suggest situations for his drawings, and Gibson always provided captions.

Income rose with skill, so that by age 21 he could splurge modestly on a quick trip to Europe. While in London he met illustrator and novelist George Du Maurier, whose technique of many narrow lines was adopted by the idolizing Gibson. Then, two months at the Académie Julian must have made Gibson feel that having studied in Paris, he was now officially an artist.

Many subjects, including politics, occupied his pen at first, but increasingly he specialized in society. Society in those days fascinated the Americans even more than politics, which was then at the bidding of the tycoons. The daughters of so-called society held the best possibilities for an artist, and Gibson's growing prosperity and fame—along with the eternal entrée of being an unattached male—gained him access to parties and drawing rooms. He did not intend to invent a leading lady who went by his name; she was christened by others. "If I hadn't seen it in the papers," he would aver, "I should never have known there was such a thing as a Gibson Girl."

Business boomed, and he discovered that by selling the originals of his magazine drawings, he could even get paid twice. At his first exhibition in New York, he received from $20 to $200 per picture. Soon this reached $3,000—then far above most anyone's annual salary. Robert H. Russell added to the abundance by publishing the first Gibson book, measuring 18 inches long by 12 inches high and containing about 80 reproductions of the artist's best efforts. Costing $5, $10, or $25, depending on whether the chosen edition was regular,

deluxe, or yet more so, they graced parlors aplenty, and still are prized by collectors.

By 1894 Gibson could afford a deluxe trip abroad, and this journey would mark a turning point in his work. His earier style of multitudinous fine lines à la Du Maurier gave way to a few bold strokes. (Even his *C.D. Gibson* changed from a chippy signature to a sinuous scrawl that was barely readable, though nobody could have been confused about who made the drawing.) Viewing the French artists has been credited with the shift, or perhaps his enthusiastic reception emboldened him, for the Gibson Girl's reputation preceded him across the sea. Throughout the remainder of his career, Gibson strove to eliminate nonessentials.

The Gibson Girl fashions

"You can always tell when a girl is taking the Gibson Cure by the way she fixes her hair," noticed English poet Robert Bridges. She would also have adopted the smoothly flowing frock or the crisp lines of skirt with tapering shirtwaist. The very beginnings of sportswear were appearing, since the modern girl had been freed for athletics: golf, bathing, tennis,

and that craze of the Gay '90s, bicycling. New attitudes as much as new attire accounted for the beautiful women the period produced. Pale and swooning, the Victorian belle faded in the face of her successor, no less a lady and no less feminine, yet substantial and independent and radiant.

"Parents in the United States are no better than elsewhere, but their daughters!" exclaimed one foreign observer. The Gibson Girl might even have been considered a symbol of the nation, recently risen to world leadership, steeped in European tradition but unshackled by outmoded convention.

Of all her admirers, none was more adoring than Dana Gibson. It mattered to him not at all that he and his fellows were playthings in the hands of the weaker sex. In one cartoon three young ladies idly maneuver kite strings at the ends of which soar their suitors.

Believing romance her lifeblood, Gibson worried incessantly over her choosing the right mate. Forlorn were his maidens who wed for money, all the worse if to an old man. International marriages, in which some puny duke swapped a title for a heap of American swag, horrified the artist as much as it bewitched high society. Her true love would be dashingly handsome. In fact he would resemble Richard Harding Davis, the best-known reporter in a day when reporters (like illustrators) were celebrities. Davis also poured out short stories, novels, and plays and Gibson frequently depicted scenes from his works. After the clean-shaven Gibson Man emerged, countless gents shed luxuriant mustaches, beards, sideburns, and muttonchops.

One lady seemed so near the embodiment of the drawings that to this day she is periodically cited as the original Gibson Girl—no matter that the print version appeared before the artist met his future wife. To lead the grand march at one of his Patriarch Balls, Ward McAllister, the social arbiter who had compiled the list of The Four Hundred, selected Irene Langhorne, one of four sisters from Virginia celebrated for their comeliness. Often had Gibson satirized the fatuous doings of McAllister, but in women, as in Madeira, the little fellow's taste was indisputable. Gibson married her on November 7, 1895. Befitting a Gibson Girl, "she looked like a woman who wasn't afraid to live and whose beauty," remembered artist Dora Mathieu, "never interfered with a lively brain." She was twice a delegate to the Democratic National Convention and shared political interests with her sister Nancy, who married Lord Astor and became the first woman Member of Parliament. Mrs. Gibson would pose for some of her husband's most heartfelt drawings and bear him two children, daughter Irene in 1897 and son Langhorne in 1899.

Photoengraving influences Gibson's spare style

Wood engraving was petering out as a widespread means for reproducing drawings when Gibson's career was getting under way. Engravers labored heroically at their painstaking task of gouging out wood between the lines, and could not help but intrude on the results, unsettling many an artist. In the new photoengraving process the backing was not wood, requiring handwork, but metal, which could be bathed in acid. Areas corresponding to the white of the drawing would be eaten away, leaving the black lines raised to take the ink.

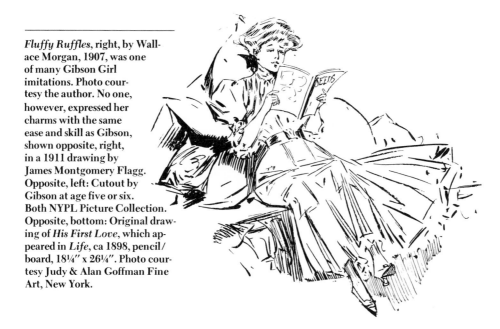

Fluffy Ruffles, right, by Wallace Morgan, 1907, was one of many Gibson Girl imitations. Photo courtesy the author. No one, however, expressed her charms with the same ease and skill as Gibson, shown opposite, right, in a 1911 drawing by James Montgomery Flagg. Opposite, left: Cutout by Gibson at age five or six. Both NYPL Picture Collection. Opposite, bottom: Original drawing of *His First Love*, which appeared in *Life*, ca 1898, pencil/board, 18¼″ x 26¼″. Photo courtesy Judy & Alan Goffman Fine Art, New York.

Assured by this method that they were all his own, Gibson made the most of lines, which were his sole commodity except for solid black regions brushed in.

Prime elements such as faces and hair received precise detailing, often hatched but seldom crosshatched. Beyond these particulars, the lines grow progressively heavy and sparse, relying on suggestion instead of detail. A couple exchanging glances across a table would have their faces minutely delineated; their clothing would be sketchy, while the back edge of the table might be wholly omitted. Once again the artist was eliminating nonessentials, the paradox being that the more skillful he became at line drawing, the fewer lines he drew. Other innovations in printing soon let him use a gray wash for halftones and pastels or cover girls in full color.

His creations were everywhere. Cups and saucers, ashtrays, spoons, tiles, even wallpaper were sold with the Gibson Girl's features. Her likeness could be bought in shops and by mail, obtained as subscription premiums, or just snipped from magazines. At charitable functions, real-life Gibson Girls imitated the make-believe kind by arranging themselves in *tableaux vivants* based on favorite cartoons. Nor were fellow illustrators above copying her image. Howard Chandler Christy had the Christy Girl, Albert Beck Wenzell the Wenzell Girl, while Wallace Morgan drew a heroine called Fluffy Ruffles. Reaching beyond illustration to the fine arts, she even influenced female figures painted by such as George de Forest Brush, Thomas Wilmer Dewing, and Abbott Thayer. This omnipresence could not have been altogether mimicry, but testified to the new women, the new art, and the new era.

Gibson claimed he didn't paint "because I have no time for it. I can't afford it." But at last he could. He had fulfilled a four-year contract with *Collier's* magazine: 100 double-page drawings at $1,000 each. The world was startled when he renounced his immensely successful career as an illustrator.

Gathering wife and children, he sailed for Europe to start anew as a painter. For all his resolve, however, the Panic of 1907 hit Wall Street, not slaughtering his finances but wounding them sufficiently to force his return home to his former occupation. He attempted to renounce cartooning beautiful girls, and simply decorated books and articles.

But World War I brought back the Gibson Girl. From posters and placards, buttons and banners, she and her cousins fathered by other artists did more than their bit at beseeching the boys to enlist and everybody else to send cigarettes, save fruit pits, and stamp out spies, rumors, and the Kaiser. Halo aside, the Columbia of his cartoons was recognizable to any Gisbon aficionado. She bid brave farewells to the nation's sons; she materialized on billboards in front of the New York Public Library to benefit war bond drives. Ever the champion of American integrity over European intrigue, the country's leading illustrator was the clear choice to head the Division of Pictorial Publicity when the government set up its Committee on Public Information. The all-volunteer corps of artists turned out 1,484 designs in 19 months, so it was appropriate that their victory dinner opened with a Gibson cocktail.

Peace had hardly returned before Gibson found himself waging a veritable battle for *Life*. When the humor journal was put up for sale following the death of editor Mitchell, the regulars could not abide the thought of the old magazine disrupted by new management, so they formed a syndicate with Gibson as major investor, to fight the competition; they won. The publication where he had gotten his start, from the purchase of a four-dollar sketch, he now owned. His contributions with their Gibson flappers continued sublime, but the role of editor-in-chief, assumed in 1920, did not suit him. He resigned in 1932 and on his corner of 700 Acre Island off Isleboro, Maine, he finally had time to make painting a prime occupation. A highlight of his one-man show at the American Academy of Arts and Letters during the 1934/35 season was a portrait of his daughter, Babs, who was after all a later-day Gibson Girl. He would keep on working at his impressionist oils until his death in New York City on December 23, 1944. But the Gibson Girl's appeal proved undying. She had the beauty that her era lavished upon her—plus the glow that comes with knowing she could never grow old. ■

edited by Mary Jean Madigan and Susan Colgan

We hope that you have enjoyed this book and that it will occupy a proud place in your library. We will be most grateful if you will fill out and mail this card to us.

1. Why do you like this book? _____

2. What do you find most helpful in this book? _____

3. Other comments? _____

May we quote? _____ (Please initial)

Bought at: _____ Gift: _____

Your business or profession: _____

Would you care to receive a catalog of our new publications? ☐ Yes ☐ No

Name _____

Address _____

City _____ State _____ Zip Code _____

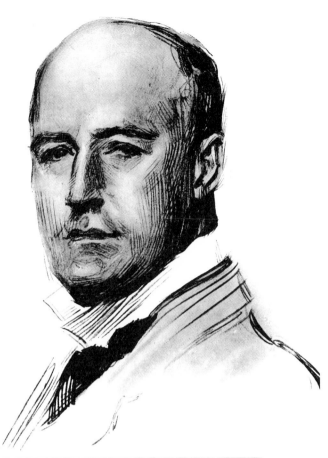

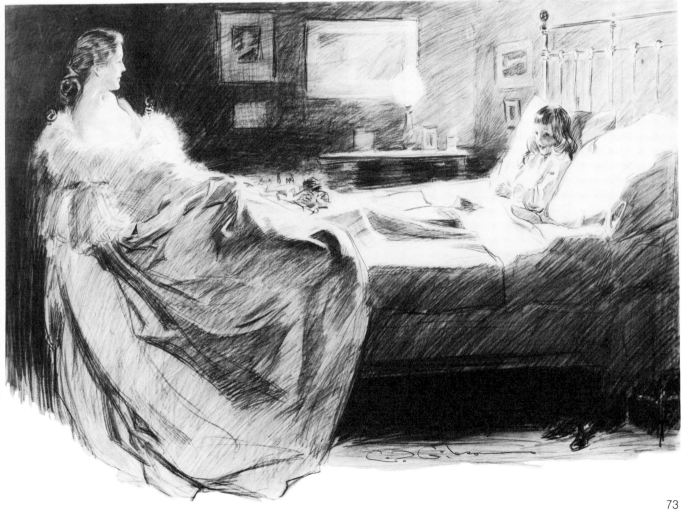

Pochoir Prints from Kiowa Indian Art

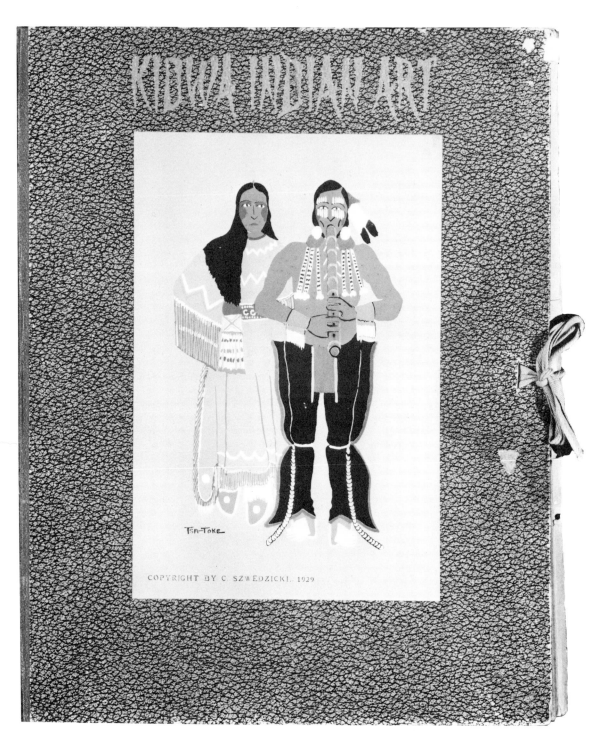

In the late 1920's, a group of Kiowa Indians trained at the University of Oklahoma created a series of watercolors that became the basis for an outstanding print portfolio, executed in a sophisticated French technique.

BY MAYBELLE MANN

While teaching home economics to young Indians on the Kiowa reservation in Oklahoma, Susan Peters noticed some unexpected behavior. Several students were drawing, and while the materials they used were crude, Peters was convinced that formal art classes should be introduced for these struggling artists. It was 1917.

Peters, sent to the Kiowa Reservation as a field matron in the United States Indian Service, organized a fine arts class the following year, according to conversations she and some of the students had with Dorothy Dunn, reported in Dunn's book *American Indian Painting*. Peters invited the teenagers, who were between 11 and 15, to join the class. The mayor of Andarko, Oklahoma, provided a room to be used as a studio, and Peters supplied the painting materials.

Nine years later Peters arranged for some of the better students, now in their early twenties, to receive advanced art training at the University of Oklahoma, where they came under the guidance of Professor Edith Mahier and Dr. Oscar Brousse Jacobson. The result was *Kiowa Indian Art*, the first set of prints based upon watercolors by American Indian artists. It was published by C. Szwedzicki (his first name is unknown) in Nice, France, in 1929. Jacobson wrote the accompanying text, in both French and English. The 750 sets of 31 prints (one of which appears on the portfolio cover) were numbered and signed by the publisher.

The prints are startling in their vigor, accomplishment, design, and beauty. The *pochoir* technique of reproduction—a special application of the ancient stencil process—was common in France in the 1920s. *Pochoir* is used less in France today and was always rare in America.

The artists were six young people who were admitted to an art class at the university's Norman, Oklahoma, campus in 1928. The class consisted of Spencer Asah, James Auchiah, Jack Hokeah, Stephen Mopope, Monore Tsatoke, and one young woman, Bou-ge-tah Smoky. They were admitted to a segregated program under special arrangement that overlooked their lack of academic background.

Accounts of their experience in Norman vary. Those carried in J. J. Brody's *Indian Painters and White Patrons* and in Jamake Highwater's *Song of the Earth* differ slightly as does Dunn's account of the events. According to the most recent version by Highwater, the Kiowa students were set up in a separate room for privacy but encouraged to mix with the Anglo art students. Little effort was made to direct them to formalized European art. Although they studied composition and anatomy, the main advantage of their classes was the availability of materials and the freedom to use them imaginatively.

Lew H. Wentz of Ponca City, Oklahoma, provided nominal scholarships, so that the artist could concentrate on their work and not worry about providing for themselves and their families. They attended class from January to May of 1928.

At about the same time, Indian artists were also being encouraged to paint by white patrons in San Ildefonso. San Ildefonso is in the Pueblo region of New Mexico near Santa Fe. Artists like John Sloan were attracted to the area. When Peters heard of these developments in New Mexico at the start of the twenties, she visited to see how common problems were being resolved in Santa Fe. She observed, for example, how they raised money for materials as well as what training techniques were used to instruct the Indians. There was, however,

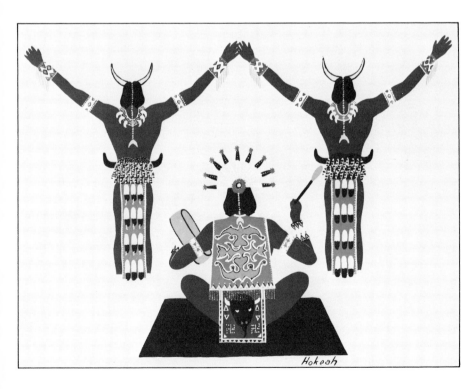

The set of 31 prints called *Kiowa Indian Art* is derived from the work of six young Kiowan Indians who studied together in a special class at the University of Oklahoma in 1928. The watercolors they produced in the class were reproduced by the pochoir technique, a stencil printing process similar to silk-screening. Opposite page: *The Love Call* by Monroe Tsatoke, 8¼ x 5⅞. Tsatoke's designs are distinguished by their vigorous treatment of the muscular human form. This one was selected for (and is shown as it appears on) the portfolio cover. Left: *Greeting of the Moon God* by Jack Hokeah, 13 x 9½. Hokeah gave up painting soon after he left the university. His emphasis, like many of the Kiowa artists, was on bold lines and simplicity of design. All illustrations in this article courtesy author's collection. Image sizes are given for each print; mat size for each page in the portfolio is 15 x 11½.

exchange of neither techniques nor styles between the tribes.

All Indians had a rich heritage of painting in their native traditions. They had always decorated their tents (the Kiowas in particular were known for their painted tepees), pottery, clothing, and the like. But the University of Oklahoma and San Ildefonso classes were the first organized efforts to introduce Indians to modern easel painting.

By the time the Kiowas reached the campus at Norman they were older than most students, and several brought wives. The results of five months of concentrated effort were, in Jacobson's own words, "simply astounding." The attitude of Americans toward the Kiowa artistic accomplishments, considered patronizing by some, was expressed by Jacobson in the text accompanying the prints. He wrote: "This art of the Kiowas should not be judged by the 'white' yard stick. They are created from a different racial point of view." A contemporary Denver art critic quoted in the same text noted: "All [Kiowa paintings] are full of the dark forces of the universe, full of the age of metaphysical symbolism and awe which is so characteristic of this very ancient race compared to whom we, white Americans, in spite of all our "Books of Knowledge' appear like a product of yesterday."

Jacobson describes the Kiowas as "peaceful, law-abiding citizens practicing agriculture." But in 1928 they were but 38 years removed from the warpath. The last attempt the Kiowas made to rebel under white domination occurred in 1890. The uprising was associated symbolically with the Ghost Dance. The Kiowas danced in symbolically painted shirts that they believed to be impervious to the white man's bullets. This belief ended when a group of unarmed Sioux wearing the special shirts was massacred that same year at Wounded Knee.

The most vigorous Indian religion of today, Peyotism, is a spiritual continuation of the ideals of the ritualistic Ghost Dance—to preserve Indian uniqueness by keeping a separate Indian society. The peyote cult spread when the Indians admitted defeat, and it sustains them to this day. It is an important source not only of symbols but also of color visions. Peyote is a hallucinogen that when ingested evokes brilliantly colored images.

The various efforts to revive the pre-Anglo past and the current religious practices at the time played a large part in the thrust and subject matter of Kiowa art: war and hunting parties; figures out of legend; ritual and messianic dreams; flutists, drummers, singers of old songs, and some genre scenes.

Paintings based on early Indian culture—rites and ceremonies—have since been labeled "traditional" to distinguish them from the work of some contemporary Indian artists. The so-called contemporary group, which sprang up after World War II, paints the harsh realities of Indian life and sneers at the traditionalists with their palettes pointed to the past. The rift between the two groups deepened when Indians, desperate to earn money from their art, watered down much of the traditional painting to adapt their work to tourist tastes. Indian painting fell into disrepute. And the traditional subject lost much of their significance, partly because they

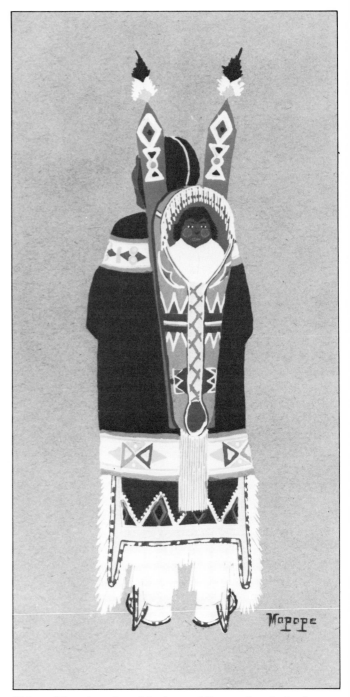

Sixteen of the prints selected for the portfolio were done by Stephen Mopope. Mopope was educated through the sixth grade in a mission school and taught to paint on tanned skins by his granduncles. (His grandfather was a Spaniard who was kidnapped from a wagon train by Indians.) All the prints shown here and on the following two pages are Mopope's. Above: *Mother and Papoose,* 8¾ x 3½. Right: *Eagle Dance,* 9½ x 8¼.

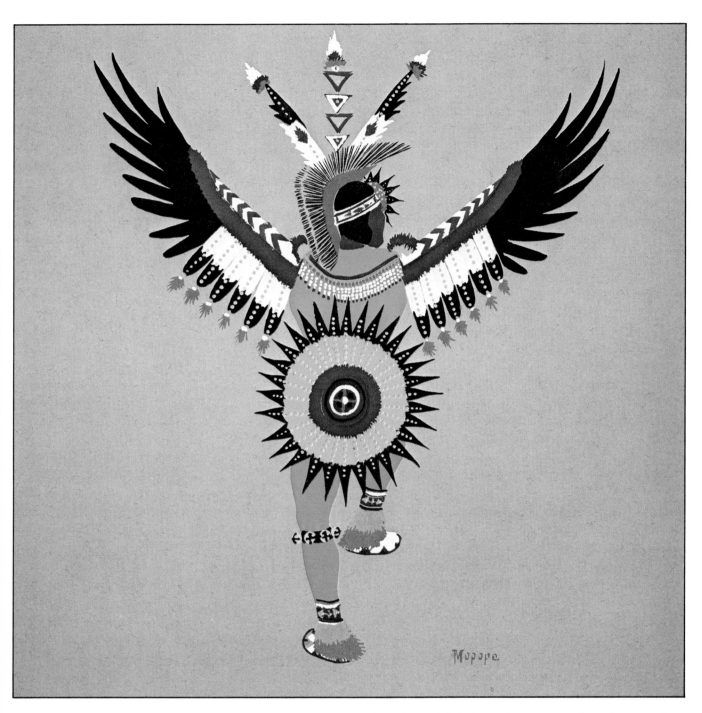

were abused, but also with the passage of time. The relatively recent battle between contemporary and traditional artists is still being fought. But we are getting ahead of ourselves here. The Kiowas, in 1928, were close to their sources, and the reception for their work was not diluted by such conflicts.

No matter what Jacobson's feeling toward the Indians may have been—patronizing or not—he recognized quality work when he saw it. He selected a group of watercolors and sent them to the International Congress of (Folk) Arts in Prague in the summer of 1928, where, according to Brody, "they created a sensation."

The status of American art in general in that era was low, and art from reservation-bound Indians was accepted only by a few. These were collectors who recognized the beauty of

the work but didn't do much to support the Indian art effort or to spread the word about the quality of the work. (Americans at the time were primarily interested in Indian artifacts.) The best Indian art was purchased for almost nothing. Most Americans didn't recognize it as very good.

European art was considered better than American in the twenties, and stencil reproduction actually was far superior in Europe. One of the finest printing processes in the world was chosen to reproduce the Kiowa watercolors. And Jacobson's text, featured both in French and in English, helped to sell the prints in American and European markets. (No doubt, the Kiowas did not profit from the sales.)

Other sets of prints based on American Indian paintings followed this first group in Szwedzicki's shop. Recent at-

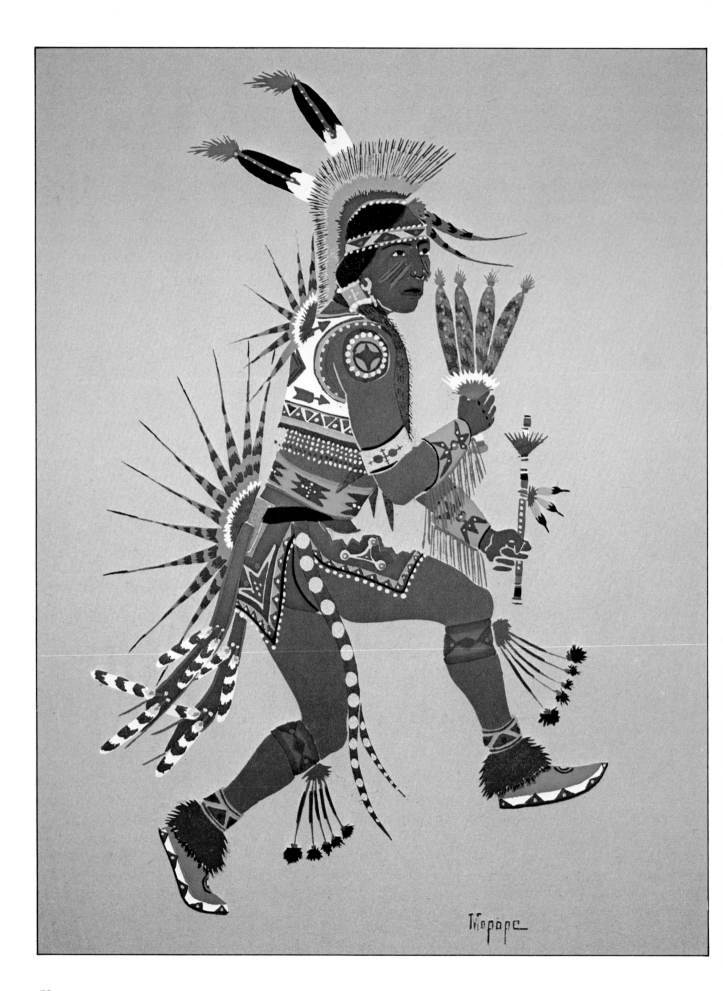

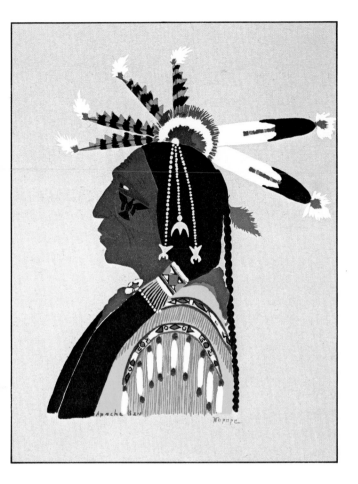

Pochoir printing ordinarily calls for between 20 and 30 stencils for the reproduction of a single work of art, although in some cases as many as 250 stencils have been used. This technique, never very popular in the United States, was perfected in France and was ideal for capturing the brilliant colors of the Kiowa watercolors. To distinguish a print from an original it is sometimes necessary to check for a copyright stamp on the reverse side. Left: *Flute Player* by Stephen Mopope, 9 x 5½. This is one of Mopope's most dynamic compositions. The feathers held by the dancer seem to tremble with color. Above: *Portrait* by Stephen Mopope, 7 x 5½. Below: *Squaw Dance* by Stephen Mopope, 11 x 7¾. Mopope painted all his life and was honored with a one-man show at the American Indian Exposition in Anadarko in 1965. His work has a more emotional quality than the other Kiowa artists, and his brushwork was extremely fine and delicate. Note the pleasure in the men's faces below as they watch the brightly-clad rearview figures execute their dance.

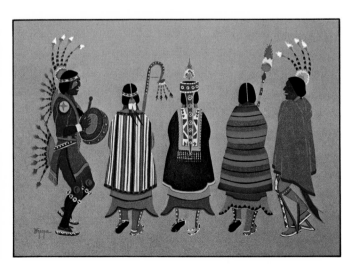

The results of five months of concentrated effort were "simply astounding."

tempts to find the publisher or his records have been totally without success.

The Kiowas did not work with stenciling techniques. But their watercolors lend themselves to the method because of their strong emphasis on decorative design and brilliant coloring. The technique of *pochoir* used by Szwedzicki in his studio was described by Elizabeth M. Harris of the Smithsonian Institution in 1977. *Pochoir* was introduced in France in the late 19th century and developed to a peak—in France and elsewhere—in the years before the Great Depression. Pochoir is hard to classify and is an anomaly today. It is not strictly printing, nor is it hand coloring; it is not "original" by the definition of the Print Council; equally it is not mechanical, because the colorists are people, not machines. It occupies a no-man's land between art and commerce, because the French, who still use the technique, are able to make a trade of craftsmanship.

Pochoir ordinarily calls for 20 to 30 different stencils, or the same number of colors, to be applied over a black-and-white reproduction, such as a collotype (a high-quality printing process). In some examples as many as 250 stencils have been used. (The maximum number of stencils used to make the Kiowa prints is not known.) First an artist skilled at interpretation of color analyzes the original, painting each tint in its proper place on a separate collotype. These collotypes are pasted on the stencil sheets and the colored patches are cut out. The sheets are plastic, oiled board, or thin sheet metal. No pieces of stencil can be left as unattached islands.

Next the colors are applied. Special brushes are used, and color, either opaque or transparent, is put on paper by painting, dabbing, brushing, sponging, spattering with a toothbrush, spraying with an airbrush—any method needed to get the right quality and texture. The finished products may be almost indistinguishable from each other—or from the print or painting that they reproduce.

The American answer to *pochoir* is the more familiar silkscreen or serigraphy processes. When the silk-screen process emerged here it preempted the American market from *pochoir* because it allows mechanization and exact repetition.

The technique of *pochoir* has kept the original Kiowa prints as vivid and colorful as the day they were made. Because the paint lays thickly on the paper, some mistake the prints for the originals, and prints have been offered for sale as "original watercolors." It is easy to tell print from original: Check the back. Each print carries a copyright stamp on the reverse side.

When other tribes saw the recognition the Kiowa art received, they adopted the idea of painting on canvas their rites and traditional ceremonies too. The initial success and acceptance of Indian art abroad indicated that the Kiowas

were on the right track. By 1932 Szwedzicki used the *pochoir* technique to print folios based on Pueblo painting. The Pueblo watercolors were quite different from the Kiowa works both in subject and style.

Jacobson was variously accused or praised for imparting his own Art Deco and regionalist tendencies to the Kiowa watercolors. (Jacobson had worked with American regionalist Thomas Hart Benton, known for capturing on canvas agrarian Midwestern scenes.) While Jacobson's influence on the artists is debatable, it is agreed that he succeeded in bringing out the talents of the Indians in a very short time. It was perhaps fortuitous that Jacobson considered their education complete in five months because it enabled the Indians to keep a kind of artistic integrity.

The first seven prints in the series are based on Jack Hokeah's watercolors. Hokeah was born in western Oklahoma. It is known that he was still alive as late as 1967. Hokeah became an actor in New York City in the 1930s and still later worked for the Bureau of Indian Affairs. He gave up painting immediately after the university experience.

From the first impact of Hokeah's *Buffalo Dance* through to the *War Dancer*, the emphasis is on bold line and simplicity of design. His watercolors have been favorably compared with the Mexican codices. In *Buffalo Dance* and *Greeting of the Moon God*, Hokeah paints rearview figures—a device used by the Kiowas but rarely seen in other Plains painting.

Spencer Asah was born near Carnegie, Oklahoma, about 1907 and died at Norman, Oklahoma, in 1954. Asah is represented by only one print in the series—a self-portrait. It is a stiffly stylized ritual representation of the artist dancing, enlivened with strong color work. While Asah attended the university he earned extra money by dancing.

Bou-ge-tah (Lois) Smoky was born near Anadarko, Oklahoma, in 1907 and died recently. In *Kiowa Family*, the bright colors and straightforward naturalism of an Indian mother with her two small children enliven the naive charm of the small genre scene. Smoky's work is held in many private and museum collections.

Sixteen of the prints are taken from works by Stephen Mopope. Mopope also painted rearview figures. The portrait-style heads, small groups, and single figures that appear in his Kiowa paintings are distinct from other Plains paintings, such as those done in San Ildefonso, where the artists generally painted large groups of people. Mopope's work is also collected by museums and individuals. Mopope was born at the Kiowa Reservation near Red Stone Mission in 1898. His grandfather was a Spaniard who was kidnapped from a wagon train. Mopope, educated through sixth grade in mission school, was taught to paint on tanned skins by his granduncles. He painted all his life and was honored with a one-man show at the American Indian Exposition in Anadarko in 1965. While it is not known when he died, records show he was alive in 1967.

Compared to Hokeah, Asah, and Smoky, Mopope's work has a more emotional quality. He handled the brush with additional delicacy and his figures are distinct one from another. Even the faces he painted reflect expression missing in some

Above: *Asah Dancing* by Spencer Asah, 7 x 8. This is Asah's only print in the series. While at the University of Oklahoma he earned extra money by dancing and this self-portrait shows him performing in ceremonial dress. Right: *Warriors* by Monroe Tsatoke, 9 x 9¼. This wild, nightmarish picture is thought by some to be the most unusual and striking print in the portfolio. The intensity of the two warriors as they lunge toward the viewer contrasts greatly with the restrained, stylized gestures of the dancer shown above. Tsatoke's watercolor captures all the fury and courage for which his ancestors were famous.

of the other works. In the *Squaw Dance*, an outstanding piece, the faces of the men indicate pleasure while the brightly clad rearview figures execute their dance.

The versatility and talent of Monroe Tsatoke comes very close to genius. The subtlety of his coloring, the foreshortening techniques he used along with depth and sensitivity make his work stand apart and above the rest. Five prints in the portfolio and *The Love Call* on the cover illustrate his capabilities. His smashing tour de force, *The Warriors*, number 30, concludes the set.

Tsatoke was born at Saddle Mountain, Oklahoma, in 1904 and died of tuberculosis in 1937. He was the son of a Kiowa scout for Custer, grandson of a white captive. Entirely self-taught, he began to paint when he was 11. When he became ill, he joined the Native American Church, painting a series of works concerning his religious experiences in the peyote faith. These were published posthumously.

Both contemporary and traditional styles of Indian painting have their place, although as time passes the ties that bind the traditional painter with the past will weaken and the significance of ceremonies and rites will continue to pale. The traditional works, such as the Kiowa prints, will be valued for their achievements. There is a place for all art no matter its source as long as it is accomplished.

The interest in this first portfolio of prints by the Kiowas has prompted a new publication of the sets. These will be published in December 1978 and produced in six-color offset, including varnish, for a faithful reproduction of the original prints. The new text will be written by Jamake Highwater. ■

Atelier 17

Atelier 17's founder-director, Stanley William Hayter, propelled printmaking in the United States out of the 19th century and liberated a generation of American printmakers from outdated conventions and techniques.

BY DIANE COCHRANE

In 1940, along with countless others, Stanley William Hayter, an English painter and printmaker living in Paris, left occupied France for the United States. On his arrival he established an intaglio printmaker's workshop at the New School for Social Research in New York City and called it Atelier 17 after the one he had left behind in Paris. The school catalogue described the course as open to "artists already familiar with the ordinary techniques of etching and engraving to carry on independent investigation." Despite the blandness of this description, hundreds of gifted young people and many highly innovative, well-known artists began to flock to the small workshop in Greenwich Village to learn how to make a new kind of print this country had never seen before.

Because of the impact Hayter made on both students and peers who collaborated at the workshop in the 1940s, many claim that he is "father of the modern American printmaker," and that Atelier 17 revolutionized American printmaking. In-

Above: *Cinq Personnages* by S.W. Hayter, 1946. Engraving and soft ground etching, 14½ x 24. This is an example of a simultaneous color engraving—a Hayter innovation. Courtesy Elvehjem Museum of Art, Madison, Wisconsin, gift of Mr. and Mrs. Mark L. Hooper.

deed, in 1944 when work produced at his shop was shown at the Museum of Modern Art, the exhibition was declared to be as electrifying to the field of printmaking as the 1913 Armory Show was to painting.

Yet mention the name Atelier 17 today to someone in the art world and see what kind of response it elicits. If the person is not heavily involved in the field, such as a printmaker, curator, or historian, for example, chances are he or she won't recognize the name at all. Even among printmakers, particularly young ones, the workshop may not be familiar.

More seasoned printmakers, of course, have. But whether they regard Hayter as the father of American printmakers or credit Atelier 17 with changing the course of printmaking in the United States depends in large part on the medium they work in. If they use intaglio methods, as Hayter does, they probably will agree. If they are concerned with lithography, woodcut, or serigraphy (silk screen), they may look on Atelier 17 as little more than an interesting, but short-lived phenomenon, or simply a historical footnote. The reason for this lies in their allegiance not only to a different printmaking process, but also to antithetical concepts concerning the role of the printmaker.

Leaving aside these differences for the moment, however, one nevertheless can say without reservation that Hayter, in a heroic, almost single-handed effort, took intaglio printmaking in the United States out of the 19th century and placed it firmly in the modernist tradition of the 20th century.

Intaglio is a term that describes a number of different processes—etching, engraving, drypoint, aquatint, mezzotint, soft ground, lift ground, and such. All these techniques have one thing in common: a line is incised in a plate, and the plate is inked and wiped clean so that ink remains only in the incised line. When dampened paper is placed on the plate and both plate and paper are run through a press under extreme pressure, the paper is forced into the lines holding the ink, thus printing the line on the paper.

The intaglio process known as *engraving* refers to the method of cutting a line into a plate (usually copper or zinc) with a hard steel tool called a *burin*, which is pushed into the plate by hand. In an *etching*, the line is bitten into the plate with acid after the artist has drawn through an acidproof layer called a *ground* (usually made of wax, lacquer, or asphaltum).

Until the 1940s, American printmaking was dominated almost totally by printmakers executing black and white etchings in a realistic manner. The country and city scenes of Edward Hopper and Childe Hassam or the social commentaries of Reginald Marsh and John Sloan are typical and among the best of this school.

What Hayter did was emancipate artists from essentially conventional traditions and offer instead European modernism and highly sophisticated technology. And he did this by the sheer dint of his personality. He was one of those rare individuals capable of infecting both students and contemporaries with excitement over an art form until they in turn transmitted to others what had become an obsession. In this

Under a Glass Bell by Ian Hugo, 1944. Engraving and soft ground etching, 9⅞ x 11¾. A close inspection of these two prints reveals they were both taken from the same engraving. In the top picture the plate's surface was wiped clean after inking, leaving ink only in the grooves. The darker print, shown below, was made by rolling ink on the plate, keeping the grooves free of ink. Courtesy Associated American Artists.

century, only Hans Hofmann and Josef Albers had a similar gift for inspiring students and professionals with their missionary zeal.

Etching, according to Hayter's credo, was only one of many processes that could be employed to create an intaglio print. Some methods, such as engraving and mezzotint, had been around for centuries but had fallen into disuse until Hayter revived them. Others were developed out of experiments in which two or more intaglio processes were combined, or in which an intaglio process was used in conjunction with relief printing or serigraphy. (Lithography, where the image is drawn in crayon on a special stone, was the one medium never used at Atelier 17.) Still other methods were brand-new inventions, some of which were the happy result of accidents in the workshop.

Before describing his accomplishments in America, however, let's backtrack for a moment to discover, in today's vernacular, where Hayter "came from."

After a brief career as an oil chemist, which was ended by illness, Hayter, 25, moved to Paris to study and work full-time as a professional artist. This was in 1926. Almost immediately, he met Joseph Hecht, a Polish engraver who was responsible for Hayter's enduring affair with intaglio processes in general, and engraving, in particular. Having learned to engrave from commercial craftsmen, Hecht began to manipulate the burin so that the line itself, rather than the form it delineated, became the vehicle of his creative expression. In his book *New Ways to Gravure*, Hayter said of Hecht: "He possessed an extreme sensitivity to all the qualities of a line—rigidity, flexibility, resilience—and saw the character of life in the line itself, not the description of life by means of the line."

Soon after Hayter's conversion to engraving as a medium of expression, he established his own studio in Paris, where he began to teach others. "When I met Hecht in 1926," said Hayter in his book, "I was very strongly impressed with the latent possibilities of his manner of using a burin, and later, realizing the necessity of collective work in a group in order to develop these and other possibilities, I set up a workshop where all equipment was available for artists who wished to work in those media."

In 1927, the studio was moved to 17 Rue Campagne-Premier and the name Atelier 17 became well-known in artistic circles in Paris. By 1930 many of the most important artists of the time were coming to Atelier 17 to work. Surrealists Joan Miró, Hans Arp, and Yves Tanguy were frequent visitors, while Alexander Calder and Alberto Giacometti made some of their first prints there. Although Picasso never printed at Atelier 17, Hayter often gave him technical assistance with his printmaking. As the reputation of the workshop increased, American artists such as the sculptor David Smith also began making the pilgrimage. Artists continued to venture to the studio until the outset of World War II.

From these early years abroad two dominant themes emerged that persisted during Hayter's years in America. First, his adherence to surrealism, particularly to that brand of surrealism called *automatism*. Automatism employs the technique of automatic drawing, which allows the artist's tool, whether it be a brush, pencil, or whatever, to define form

Until the 1940s, American printmaking was dominated almost totally by printmakers executing black and white etchings in a realistic manner.

Opposite, top: *Theseus* by Jacques Lipchitz, ca 1944. Etching, engraving and liquid-ground aquatint, 13½ x 11⅛. Courtesy The Art Institute of Chicago: The Joseph Brooks Fair Collection. Opposite, below: *Lilith* by Reuben Kadish. 1945. Etching and aquatint, 13½ x 9¾. Courtesy Reuben Kadish. This page, top: Untitled by Jackson Pollock, 1944-45. Engraving and drypoint, 11⅞ x 9⅞. Courtesy The Brooklyn Museum: Gift of Lee Krasner Pollock. This page, below: *The Bull* by Gabor Peterdi, 1939. Engraving, 7¾. Courtesy The Brooklyn Museum: Gift of the artist.

solely by chance. The theory behind automatism is that subconscious images, otherwise unavailable to the conscious mind, will be released. When using this technique, Hayter let the hand holding his burin incise a plate with undirected movements while the other hand, equally undirected, moved the plate around. Once an unconsciously formed linear pattern was produced, it was refined so that a rational composition, many times incorporating a human figure, was created.

Hayter's second preoccupation was with the workshop system, which was based on the collaborative efforts of artists willing to involve themselves in the *total* process of printmaking. In this system, artists delegated *no* part of the technical process to professional printers. Hayter believed that only artist-printmakers could develop the techniques necessary to carry out the creative ideas behind them.

That is not to say that he liked to surround himself with experienced artist-technicians. When he arrived in New York, according to Joann Moser in her catalogue *Atelier 17*, accompanying the 50th anniversary retrospective exhibition of works by members of the workshop:

"He wanted both young artists who had not already determined their own means and styles as well as more mature artists who could bring to the group the benefits of their experiences. He actively solicited accomplished painters and sculptors even if they had never tried printmaking before, if he thought they would bring a fresh outlook to printmaking. He did not want their prints to be mere transcriptions of their work in other media. In addition he encouraged artists whose primary interest was in printmaking and who might be inclined to experiment with and exploit the unique possibilities inherent in printmaking. Above all, he wanted to assemble an international group. . . ."

He got what he wanted. Jacques Lipchitz, Marc Chagall, Miró, Karl Schrag, Gabor Peterdi, and Mauricio Lasansky were just a few of the foreigners who, from time to time, joined with Robert Motherwell, Jackson Pollock, Alice Mason, and a hundred other lesser-known American artists who passed through the workshop doors during the 1940s.

What came bubbling out of this international brew was truly intoxicating. While most prints bear the mark of surrealism, the illustrations here evidence the great variety of innovative work produced at Atelier 17 in the forties. There's not a traditional scene to be found among them. The excitement of the decade is described almost rhapsodically in an anecdote written by Leon Katz in *Print* magazine in 1961. It was about the printing of a new plate made by André Racz:

"André Racz (from Rumania) had just finished his *Perseus* plate. Lasansky (from Argentina) was there and a few others including myself. Someone cut the paper, another prepared the blankets. One turned the spikes and I held the blankets stretched.

"We had forgotten whose plate it was and I feld surely within half an inch from heart failure. When finally someone lifted slowly the paper from the plate, we knew we were looking at a print the like of which no one had ever seen before. The freedom to follow boldly one's artistic intuition was taken for granted. The search for inherently graphic realities in a print took the place of the plain descriptive realism of the

Composition No. 2 by Joan Miró, 1947. Soft ground etching, 4⅞ x 5⅞. A soft ground etching is made by rolling grease, tallow, or vaseline over a hot plate. Once the surface cools, any number of objects may be used to produce an impression. In this print Miró used, among other things, his own fingerprints. Courtesy The Brooklyn Museum.

past. There existed an almost ecstatic appreciation of the moment when hitherto unborn images were pulled from their invisible world of possibility into the world of visible relativity . . ."

Sparked by Hayter's unbounding enthusiasm and energy, the artists who worked at Atelier 17 also made a quantum leap forward in print technology. Of particular importance were their experiments in altering the plate to create sculptural or three-dimensional effects. *Gauffrage* and *soft-ground etching* were just two of the many techniques that were explored for this purpose. A *gauffrage* is made when a wide, deep gouge is cut in a copper plate. The gouge, however, does not have enough surface texture to retain ink. Thus, when the paper is forced into the concavities, a print with raised white lines is produced. *Soft-ground etching* is made from a plate covered with a ground to which Vaseline or tallow has been added. Since this ground never really hardens when dry, any number of textures such as fabrics and human hands can be pressed into it.

These processes were the forerunners of collagraphy (prints made from a collage plate composed of a variety of materials which have been firmly glued to a base plate), em-

The Big I by Alexander Calder, 1944. Soft ground etching, 6⅞ x 8⅞. The print technique Calder used was the simplest one. After greasing the plate, he placed a piece of paper over it and drew on the paper. Once the paper was peeled away, the imprint of his design was left behind. The plate was then ready to be dipped into the acid bath for the etching process. Courtesy Free Library of Philadelphia.

bossing, paper casting, and other techniques widely adopted by printmakers in the 1960s and 1970s.

Members of the workshop also searched for new ways of printing. In particular, they tried to perfect the tricky procedure of printing color intaglio prints. The usual method was to use a separate plate for each color. But by the 1950s artists at the workshop had developed and improved the color process to the point where several colors could be printed from one plate, a technique Hayter called *simultaneous color printing*. The theory behind the technique is this: When a thinner, less viscous ink is rolled over a thicker ink, the two colors mix. But when a thicker ink is rolled over a thinner ink, the first color rejects the second, which adheres only to the surface surrounding the first color. Then, by varying the viscosities of successive colors, more and more colors may be combined in a single print. This emphasis on color printing at Atelier 17 surely anticipated the widespread market for color prints in the last two decades.

Technology cannot be viewed as a separate endeavor from creative thinking, according to Hayter's philosophy. Instead, it is inextricably involved with the creative process. As Katz wrote in *Print:*

Sparked by Hayter's enthusiasm, the artists made a quantum leap forward in print technology.

Doma by Mauricio Lasansky, 1944. Engraving and drypoint, 19½ x 13¾. Lasanky's execution of this print was well-suited to his violent subject matter. The clean, thin lines were made with a burin, the common tool of the engraver; while the furrowed lines, like those on the horse's mane, were made with a drypoint needle. Courtesy Library of Congress.

"As a matter of course, a new technique had to be found for each new approach. Thus the usual idea of one technique just being good or bad became meaningless. Equally meaningless was any attempt to divide the creative process into independent areas of mind separated from matter or visions, ideas or emotions flitting across a vacuum with technical tricks. Visions, emotions without proper technical expression are invisible and a technical performance without its nuclear center of emotional, intellectual or visual power is like a soul-less body. Bill [Hayter] fought with great intensity against this ignorance of interdependence of technique and idea."

The research and development carried on at Atelier 17 was the direct result of a workshop staffed solely with artists.

Prior to 1940 most American workshops, like their European counterparts, tended to be commercial enterprises run by craftsmen and printers who printed plates for artists. Other workshops, established by the Federal Art Project in the late 1930s, were studios where artists could make prints but where they were not likely to be encouraged to produce work involving unfamiliar artistic expression.

At Atelier 17, the rapid communication and refinement of ideas flourished as artists talked and watched each other work. Said Karl Schrag, noted printmaker and short-term director of the workshop, in *New University Thought:*

"The profound effect of this workshop upon the development of graphic art in our time is an historic fact—in part this

effect is due to the extraordinarily dynamic and enthusiastic personality of the artist, who is the workshop's founder, Stanley William Hayter; in part it is due to the workshop idea as such and to the results it could produce in an enormously talented group. Only through exchange of knowledge, only through immediate and intense communication, could such progress come about. Single artists, working alone and separated from each other could never have moved the whole understanding and concept of the modern print ahead with similar strength and effectiveness."

Today the print workshop is a concept that's here to stay. It exists on dozens of college campuses, and many of the workshops are taught by former Atelier 17 members or students of these members.

Earlier we spoke of printmakers and others who see Hayter in a somewhat different historical perspective than his admirers. Basically they make three criticisms.

First, they believe that except for the mature artist working at Atelier 17 who had already established his or her own esthetic, too many students were influenced unduly by Hayter's own surrealistic style—they progressed only far enough to become little Hayters, and because of his powerful personality, further development was stymied.

Second, because of the emphasis on technical experimentation, many students relied too heavily on technical tricks and not enough on original thinking despite Hayter's fight, as Katz put it, against ignorance of the interdependence of technique and idea. To some extent both of these criticisms are justified.

The third reservation is an outgrowth of the second but represents a philosophical schism among printmakers, rather than a genuine criticism. The issue in dispute is whether or not a printmaker should do it all and function as the artist-printmaker—the role Hayter championed—or rely on the expertise of skilled craftspeople. Those critical of the former approach argue that overinvolvement with technical processes robs the artist of both the time and energy necessary to nurture creative talents.

Obviously there is no right or wrong answer to this issue, nor does it in any way invalidate the importance of Hayter's achievements in the United States. The workshop continued to function in New York until 1955 under other directors, and Hayter returned to Paris in 1950 to re-establish his old studio. Even June Wayne, the printmaker who founded Tamarind Lithography Workshop specifically to train expert craftspeople to work with artists, has high praise for Hayter: "Hayter's impact was that of a great teacher and many of his techniques literally changed the look of prints . . . what he accomplished without public or private subsidies was nothing short of miraculous."

It is possible that if Hayter had remained in this country, his name might be recognized as easily as, say, that of Hans Hofmann's. Or if there had been a better market in the 1940s for prints, Atelier 17 might come to the lips of collectors as quickly as Tamarind does today.

Speculation, of course, is futile. The fact remains that Stanley William Hayter and Atelier 17 did permanently revolutionize the American intaglio print. ∎

Cacophony by Sue Fuller, 1944. Soft and hard ground etching, 11¾ x 8¾. This print is a collage of textures. After an initial soft ground impression was made, additional objects were then pressed into the corners. The impression in the upper left and elsewhere seems to have been done by a paper doily. Courtesy Sue Fuller.

Collecting Photographs: A Primer

In recent years photography has moved from the fringes to the center of high culture; the dramatic change has brought a sharp rise in the market value of many photographs.

BY BONNIE BARRETT STRETCH

John Szarkowski, director of the department of photography at the Museum of Modern Art, has called photography "one of the richest and most puzzling of all the arts." As a medium of uniquely various styles, techniques, and subject matter, photography does not submit easily to the familiar categories of the better-known arts. In its brief history it has managed to employ most of the themes and sensibilities explored through the traditional art media, but it also has developed others that are entirely new.

From the portraits, landscapes, and still lifes of the earliest photographs, photography expanded to embrace the documentation of great wars; the pictorial allegories of such artists as Gertrude Käsebier, F. Holland Day, and Annie Brigman; the cubist forms of Paul Strand; the graphic studies of Man Ray; the surrealism of Herbert Bayer; the intensely personal mythologies of Clarence John Laughlin; the mystical messages of Minor White.

In addition, photographs have created an incomparable record of the quotidian events of family and community life; they have captured the decisive moments perceived by the fleet eye of Henri Cartier-Bresson, and photographs have revealed the mysterious and beautiful worlds of the microcosm and the split second. And let us not ignore the commercial uses of photography—fashion, illustration, and advertising—which have definitively altered our culture. This entangle-

90

Newcomers to the study of historic photography are usually surprised by the variety and richness of color found in all of the early photographic processes, as well as the subtle painterly effects revealed in early attempts at color picture taking. All pre-1900 photographs were not black and white; reproductions in newspapers, magazines and books have created this false impression. Illustrations on the first three pages of this article show the range of colors that make early photographs of interest to collectors and connoisseurs. Note the shifting tones of the early albumen prints and the unusual wash of color on the gum trichromate—a precursor of the modern colored photograph. Opposite page: *Still Life* by Auguste and Louis Lumière of France, 1899-1900; stereo gum trichromate on glass. In this double-image stereo view, the gum trichromate process creates an effect like a wash drawing and gives a sumptuous demonstration of the possibilities for capturing color. Collection Roger Therond, Paris. Above: *Still Life* by Roger Fenton, England, ca 1860; albumen print, 13¾″ x 16½″. Albumen printing was introduced in 1850. In good condition an albumen print varies from dark, purplish, bitter chocolate color through a range of browns to a rich russet. The dark tones are velvety and deep; the whites creamy. Courtesy The Royal Photographic Society Bath, England. Left: *Crimean Braves* by Joseph Cundall and Robert Howlett, England, 1856; photogalvanograph, 16½″ x 7 4/5″. The photogalvanograph, a photomechanical print, was a reproduction of an original photograph. The process was patented in 1854 but the quality of half tone reproduction it achieved was not good enough to assure its commercial success. However, the primitive quality of the process makes this type of print ultimately interesting and attractive to collectors. Rubel Collection, courtesy Thackery & Robertson, San Francisco. All photographs acquired from *Photodiscovery, Masterworks of Photography 1840-1940* by Bruce Bernard. c 1980 Times Newspapers Ltd. Published by Harry N. Abrams Inc.

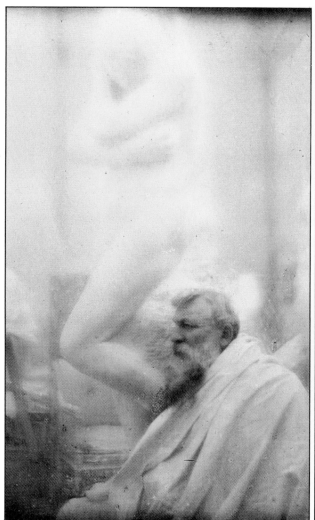

The breadth of the photographic medium is vast. Like other graphic arts, it has a syntax; one must learn to look and discern to fully appreciate the differences among the various styles and printing techniques. Above right: *The Fisherman's Daughter* by Frank Meadow Sutcliff, English, 1900; silver bromide print, 18″ x 12½″. Although Sutcliff is best known for his genre scenes of fisherfolk in Whitby, Yorkshire, here he has used a more formal pose suggesting the well-known paintings of women who await the return of their seafaring men. The bromide process, developed in 1873, became popular in the early 20th century. Bromide prints can produce blacks with a cold greenish-gray cast, or they may be toned to yield various other colors. Above left: *Rodin with Sculpture of Eve* by Edward Steichen, 1907, autochrome, 6¼″ x 3¾″. This is one of Steichen's many portraits of Rodin. The autochrome, of which Steichen's *Rodin* is a majestic example, was the first practical and commerically available color process, patented in 1904 by the Lumières (see first page of this article). This process resulted in a picture on glass too dense to see without back lighting, but infused with an interesting quality not unlike the paintings of the impressionists. The Metropolitan Museum of Art, The Alfred Stieglitz Collection, 1955. Right: *Trois Rivieres*, Quebec, 1936, by Paul Strand; gold-toned platinum print, 6″ x 4⅔″. Strand's early work was concerned with studies in design; while shapes and patterns were the focus, the images never completely lost touch with reality. *Trois Rivieres* reveals some of these early concerns (note patterning of fence in foreground) but it is decidedly less abstract than other Strand works. The approach is simple yet evocative of the object and scene he is trying to capture. Here, Strand's use of the platinum process gives extraordinary tonal delicacy; this process is distinguished by a full range of luminous grays in the mid-toned and shaded areas. Platinum, one of the most stable substances, creates prints as permanent as the paper base. Such prints are usually silver gray, but warmer tones can be added. Courtesy National Gallery of Canada, Ottawa; all photographs acquired through *Photodiscovery*, Harry N. Abrams.

Photographic processes have their own syntax, much as engravings, lithographs and the other graphics do.

ment of art, sociology, history, anthropology, psychology, science, journalism, commercialism, and more, forms the great intellectual puzzle at the heart of the medium.

Learning to look

Most people find the transition to photography from the other visual arts a difficult one. Our lives are so filled with photographic images that it is not easy to think of photographs as rare and precious objects. One thinks of "art" as something large, colorful, created by hand, and somehow linked to a universal imagination.

Photographs, on the other hand, are comparatively small and mostly monochrome, although seldom simply black and white; they are made with the aid of a machine; and they are grounded in fragments of actuality. "The best thinkers in the visual arts do not know how to look at photographs yet," says Daniel Wolf, a dealer who specializes in nineteenth-century photographs as well as contemporary work. Looking at them requires an important shift in sensibility in order to begin to see photographs as beautiful objects that stand on their own, images to which one can return again and again.

Essential to making that shift is seeing as many original photographs as possible, from every period, in every style. As William Crawford makes clear in his recent study *The Keepers of Light*, photographic processes have their own syntax, much as engravings, lithographs, and the other graphics do. It is necessary to see the original prints to discover the importance of scale, the richness and range of tone, the varieties of color, the play of texture, all of which determine the quality and character of different images.

One must see the luminous surface of an albumen print, the soft texture of a salt print, the subtle tones of a platinum print, the colored coating of a gum bichromate print, the sharp snap of a modern silver print, to appreciate the range of expressive moods and modes achieved throughout photography's brief history. For some people the experience is revelatory.

Samuel Wagstaff, a former curator of contemporary art at the Detroit Institute of Arts, recounts frequently his visit to the 1973 exhibit at The Metropolitan Museum of Art entitled "The Painterly Photograph." It was an exhibition of photographs from the Stieglitz collection emphasizing the pictorial masters. "It was the first time I had seen an original of Steichen's *Flatiron Building*," Wagstaff recalls. "It is an unbelievably strong work of art, equal to anything in painting being made at that time. For the first time I realized photography was something very great." A short time later Wagstaff sold his collection of contemporary paintings and sculpture

and embarked on creating what is today one of the largest and most important private collections of photographs.

Developing connoisseurship

Most people come to photography through a style or genre or period with which they are already familiar. One collector who had formerly concentrated on art deco gravitated almost at once to the work of Man Ray and other artists exploring spatial ambiguity and graphic design in the 1920s.

For Paul Walter, a collector whose interests range widely through the arts, the transition to photography was a natural extension of his concern with topographical and botanical paintings and drawings done by English artists in India. In the early part of the nineteenth century, these were entirely watercolors and prints. By mid-century, photographs had intruded, and eventually they came to dominate the genre. Walter's interest in the whole Anglo-India experience led him to include among his acquisitions an ever-expanding collection of major nineteenth-century photographs from all of Europe as well as from India, China, and Japan.

Unique riches for collectors

The richness of photography tempts many collectors to collect comprehensively; once they have crossed the threshold into this new and complex world, they are drawn on to explore the whole territory. Few people can really afford the time and money necessary to do this successfully. Nonetheless, one of the rewards photography still holds out to its lovers is the fact that major works by eminent artists from all periods are still available to the private collector, and at relatively moderate prices. One of the great benefits of photography's new place in the art market is the remarkably easy access to important original prints.

At auction exhibitions some of the finest works by the greatest masters are there to be examined. This is doubtless a unique moment in history, for soon the nineteenth-century and early twentieth-century masterpieces will be in private collections or stored in museums, not to be so democratically available again. Today, however, there is a photographic feast for those who care to look.

Risks as well as rewards

But rewards do not come without risks, of course. And the risks in the photography market are multifarious indeed. As a relatively young and neglected medium, photography lacks the extensive critical and historical framework developed for the other visual arts over long generations. There are no cata-

> ## "The collecting of photographs is a different sort of search, filled with mysteries and contradictions and unexpected adventures."

logues raisonnés, for example, to provide information about the quality and rarity of a particular image. There are few studies of any photographer's entire body of work. Until recently most of the critical writings in the field had been done by photographers propounding their personal esthetics. Moreover, the two major histories—Beaumont Newhall's and Helmut and Alison Gernsheim's, both entitled *The History of Photography*, are out of date; Gernsheim's is out of print, already a collector's item itself.

In the past decade a number of thoughtful and knowledgeable art dealers have tried to organize and clarify this complex and confusing field. Most dealers and auction house directors readily admit that many mistakes have been made. Some photographs have been seriously overpriced; others of greater value have been ignored.

"It was hard in the early sales to know what to do," explains an auction house expert "We really didn't know what was out there. For example," she recalls, "we thought *Camera Work* gravures were a nice way to introduce people to the market. Their quality is just beautiful and we had some idea of the quantity that might exist. No one focused on the fact that they weren't original prints or that there might be original prints of these images out there, and that one should see the original print before deciding to buy a gravure."

These gravures from Alfred Stieglitz's magazine *Camera Work* (1903–1917) continue to be a staple of the photography market, although their importance has been reevaluated. High-quality reproductions of works by the greatest photographers of that period are to be found in *Camera Work*; the gravures were pulled by hand, usually under Stieglitz's personal supervision, and then "tipped" (affixed) into place in the magazine. Today they sell for several hundred dollars each; original prints by these master photographers would cost several thousand dollars.

Some gravures have been found to be more rare than others. There are images such as Stieglitz's *Steerage* or Paul Strand's *Wall Street* that are available only as gravures, and these naturally command high prices. In gravure as well as other areas, knowledge is constantly expanding and new evaluations are being made. New material is surfacing from old files and collections and from the attics and basements of photographers' families and friends. New images by known artists appear, as does work by previously unknown or unrecognized artists.

Much has been learned in the past six years, especially since Sotheby Parke Bernet began regular photography auctions that heralded the new place of photography in the art world. Unfortunately, however, a great deal of this knowledge is in the minds of assiduous dealers and collectors who are too busy pursuing their quarry—new works, new artists—to write down their discoveries for a larger public. Thus the market remains slippery ground for the uninformed novice.

In addition, collectors new to the field should consider carefully certain practices and terminology developed for the market to decide how these devices relate to their individual collecting goals. Of particular importance are the concepts of the "limited edition" and the "vintage print."

The limited edition

The creation of limited editions is one of the most controversial practices among photography dealers. The idea is lifted directly from the graphics market and is intended to provide collectors with a familiar reference point and an assurance of some degree of rarity. It has little relevance, however, to the problems of photography. It merely addresses the concerns of uninformed buyers who are troubled by the photographic negative, assuming that endless numbers of prints can be made from it. This is certainly possible in theory. In fact, however, this concern reflects a lack of knowledge about the process of creating a fine photographic print.

Unlike etchings and lithographs, where a large number of prints can be pulled at one time, each photographic print is made individually, the last print requiring as much time and effort as the first. Each print may take anywhere from an hour to several days to make. The photographer may go through dozens or hundreds of trials before achieving the quality he or she is striving for.

Because of the difficulty of making each print, photographers do not normally print in quantity. They may make two or three prints of one image and not return to that photograph except on the demand of a buyer. Until the 1970s the market for photographs was so small that very few prints of any single image were ever made. Edward Weston may have made all of twelve prints of *Pepper No. 30*, the most popular of all his photographs.

Thus the creation of limited editions in quantities of 25, 50, or 100, as is being practiced occasionally today, actually creates more prints of individual images than otherwise would be available. Instead of enhancing rarity, it actually reduces rarity.

The question of rarity

How important is rarity to photographic value? Many photographers and critics hold that the concept is totally antithetical to the nature of photography as the most democratic of the arts. As a practical market matter, however, if there are only two prints of an important image by a major artist, and one of these prints is in a museum, the other one is likely to bring a very high price indeed.

Many diverse areas await the interested photo collector's exploration; here the work of an early French photographer is juxtaposed to that of American landscape photographer Carleton E. Watkins. Top: *Cityscape, Paris*, 1864, by Charles Soulier; albumen print, approx. 8 x 10″. Soulier was one of the first to take instantaneous photographs in the streets of Paris. He began exhibiting his work from 1861 and is known primarily for his street scenes, landscapes and urban studies. Courtesy

Daniel Wolf Gallery, New York. Above: Two *Views of Thurlow Lodge*, ca 1874, Menlo Park, California, by Watkins, who is known particularly for his landscape views of the Yosemite Valley. The Thurlow Lodge photographs are part of a two volume set of gold-toned albumen prints containing 60 mammoth views (15¾″ x 20½″) which sold at auction for $75,000. Courtesy Christie's East, New York.

Below: Edward Weston's famous and perhaps most popular print, *Pepper #30*, 1930; silver print, 8" x 10". Weston made contact prints from the negative, never enlarging his prints beyond that size. It is believed only 12 prints of *Pepper #30*, made by Weston, exist. Courtesy Witkin Gallery, New York and the Edward Weston Estate. Right: *Landscape, Sevrès*, 1851, by Henri Regnault; salt print from waxpaper negative, approx. 9" x 11". Interested in photography since its inception, Regnault kept a studio at Sevrès and frequently experimented with the waxpaper negative. This process was popular for a while because it avoided use of the cumbersome glass plate.

However, the waxpaper process was abandoned by the 1860's in favor of speedier methods offering greater variety. Courtesy Daniel Wolf Gallery.

On the other hand, only a few images by any one photographer are extremely popular. These images command the highest prices and they are also the most numerous. Demand, not supply, is the usual governing factor of value. Witness the fact that Ansel Adams's *Moonrise, Hernandez, New Mexico*, which has set several records as the most expensive single modern image, is also the most printed image in the history of art photography, exceeding 900 copies, all made by him.

In fact, few dealers claim that limited editions enhance rarity. Rather, they justify the creation of limited editions as a practice that helps photographers enhance the asking price of their work. Many dealers, however, agree with Marcuse Pfeifer, a New York dealer particularly concerned with young photographers, who declares: "Limited editions have nothing to do with photography. You don't go into a darkroom and make an 'edition.' It's particularly a bad idea for younger photographers who still have only a few images that sell well. It's a bad idea to cut off their livelihood."

The vintage print

A concept that has become a cornerstone of the photography art market is the "vintage print." Vintage prints are those prints made closest to the time the picture was taken and the negative developed. The idea is that these prints represent better than later ones the original intention of the photographer. Most dealers and serious collectors would agree with collector Peter Coffeen that "photography is above all a timely medium. A print made in 1935 of an image taken in 1900 cannot be as true to the moment, as immediate in feeling as a vintage print." Thus vintage prints are considered the most desirable and command the highest prices.

Listed below are various types of prints, in order of descending value: those made by the photographer several years after the negative; those made by an assistant to the photographer but under his supervision; posthumous prints made by one of the photographer's trained assistants or by a

Photographers sometimes spend several days waiting for the desired light; sometimes a split second. Left: Edweard Muybridge is primarily known for his contributions to western landscape photography and for his motion studies. This lesser known photograph from his Central America and the Isthmus of Panama series, called *Old Panama Bridge Near the Beach*, 1876, shows his expertise with the medium and exemplifies his interest in achieving depth by exaggerating the distance between near and far objects. Note his use of reflection to increase the sense of depth and space. This albumen print is 5″ x 9⅓″. Below: *The Daughter of the Dancers*, 1933, by Mexican photographer Manuel Alvarez Bravo; silver and platinum print, 8″ x 10″. Both courtesy Witkin Gallery, New York.

master printer such as George Tice; and, last and least, posthumous prints made by a technician in a laboratory.

These are convenient categories of value that have been very helpful in organizing the photographic market around a valid principle. Clearly an original print by a nineteenth-century artist such as Frank Meadow Sutcliffe has a different esthetic quality from the modern reprints from his negatives made by W. Eglon Shaw. The categories are particularly applicable to artists such as Edward Weston or the members of the Photo-Secessionist group, photographers who were deeply concerned with the craft of printmaking.

But what is one to make of vintage prints by Brassaï or Henri Cartier-Bresson or any of the other master photojournalists who seldom did their own printing and whose work was intended for reproduction? Brassaï's most famous work was documenting the demimonde night life of Paris in the 1930s, and his prints from that time were made to be reproduced in his great book *Paris de nuit* as well as in other publications. He did not begin to make exhibition-quality prints until the 1970s.

Perhaps the most highly acclaimed photojournalist of all time is Henri Cartier-Bresson, whose work over the past four decades has been among the most influential. No one would deny his special genius, a genius that lies in his "camera vision"—in his ability to transform a momentary intersection of time and place into an image of formal eloquence with just a quick press of the camera button at precisely the right moment. He himself called it the "decisive moment," and it has nothing at all to do with the craft of printmaking.

Indeed, all of Cartier-Bresson's prints were made in commercial laboratories, and most of them were intended for reproduction in books or magazines. A few were made for rare early exhibitions and many of those are now yellowed with age. Today the photographer disavows all earlier prints and declares that only modern signed prints are a valid expression of his work. These prints, made in a good commercial labora-

tory in Paris, are priced at $1,200. Collectors must ask what they are paying for here. The images are exquisite, but is not the artist's *intention* realized equally well in a book or any other reproduction?

There is no agreement on this question. Some people find the modern prints to be entirely satisfactory and well worth their price. Some dealers feel that the most valid expression of the artist lies in the old prints intended for magazine reproduction, the kind of print originally acceptable to the photographer. Others of equal experience believe that prints made for reproduction have little esthetic value and therefore not much monetary value. They counsel less emphasis on the sanctity of the vintage print and more emphasis on the quality of the image and the rendering of the print.

More broadly important to the field of photography are the questions raised by the critic A. D. Coleman, who argues that such market definitions as the vintage print serve to restrict the photographer's right to reinterpret work at a later date.

"In terms of looking at an artist's work as a *body* of work," Coleman believes, "the viewer should be interested in the relation and changes in prints made at different times."

Growing commitment to the field

All these issues are very new, raised only in the last decade by photography's escalating position in the art world. None of the questions will be settled soon; some may never be laid to rest. What is certain is that the energy and interest generating these concerns will continue to grow.

One hundred and eighty galleries across the country now specialize in photographs. Light Gallery in New York City, the oldest and largest gallery dealing solely with contemporary work, is doubling its exhibition space. Gallery owners such as Marjorie Neikrug say they are seeing increasing numbers of people purchasing their first photograph. "Many of these are people who have already collected successfully in the other arts," says Neikrug. "They are people of discerning

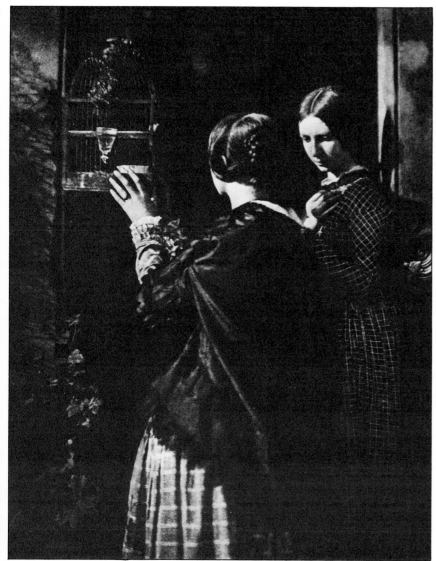

Opposite page: *Church facade near Rahway, New Jersey*, Wright Morris, 1940; silver print, 8" x 10". A writer and photographer, Morris was strongly influenced by the midwest where he was born. While his pictures never include people they poignantly bespeak the inhabitants of rural America. Courtesy Witkin-Berley Ltd. This page: both photographs are from Alfred Stieglitz's publication, *Camera Work*. The photogravure is a photomechanical printing process that gives prints of high quality by a chemical etching procedure from the original photograph. *The Bird Cage*, left, by David Hill and Robert Adamson, Scottish photographers of the mid 19th century, appeared as a gravure (6½" x 8½") in *Camera Work*, October 1909; but the original was a calotype dating from 1845. Above: *Still Life*, 1908, by Baron Adolf de Meyer; gravure, 8⅔" x 6½". Courtesy Witkin Gallery, New York.

taste who have done their homework and know what it is they want."

In addition, as Evelyn Strassberg of Light Gallery points out, "The universities are graduating more students knowledgeable about photography, who are creating a more sophisticated, appreciative audience." New histories are appearing, such as William Welling's *Photography in America: The Formative Years, 1839–1900* and Volker Kahmen's *The Art History of Photography*, among others. New centers at the universities of Arizona, New Mexico, and Texas have joined the George Eastman House in Rochester, New York, and the International Center of Photography in New York City as repositories for the work of eminent photographers who are retired or deceased. Dennis Longwell, now of the Marlborough Gallery in New York City, formerly of The Museum of Modern Art, stresses the vital need for more funds to allow these institutions to publish needed research and critical writing based on their extensive bodies of primary materials.

Despite these profitable efforts, it seems unlikely that photography will ever submit to the traditional parameters of the art history world. It is simply too diverse, expansive, and idiosyncratic a field. What John Szarkowski of The Museum of Modern Art wrote in 1973 is just as true today:

"Collectors of Roman coins or impressionist paintings know the satisfaction and the despair that come with the realization that their task might, at least in theory, be finally completed. . . . The collecting of photographs is a different and riskier sort of search, filled with mysteries and contradictions and unexpected adventures. Even photography's eternal verities are provisional, and its future is as unpredictable as that of any other living species. . . .

"It can be said with certainty only that photography has remained for a century and a quarter one of the most radical, instructive, disruptive, influential, problematic and astonishing phenomena of the modern epoch."

One might add, it is also one of the most rewarding and most beautiful. ■

Daguerreotypes

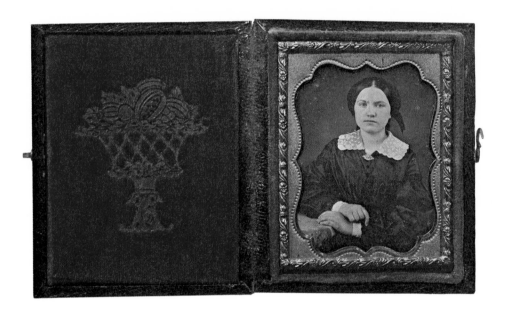

Although theories about photography had been in the air for years, Daguerre was among the first to succeed in permanently fixing an image in light on a surface.

BY CARLA DAVIDSON

An alchemist handing out his secret formula on street corners would scarcely attract more interest than did Louis J. M. Daguerre in 1839 when he announced that he had wrought a photograph.

"Is it possible," thundered a German thinker, "that God should have abandoned His eternal principles, and allowed a Frenchman in Paris to give to the world an invention of the devil? God created man in His own image and no man-made machine may fix the image of God." Contrariwise, a French journalist envisioned the new invention as "ruling the universe of matter in a dominion second only to the spontaneity of the Creator." To American Samuel F. B. Morse, inventor of the telegraph, Daguerre's contribution was simply "one of the most beautiful discoveries of the age."

Although theories about photography had been in the air for years, until Daguerre no one had found a way to fix a photographed image permanently upon a surface. (Joseph Niépce collaborated with Daguerre in this project but died

Because the slightest touch would mar the surface, daguerreotypes were often placed behind glass and fitted into a miniature case with silk or velvet lining. Above: *School teacher*, ca 1845, 2⅞ x 2⅜. Mysak/Studio 9, courtesy author's collection.

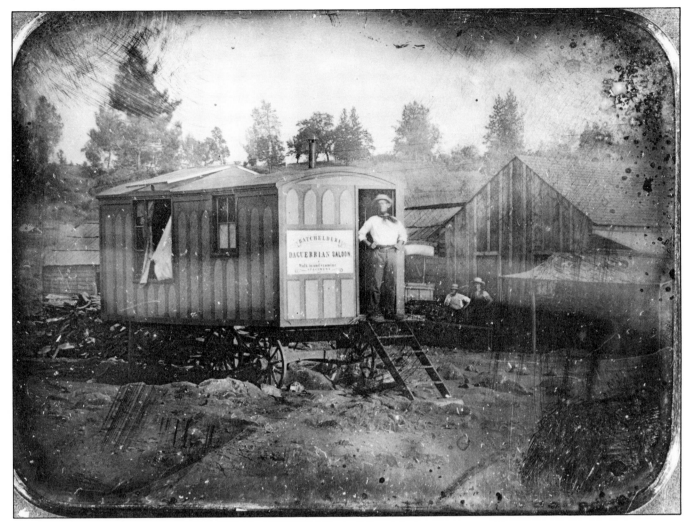

Perez Batchelder, an adverturesome daguerrian photographer, found this abandoned ship's house and cleverly converted it into a traveling studio. His assistant, Isaac Baker, stands proudly in the doorway, ca 1850. Courtesy Oakland Museum, History Division.

before the final stages of the process were discovered.) Forecasting the future of this development, Daguerre wrote, "By this process, without any idea of drawing, without any knowledge of chemistry and physics, it will be possible to take in a few minutes the most detailed views, the most picturesque scenery, for the manipulation is simple and does not demand any special knowledge."

Word of the new sensation traveled across the Atlantic by the first departing steamer, inspiring scores of would-be photographers to venture their savings on a studio, equipment, and a new profession. (Mercury and the materials and components necessary to make a daguerreotype were easily purchased locally through jewelers, and chemists.) Over the next decade, some took to the road in fitted-out wagons, drifting off across the plains, showing up in the smallest hamlets. They all found plenty of eager customers. Everywhere, Americans donned their best clothes, waited their turns in line, and submitted to an iron headrest, which would enable them to hold still for some thirty seconds (several minutes at the very beginning), while the photographer fiddled with the camera and the chemicals.

Thus, for the price of a dollar, an ordinary man could buy an image of his own face, without ever noticing that, reflected back in the mirrorlike surface, was the face of a nation: tough, innocent, optimistic, and proud—the portrait of America at mid-century.

The term *daguerreotype* is often mistakenly conferred on any early photograph, but it is the appearance of a silvery, reflecting surface that identifies this process. A silver-coated copper plate, one side sensitized by fumes of iodine, was exposed to light in the camera, then the image was developed in vapors of heated mercury. No negative was necessary or possible, making each picture one of a kind. As in a mirror, left and right were reversed and lettering would read backward. (Later, a prism in the camera corrected this flaw.)

Because the plate's surface was extremely sensitive to abrasion, and the silver to tarnishing, the slightest touch would mar the image. Thus the picture was protected behind glass, matted with a decorative metal frame, and fitted into a miniature case with silk or velvet lining. These accessories were often beautifully elaborate, and today some collectors are as interested in the decorative cases as in the photograph itself.

101

Millions of daguerreotypes were made in America, where the process was far more popular than in Europe.

Daguerreotype plates were manufactured in several standard sizes, from little more than an inch square to six or seven times as large.

Although a few photographers signed their work, identification is uncertain at best. For one thing, the signature is stamped on the easily interchanged case or mat; for another, the most well-known photographers employed assistants who are largely anonymous. When the photograph bears a signature, we have some idea, at least, of the studio in which it originated.

The Boston studio of Southworth and Hawes was responsible for work of extraordinarily high quality. The two partners, Albert Southworth and Josiah Johnson Hawes, photographed many famous Americans, taking special care with lighting, setting, and pose. The day that Massachusetts Chief Justice Lemuel Shaw strode into the studio, he stood for a moment under a skylight. As slanting light carved and stippled his monumental features, one of the two partners made a remarkable picture. It appears as ageless as the bust of a Roman senator, and as ephemeral as a flicker of sunlight.

It was not necessary to be a famous photographer or sitter to produce an engaging photograph. Some perfectly ordinary people projected a kind of star quality that was perfectly captured by the small lens of the camera. Although a name, a place, a date, and a history are missing from these portraits, they, too, are complete works of art.

Just ten years after Daguerre's announcement, a New York journalist observed, "If our children and children's children to the third or fourth generation are not in possession of portraits of their ancestors, it will be no fault of the Daguerreotypists of the present day; for verily they are limning faces at a rate that promises soon to make every man's house a Daguerrean gallery."

It is estimated that millions of daguerreotypes were made in America, where the process was far more popular than in Europe. It remained in use until the 1860s, when developments such as the glass-based ambrotype, tin-type, and glass-plate negative in rather quick succession rendered it obsolete. Over the years photography was simplified and popularized to the extent that it became commonplace. Images were glued into albums, stored in trunks, burned with the trash, and forgotten. It is only recently, with the corresponding burst of interest in all sorts of American artifacts from an earlier age, that daguerreotypes have become the object of serious attention by avid collectors.

This is apparent when newspapers report on fierce competition for important pictures, such as the payment of $14,000 for an early view of the Capitol building, or the theft of a $9,000 daguerreotype portrait of Edgar Allan Poe from a university library. Such pieces will continue to fetch top dollar, but at the bottom of the scale are the thousands of scratched

Top: Lemuel Shaw, by Southworth & Hawes, 1851. Courtesy The Metropolitan Museum of Art. Middle: Unknown man, ca 1845. Courtesy Mysak/Studio 9, author's collection. Bottom: Frederick Douglas, ca 1850. Courtesy Smithsonian Institution.

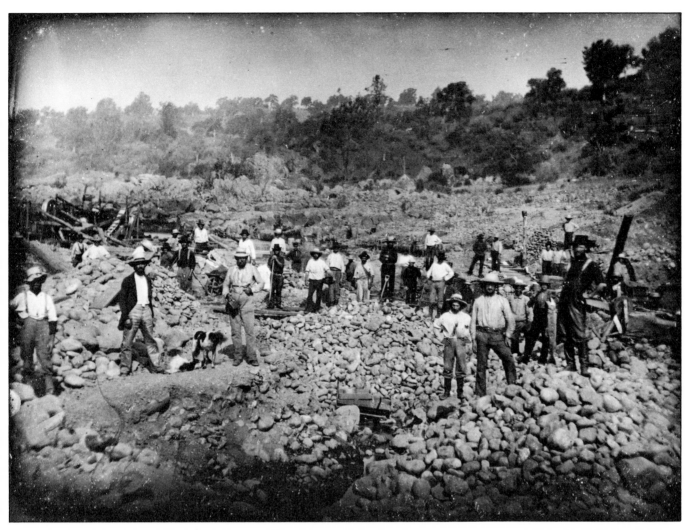

Opposite page: Daguerreian portraits were done in a primitive fashion, without the sophisticated aids of modern photography, but they produced some remarkable results. Albert Southworth and Josiah Johnson Hawes, who produced the top picture of Massachusetts Chief Justice Shaw, were famous for their bold and seemingly effortless portraits. Above: Placer mining, Hangtown, California, ca 1850. Apparently gold fever wasn't running very high when the photographer stopped by. This somber crew had no trouble holding their pose. Courtesy Bancroft Library, University of California, Berkeley.

Vanished Photographs

Like explorers for sunken gold, photographic collectors are drawn to legends of buried treasure. To date, no one is known to have turned up a daguerreotype of a New York City scene, despite the city's close association with the earliest history of photography in America. In 1840, according to contemporary newspaper accounts, Samuel Morse photographed and exhibited a view of City Hall. It has vanished without a trace. So have the original daguerrean city views used for copying by engravers of early illustrated magazines. Considering that New York was the photographer's mecca (in a single year, thirty-seven daguerrean galleries flourished on Broadway alone), considering that such views exist of most other American cities, this lack is baffling. It is only partially explained by such natural disasters as the 1852 fire that swept Edward An-

thony's National Daguerrean Gallery. Six years later the *American Journal of Photography* praised James Cady's unprecedented action shots of the city's bustling streets. These too are gone.

Seeking a more exotic landscape, a photographer named Eliphet Brown accompanied Perry on his 1853 trip to Japan. Brown was known to have made more than 200 daguerreotypes of this historic venture. Yet all that remains of his effort are the engravings illustrating the official report.

Hundreds of full-plate daguerreotypes of California life taken in 1849-50 by Robert Vance have also disappeared. They were safely carried to New York for an exhibit and later were seen in St. Louis, but there all traces end. A tantalizing printed catalogue survived. It lists such views as "Indians dressed for a dance," "View of Steamer *Confidence*," "A California theater," and "Miners at work at Gold Run."

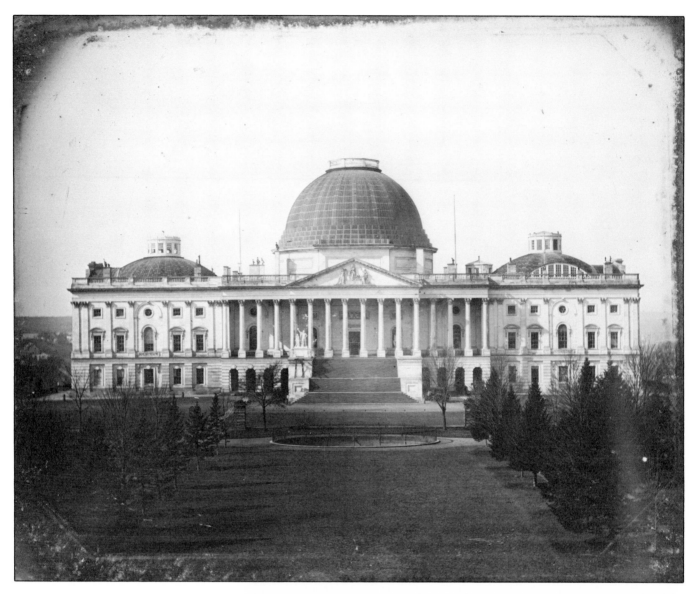

Above: This half plate daguerreotype of the Capitol, which is said to have been taken in 1846 by prominent daguerreian artist J.H. Plumbe, is one of a series of Washington views. Purchased for next to nothing at a San Francisco area flea market in 1972, it was later sold along with five others for $12,000. The five are the earliest known photographs of the Capitol. Courtesy Library of Congress. Right: Child's funerary portrait, ca 1850. Portraits of deceased children—often pictured as if asleep—were popular in the mid-19th century. Here the inclusion of a rosary gives further evidence that this child is dead. Opposite: Brass ensemble, ca 1850, 4½ x 5½. Subjects who posed with the tools of their trade, like these musicians, are rare and considered a valuable find. Both courtesy George Eastman House, Rochester, New York.

and tarnished portraits of unknown sitters, often the work of second-rate photographers, that can still be found for a few dollars at a local flea market. Between the two extremes stand other subjects especially interesting to collectors.

Because they so rarely turn up (and were never made in quantity to begin with), portraits of blacks, Indians, and Orientals are highly prized. Some buyers concentrate on a single category, such as babies and small children, whose tendency to wriggle could defeat the most experienced photographer. It is uncommon to find a good sharp picture of a child, probably because thirty seconds was too long for most little ones to stay still. If he or she is cradling a toy or pet, the price is much higher.

From the very beginning, no subject was off limits to the curious photographer. He made strangely peaceful portraits of the dead, as well as frank studies of nudes.

Among the most valued portraits are those in which the subject proudly poses with the tools or costume of his trade or hobby: a barber, nine members of a brass band, a blacksmith, a Mason wearing his symbolic apron.

Outdoors, technical problems were posed by variable conditions of light and movement. Such views as San Francisco's thriving waterfront, muddy streets and wooden shacks of the village that would become St. Paul, or a decorous militia muster on Boston Common are among the rarest finds and the most expensive.

Today a handful of photographers have turned back to the original techniques to make modern daguerreotypes. These are almost always signed, dated, and acknowledged as new, but the buyer must beware of the occasional forgery. A way to avoid such fakes is to suspect a picture that bears a relatively low price tag, say, a rare item such as a view of a California gold mine selling for a few hundred instead of a few thousand dollars. It is also wise to deal with established collectors and galleries. Located in many cities, shops specializing in "photographica" often do business across the country by mail-order catalgue. Vintage photographs are offered regularly at auction. Photographic historical societies publish newsletters, conduct sales, and generally provide the new collector with information on everything that is happening in the field, as well as the chance to trade information and pictures with other private collectors.

Master collections of daguerreotypes can be seen (often by appointment only) in Washington at the Library of Congress

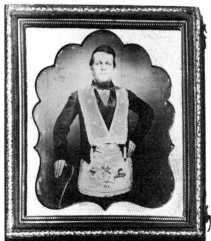

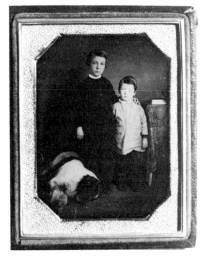

and at the National Portrait Gallery. Other collections appear at New York's Metropolitan Museum of Art, the International Museum of Photography at George Eastman House in Rochester, New York, the Museum of Fine Arts in Boston, the Chicago Historical Society, and the University of Texas at Austin, to name only a few. More sources and much helpful information can be found in books. Among the best are *The Daguerreotype in America* by Beaumont Newhall, *Collector's Guide to Nineteenth-Century Photographs* by William Welling, *Collection, Use, and Care of Historical Photographs* by Robert Weinstein and Larry Booth, *The Spirit of Fact* by Robert Sobieszek, and *Mirror Image* by Richard Rudisill.

Is it too late to begin a daguerreotype collection? The same question has been asked of Oriental rugs or tin toys. The answer is the same in all cases. Start modestly, learn along the way, and ultimately trade up. ■

The avid daguerreotype collector is always on the lookout for details which will increase a picture's value. For example, while portraits of children are rare, unusual details such as uncommon props, pets, or toys will increase the picture's worth. Above, top: Girl with doll, ca 1850, 2⅞ x 3⅜. Middle: Mason, ca 1850, 3¼ x 2¾. Bottom: Boys with dog, ca 1850, 4⅝ x 3¾. All Mysak/Studio 9, courtesy author's collection.

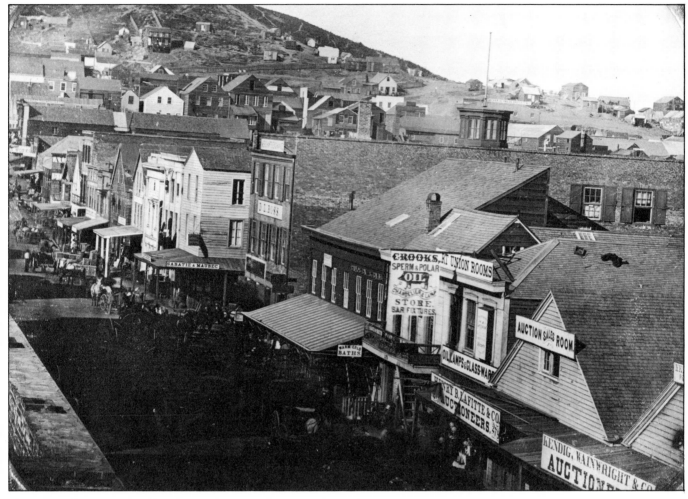

Shooting outdoors was especially tricky for the daguerrian photographer. As a result, outdoor scenes are rare. The above view of Montgomery Street in San Francisco by Fred Coombs, 1850, 4½ x 5½, is a great treasure. Note the clarity of the print: the tools a workman left on the roof across the street are clearly visible. Facing page: Valentine Denzer, circus artist, ca 1850. Both courtesy George Eastman House.

Discoveries

No matter what you collect or when you started, some old-timer will always be around to sigh about the really good days when you could have picked up those patchwork quilts, Tiffany shades, or whole-plate daguerreotypes for a song. The theme goes: "Attics full." "Shoeboxes full." "Take them all for dollar." "This stuff? I was just going down to the dump with it."

Despite the gloom, despite the rising prices, despite the mournful cry that there's nothing left to be found, percipience combined with luck still manages to yield up some treasure.

In 1972 a Californian picked up eight half-plate daguerreotypes of public buildings in an unidentified city for $28. They changed hands and the new owner learned that seven were 1846 views of Washington, D.C. by one of the best-known early photographers, John Plumbe, Jr. One turned out to be of a church in Cincinnati. For $12,000 the Library of Congress bought six of the Washington scenes, including such subjects as the partially completed Capitol, the White House, and the General Post Office. In early 1978 one of the original eight, a slightly different view of the Capitol, was sold to a private collector for $14,000, one of the highest prices ever paid for a single photograph of any kind.

Another remarkable find was stashed in the attic of Harvard University's Peabody Museum until 1976. In an unused storage cabinet, a staff member found 15 daguerreotypes of Southern slaves bearing the signature "J. T. Zealy, Photographer, Columbia." Starting with just this slender lead, her diligent research led her to conclude that the portraits were commissioned in 1850 by famed naturalist Louis Agassiz to bolster his theory of racial development. This is a major discovery, bringing to light some of the earliest portraits of Southern slaves, probably the first to be identified by name and plantation. Three even bear designations of the slave's African tribe or region.

Early British Landscape and Architectural Photography

The common aim that bound these photographers was their desire to render clearly details of architecture and topography. This ambition distinguished them from their colleagues who were more interested in art photography or pictorialism.

BY DIANE COCHRANE

AND ALAN KLOTZ

When Queen Victoria and Prince Albert opened the "Great Exhibition of the Works of Industry of All Nations" in 1851, England was preeminent in scientific and technological discoveries. The exhibition, the first of its kind to be held anywhere in the world, was housed in one of the masterpieces of 19th-century architecture—the Crystal Palace, a prefabricated glass and iron building, 1,848 feet long, 408 feet wide and 100 feet high. Thanks to an invention of immense consequence for modern experience—photography—pictures of this colossal greenhouse exist today, although the structure does not.

The Crystal Palace and its exhibits celebrated the industrial revolution; photography was a product of this revolution. The Crystal Palace paid homage to the British Empire and its commercial successes; photographs reported to the folks back home what the Empire looked like. The Crystal Palace stood for progress and national pride, well expressed in early pictures of distant feats of British engineering as well as nearby scenes of the verdant English countryside.

Compared to the sophisticated equipment and technology required to build the Crystal Palace, however, the camera was a relatively primitive affair. By 1839, the principles of photography were well established and in the following dec-

ade scientific know-how brought about major improvements in picture-making processes. Still, from 1850 until about 1880, when the widespread use of the gelatin dry-plate negative literally lightened the photographer's burden, it was necessary to transport dark tents, a variety of volatile chemicals and other impedimentia to on-site locations. Those who mastered this cumbersome technology capitalized on the medium's ability to describe in meticulous detail ancient ruins and brand-new buildings, exotic foreign landscapes and serene, domestic scenes.

These early 19th-century topographic photographs can be appreciated solely from a historical perspective, but the best of them are prized by collectors for their technical excellence and high level of artistic quality. The photographers, however, rarely attempted to make art. They were simply topographic cameramen, producing images perceived as records or as objects of study. Any aesthetic pleasure these early photographs give is, by and large, fortuitous.

The foremost early British topographic landscape and architecture photographers includes Francis Bedford, Samuel Bourne, Philip Henry Delamotte, William England, Roger Fenton, Francis Frith, James Robertson, John Thomson, James Valentine, and George Washington Wilson. (See box for biographical details.) These architectural and topographical photographers had a common aim: to render clearly the lay of the land, an ambition that set them apart from some of their colleagues. There are two major traditions in 19th century photography: art photography, or pictorialism as it is also called, and topographic photography. The pictorial tradition derives from the camera's ability to make a picture and the camera operator's desire to make art. The aesthetics of art photography have varied over the years, but the

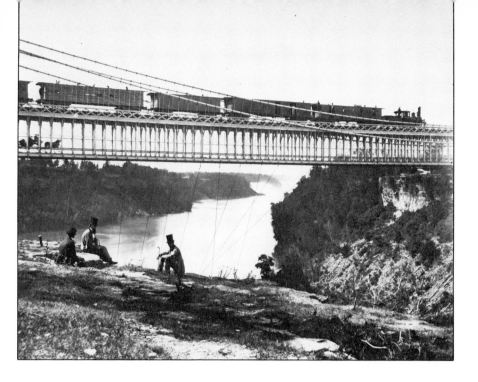

It was the goal of the early topographic photographer to provide as much detail as possible for the armchair traveler. In William England's *Niagara Suspension Bridge*, 1858, albumen print, 9½" x 11½" the viewer finds a group portrait, a magnificent bridge, a train, and a horse and buggy—all in one powerful composition. The Museum of Modern Art.

not men like the exgreengrocer, turned photographer, Francis Frith. Pyramids and palaces were not part of their everyday experience; the pleasure they took in these perceptions shows through in their pictures. By today's standards, the temple in Frith's *Koum Ombo* would be criticized as being too small, but he shot it as he saw it rising up out of the desert. Although the composition is not dramatic, the setting and Frith's awe create an exciting image.

The topographic photographers also tried to incorporate as many details as possible into their pictures. In *Niagara Suspension Bridge*, for example, William England captured a scenic wonder, a group portrait, a triumph of modern engineering, a railroad train, a horse and buggy, and held them together with his dynamic sense of composition.

The power and importance of the topographic photograph lay in its literalness. Scenes previously known through descriptions of travelers or exaggerated engravings or paintings were now regarded with suspicion by the Victorians because they believed only the photograph told the truth. At first, collectors of this truth-in-photography school belonged primarily to a small but sophisticated group of upper-class Englishmen led by Queen Victoria and Prince Albert, both avid amateur photographers. By the 1860s, however, a large middle-class audience developed an insatiable appetite for these pictures.

To satisfy the demand, commercial publishers, like the British art firms of Agnew's and Colnaghi's, went into the photography business and distributed prints by leading photographers. Some individual photographers also saw the market potential. Frith in England, and Valentine and Wilson in Scotland established their own firms. All employed staffs to photograph landscapes and architecture. (Frith's company, which became one of the largest photographic publishing firms in the world, continued to operate into the 20th century.) Photographs could be purchased individually or in albums. They were also tipped into books before photomechanically produced illustrations became commonplace in the early 1880s. Although topographic photography flourished in

prevalent notion of early pictorialists like O.G. Rejlander and Henry Peach Robinson, held that the world as is was too banal to be considered art. The function of art, they argued, was to elevate subject matter. It was the duty of the artist-photographer, therefore, to manipulate his subject matter—sometimes by chemical or mechanical means in the printing process—until it was transformed into art.

The topographic tradition, on the other hand, stems from the intrinsic ability of the camera to delineate and describe. In its pure form, the topographic photograph was clinically objective and to a great degree anonymous. If a building was the subject, the photographer showed how it fitted into the landscape. No attempt was made to tell viewers how it should be seen. The results might be intensely interesting compositions such as Robertson's *Great Mosque, Constantinople*, but they did not represent any manipulation of the subject. They were simply efforts to get the best architectural angle, not necessarily the most artistic.

There is, of course, a potential danger in such categorization. No topographic photograph is totally devoid of artistic merit, just as no "purely artistic" photograph fails to render at least some objective data about its subject. Certainly the celebrated late 19th-century art photographer Frederick H. Evans provided much information in his architectural photographs.

But the difference between artistic and topographic photography persists. Evans saw buildings in terms of space and light, evoking an interpretation through the use of chiaroscuro. Roger Fenton, on the other hand, emphasized the *chiaro*, not the *oscuro*, to illustrate the integrity of the subject. Evans's point of view was poetic, Fenton's factual. Fenton exhibited a keen perception of architecture, and his pictures capture such sublety as the correlation of a church door's proportions to those of an adjacent window.

These early photographers brought a fresh eye to their craft. They were entranced with the camera's amazing ability to control perspective and to focus on the tiniest details of exotic scenes, a world many had never seen before, certainly

Among the technological wonders celebrated at the Crystal Palace exhibition of 1851 was photography. Appropriately enough, it was the camera, and primarily the work of the official photographer for the exhibition, Philip Henry Delamotte, that best documented the spectacular technological feat of the palace itself. The view below, called *The Centre Transcept from the Garden*, albumen print, 9⅛″ x 11⅛″, was originally made in 1851, and later appeared in the *Photographic Views of the Progress of the Crystal Palace, Sydenham, Taken During the Progress of the Works, by the Desire of the Directors*, 1855. The Corning Museum of Glass.

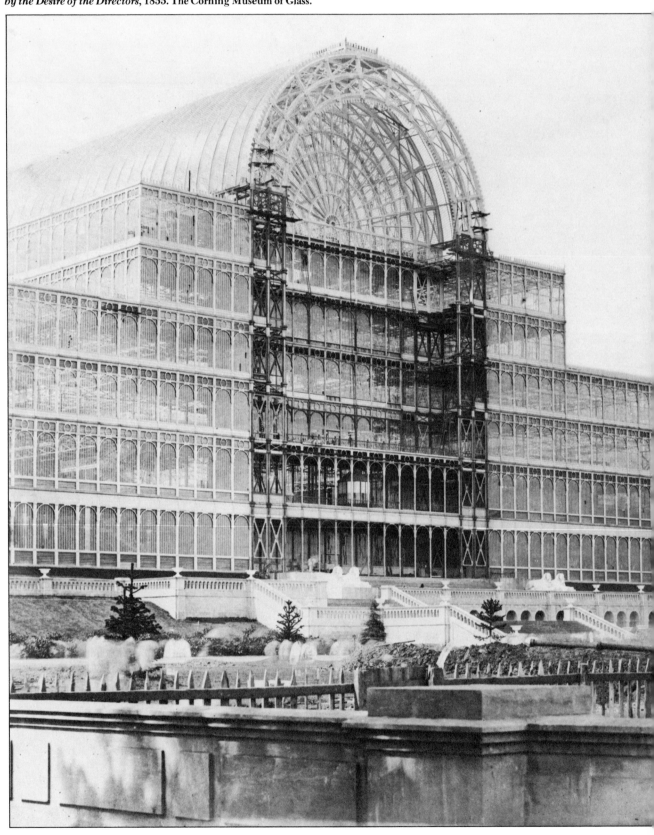

William Fox Talbot's *The Tomb of Sir Walter Scott*, above, ca 1848, is an example of the early calotype process, which lent itself to softedged and romantic works. Because the photographic image is produced by chemical salts embedded within the print paper itself, the calotype print often has a grainy or misty appearance.

most industrialized countries during this period, only in Britain were such pictures printed and distributed on such a vast scale.

As photography became big business, market pressures created a change in the topographic tradition. While the public still demanded precise accuracy, an element of lyricism crept in. The photographer shifted from showing just "what's there" to a somewhat more commercial approach of "what the public might like to think is there." Bedford and Frith's later landscapes are more scenic than their earlier ones, particularly their Holy Land pictures, while Valentine and Wilson very obviously romanticized their subjects. Despite this desire to please their audience, the clarity of their presentation along with an anonymity of style kept all within the topographic tradition.

Since thousands upon thousands of photographs were printed during the last half of the 19th century, one might think that picture taking was a simple process. In fact, its technical development was complex.

Unlike other English triumphs exhibited in the Crystal Palace, photography could not be attributed solely to the inventiveness of the Anglo-Saxon mind. England and France simultaneously produced photographic pioneers. As early as 1826, a provincial Frenchman, J. Nicéphore Niépce, made the world's earliest surviving photograph by a process he called heliography, exposing a plate of polished pewter, coated with Bitumen of Judea, to light. After Niépce died, his partner, Louis J.M. Daguerre developed a different method of capturing an image on a light-sensitive plate of silvered copper. Daguerre's process was made public in 1839. It became an instant sensation because of the breathtaking clarity of the images. Remarkable though the daguerreotype was, it had an enormous disadvantage: each picture was a one-of-a-kind item.

Across the Channel, gentleman-scholar William H. Fox Talbot was conducting equally important research. Experi-

menting with silver salts on writing paper, he was able to fix images directly on the paper. He presented his findings on these "salt prints" to the Royal Society in 1839. In 1841, Talbot perfected the calotype process which produced a paper negative that could be printed in duplicate. The calotype image, formed as it was by the action of light on sensitive salts embedded within the paper itself, had a somewhat grainy appearance that was matte and soft in comparison with the sharp, shiny mirrored image of the daguerreotype.

In 1851, L.D. Blanquart-Evrard introduced a paper coated with albumen (egg white) and made light-sensitive by immersion in a silver nitrate solution. Albumen prints soon became popular and they dominated the industry for the next 40 years. Distinguished by a rich, glossy purple brown tone fixed in the albumen layer on the surface of the stock, albumen prints could be produced from various types of negatives, including the paper calotype or the newer collodion negative.

The collodion wet-plate technique, perfected by the Englishman F. Scott Archer in 1851, was a negative-producing process that revolutionized photography. It afforded prints of unparalleled clarity and tonal range. This process was the preferred one until the 1880s, when dry-plate gelatin negatives came into use. However, it was not simple to make a collodion negative. Glass plates had to be evenly and carefully coated with the volatile collodion emulsion and silver nitrate, then exposed in a camera and developed before the plate could dry out. The difficulty of coping with the smelly, dangerously explosive collodion process and the cumbersome equipment it entailed was especially great for landscape and architecture photographers, who often traveled abroad to in-

hospitable climates and treacherous locations. Just getting there was half the battle. Entire darkrooms with cameras, tripods, jars of distilled water, unstable chemicals, scales and funnels had to be transported. Arriving with the thick glass plates intact was a considerable feat. Other supplies might not arrive at all. The Pacific & Orient steamship line to India, for example, refused to transport collodion because its active ingredient was the explosive ingredient of smokeless gunpowder.

Hazardous conditions threatened more than just equipment and supplies. Intrepid photographers like Samuel Bourne, who scaled the Himalayas with an army of bearers, courted disaster in the traditional manner of the English adventurer:

> One false step, one little slip, and I should have found myself in eternity the next moment. . . . How my coolies with their heavy loads, some of them unwieldly things like tentpoles, even contrived to get safely over the five miles of walking on a ledge, instant death staring them in the face at every step, remains a profound mystery to me at this day.

Moreover, the photographer was chained to the darkroom since the entire picture-taking process had to be completed before the collodion emulsion dried on the glass plates. Studio photographers may have found this a minor discomfort, but those in the field encountered hardships bordering on the intolerable. Roger Fenton, who chronicled the Crimean War by touring the combat areas in a horse-drawn van that served not only as a darkroom but also as his cooking, living, and sleeping quarters, lamented, "When my van door is closed, perspiration is running down my face and dropping off me like tears. . . . The developing water is so hot that I can hardly

Leading early British landscape and architecture photographers

Francis Bedford (1816–1894): With Roger Fenton, he founded the Royal Photographic Society of Great Britain. He accompanied the Prince of Wales on a tour of the Holy Land in 1862 at the request of Victoria and Albert. Pictures from the trip were published in a book entitled *The Holy Land, Egypt, Constantinople, Athens, Etc.* He is famous for the beauty and clarity of his English landscapes and cathedrals.

Samuel Bourne (1834–1912): Took up photography in the mid-1850s before moving to Calcutta where he set up the commercial studio of Bourne and Shepherd. As one of the earliest mountain photographers, he made several expeditions in the Himalayas and in 1866 took photographs at the highest recorded elevation—18,600 feet. He returned to England in 1872.

Philip Henry Delamotte (1820–1889): As the official photographer for the Crystal Palace Company, he documented the building of the structure in Hyde Park and its razing and removal to Sydenham for a new opening in 1854. An artist as well as an early calotypist, in 1854 he

organized the first exhibition in which photographs were displayed as an art form together with paintings and drawings.

William England (d. 1896): Another early photographer, England started out as a daguerreotypist. In the 1850s he switched over to the wet plate process and as an employee of the London Stereoscopic Company, took landscapes and architectural photographs in Ireland, the United States, and France. After he left the company in the early 1860s he specialized primarily in the alpine views for which he is best known.

Roger Fenton (1819–1869): Considered by many the greatest of the early English photographers, Fenton enjoyed a brief but varied career. Before taking up the camera in the late 1840s, he studied art and law. In 1852 he went to Russia to photograph the building of a suspension bridge by an English engineer, and during the Crimean War in 1855 became the first war photographer. Fenton also took a large series of photographs of art treasures for the Trustees of the British Museum, and portraits of the Royal family, as well as many English cathedrals and land-

Although he became more of a romantic over the years, Francis Frith's early and finest work—as shown above left in *Koum, Ombo*, 1857, albumen print 6″ x 8″—expresses the early typographical photographers' awe at the impressive architectural sites of the Middle East. Sensing the commercial market for such views at home, Frith started one of the most successful photographic publishing firms, Francis Frith & Company, upon return from his travels in 1860. Private collection; photo Mysak/Studio Nine. John Thomson was noted for the pictures he took in the Far East; his work was published in several books. The *Chinese Tower*, above right, originally an albumen print, was reproduced in photogravure in *Illustrations of China and Its People*, a four-volume work published in 1873. Courtesy Daniel Wolf Gallery, New York; photo Melvin Adelglass.

bear my hands in it."

Much time was involved in unpacking and repacking the equipment. A dark tent could be erected at a vantage point midway between two or three shooting locations, but it was never safe to carry the sensitized plate a greater distance than a few minutes walk. Progress was slow; the man who could bring back as many as six pictures after a day's work was lucky.

At this time, all pictures were contact-printed and therefore the same size as the glass plate negatives. The professional had to carry several cameras, as well as the fragile large plates. On his Nile excursions, Frith took three cameras: one for stereoscopic views, one for 8 by 10 inch plates, and one for 16 by 20 inch mammoth plates. Prints made from large-scale negatives under difficult conditions are generally highly prized by today's collectors. ■

scapes. In 1862 he abandoned photography and returned to the practice of law.

Francis Frith (1822–1898): Frith's career was as diverse as Fenton's. He started out as a greengrocer, moved on to set up a printing company, and finally became a professional photographer in 1856. His finest works are the fruits of three tours to the Mideast between 1856 and 1860. On the third trip he traveled 1,500 miles up the Nile, farther than any other photographer. On his return he established Francis Frith & Company, a photographic publishing firm, and decided to photograph the architecture and landscape of as many cities, towns and villages in England, Scotland, Wales, and Ireland as he could. Later he covered a number of European locales. All told, he took over 60,000 pictures between 1856 and 1898.

James Robertson (dates unknown): While chief engraver of the Imperial Mint of Constantinople, Robertson shot many views of that city as well as of Malta and Athens. Then, after Fenton left the Crimea, Robertson took his place. Following this, he served as an official British photographer in India during the 1857 Bengal/Sepoy mutiny.

John Thomson (1836–1921): The reputation of this Scotsman, who traveled widely in the Far East in the 1860s and 1870s, rests primarily on photographs that appear in three books: *The Antiquities of Cambodia, Illustrations of China and Its People,* and *Street Life in London.* He is best remembered for depictions of people and their customs, but his photographs of landscapes and buildings are also superb.

James Valentine (d. 1880): This lithographer and amateur photographer founded Scotland's largest photographic company in Dundee in 1880, the year of his death. The firm was carried on by two sons, George D. and W.D. along with several staff photographers. Therefore, none of the photographs initialed JV can be attributed to any single person. The firm specialized in resorts and idyllic scenes of rural and suburban life.

George Washington Wilson (1823–93). Like most of the other photographers mentioned here, Wilson was a commercial photographer. In his three printing establishments he kept over 1,700 different views in stock of English and Scottish cities, castles, cathedrals, lakes, mountains, and seascapes for tourists and armchair travelers. Among his clients Wilson counted Queen Victoria from whom he had a standing order "to furnish her with copies of the views which he may take." Highly skilled in the technique of photography, he wrote *A Practical Guide to the Collodion Process in Photography* in 1855.

Western Landscape Photography

Part explorer and part artist, these adventuresome photographers dragged their cumbersome equipment on muleback into some of the most inaccessible territory in this country.

BY BONNIE BARRETT STRETCH

For those of us whose vision of Western landscape derives from picture postcards and John Wayne movies, or from the grand paintings of Albert Bierstadt and Thomas Moran, the works of the classic 19th-century Western landscape photographers require a major adjustment of sensibility, a quality of attention we seldom devote to the familiar spectacle of our West. These tough, impassive, mauve gray photographs are not familiar images; they are not intimate or human centered, with an easy emotional appeal. Rather, they carry the sense of a naked authenticity—no melodrama, no romanticism, no sentiment, only the thing itself, seen steadily and whole.

While the quietistic mood and the rich luminosity of many of these photographs recall the romantic and pastoral modes of European landscape painting, their architectural composition, sharpness of detail, and clarity of structure evoke a completely fresh esthetic. It is an astringent vision of the land in which the eye of the scientist/geologist/explorer is coupled perfectly with the eye of the artist. Behind the desire for clarity and detail lies a profound reverence for nature as a "vessel" of spiritual meaning. It was this sensibility that motivated the artistic struggle for the right viewpoint, the right light, the right exposure that would reveal the complexities of the natural scene as necessary parts of a universal whole.

The period from 1860 to 1885 has been called the "golden age of landscape photography," and art collectors, dealers, curators, and critics who have immersed themselves in this genre have declared it one of the most important and original aspects of 19th-century American art. While the land, and particularly the Western landscape, has always held a special fascination for the American imagination, only a handful of artists—painters or photographers—undertook the challenge of working in a rugged, ungiving wilderness far from the conveniences of human civilization. This was virgin land, physically and esthetically. There were no familiar motifs here, no established viewpoints, no artistic modes and traditions to preshape the vision. Particularly for the photographer, it was a wholly new experience, an opportunity to shake the traditions of Europe and the East Coast, and to experience and capture the grandeur of the continent with a vision as fresh and original as the landscape itself.

The freshness of expression was enhanced by the advances in photographic technology that occurred simultaneously with the opening of the West. The perfection in the late 1850s of the wet-plate negative process permitted for the first time the creation of large, detailed works outdoors, works

Carleton E. Watkins was the first American photographer to record wilderness settings with deliberate, artistic intentions. In 1867 he established the Yosemite Art Gallery in San Francisco to exhibit his work. Weston Naef, author of *Era of Exploration*, described Watkins' photographs as "the embodiment of divine perfection." Right: *Mirror View, El Capitan, Yosemite Park, California*, ca 1866. Daniel Wolf Gallery.

William H. Jackson lugged 100 pounds of equipment up the steep trail of Notch Mountain in order to get the precise angle he wanted for his famous shot of the Mountain of the Holy Cross. His dedication was typical of many of the Western landscape photographers. Below: *Mountain of the Holy Cross*, Colorado, 1873. Academy of Natural Sciences, Philadelphia. Right. *Saquache Range* from Mt. Ouray by William H. Jackson, ca 1880. Daniel Wolf Gallery.

After viewing Jackson's striking photograph, Longfellow was moved to compose his poem, "The Cross of Snow."

that could also be reproduced and distributed to a wide audience. (This process is described later in greater detail.) The earlier daguerreotypes, being one-of-a-kind, delicate, and too tricky to handle in the glare of outdoor light, were really a cabinet art best used for portraiture. The primitive calotypes, while furnishing a negative, could not produce the necessary crispness of detail and informing tonal range. The new wet-plate process, although cumbersome and complex, provided the photographers the first practical means to capture the magnitude of scale and the awesome depth of field before

them with a precision and subtlety that has seldom been matched. Working often with enormous apparatuses that could accommodate a glass negative of up to 20 by 24 inches (there was no satisfactory enlarging process), the Western photographers strove for images that could match their insights. Their mammoth-plate pictures were intended to hang on the wall and receive the same serious attention as paintings. They took their unwieldy equipment to the tops of mountains, over the edges of precipices, and down wild rivers to meet the demands of their subject matter and their expanding artistic perceptions.

There were only a dozen or so men who made these efforts, and, to rely on Weston Naef's *Era of Exploration*, the most thorough study of the genre to date, only five of these photographers completed a large body of artistically distinguished work that has survived to this day.

Of these artists, Carleton E. Watkins was the first, working alone and with no esthetic precedent. His journey into Yosemite Valley in 1861 marked the beginning of a career dedicated to penetrating artistically the Western wilderness and furnished the first group of significant landscape photographs of the American West. Watkins was followed within a few years by the Englishman Eadweard Muybridge. While there were many other photographers working the spectacular West Coast scenery for photographs to sell to a commercial public, these two men took a conscious artistic stance toward their subject matter that made the quality and intention of their work unique. They copyrighted and dated their images and sought artistic acclaim as well as commercial success. Watkins submitted some large-plate photographs to the Paris Exposition in 1868 and won international recognition along with a bronze medal. Muybridge's images met with equal success at the 1874 Vienna International Exposition.

Both men worked with the difficult mammoth-plate equipment as well as with smaller formats, and covered much of the same territory, sometimes working from almost the same camera stance. But the works of the two artists, taken as a whole, reflect distinctly different attitudes and styles. Muybridge was much more the romanticist, seeking viewpoints that enhanced the drama of a site, selecting brilliant light effects and emphasizing extremes of space, shape, and distance. Watkins's esthetic was more classical, seeking norms rather than extremes and concentrating on revealing the essential harmony of nature, balancing the many and complex elements into a perfectly articulated whole. As Naef put it, Watkins's work depicts nature as "the embodiment of a divine perfection," while "for Muybridge, nature was a series of juxtaposed paradoxes."

The work of Watkins and Muybridge was seminal to the later work of Andrew Joseph Russell, Timothy H. O'Sullivan, and William Henry Jackson. Both Russell and O'Sullivan were Civil War photographers who went West when the war ended. Russell became the official photographer for the

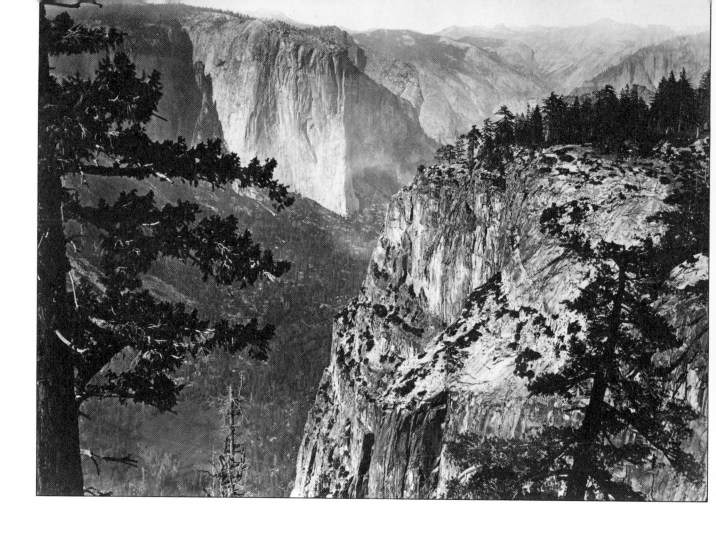

Union Pacific Railroad in 1868, and his work presents strongly composed visualizations of his threefold theme of man, machine, and nature. In 1867 Congress appropriated money to finance the geological exploration of the Fortieth Parallel, the first of the great surveys of the geography and mineral resources of the West. Clarence King, leader of the survey, took along O'Sullivan to visually record the extraordinary territory between the front range of the Rocky Mountains and the Sierra Nevadas. F. V. Hayden, organizing an expedition in 1870, followed King's example and hired W. H. Jackson to photograph with his team.

While moving with the survey, the photographers were free to seek out their own choice of subjects and manner of presentation. It was a unique opportunity to explore an untouched territory that would not be seen by another white man for ten more years. Aware of the pioneering aspect of their work, the photographers took great care with their images, intending them to stand as esthetic creations, not just ephemeral records. O'Sullivan in particular developed an original vision. In his photographs, light becomes a structural, rather than a dramatic, element, and the sense of extreme scale serves to convey a feeling of underlying formal and geologic order. An image such as *Vermillion Creek Canyon,*

Utah startles the modern eye by seeming to look forward a hundred years to the abstract vision of a Robert Motherwell or Mark Rothko.

If you doubt the artistic drive of these photographers, ponder what else led them to drag a ton of equipment on muleback into the most grueling kind of territory. They had to carry cameras of many different sizes, glass plates for negatives, plateholders, and tripod; and the wet-plate process demanded a fully equipped dark-tent on the scene, as well. The dark-tent, which collapsed into a box the size of a large suitcase, was big enough, when fully set up, for the photographer to get his upper body inside, while daylight was excluded by a canvas light trap. In addition, chemicals for coating, sensitizing, developing, and fixing had to be transported, as well as drying trays and containers of water, which was not always available on the scene. Missing was a light meter, which did not yet exist. The photographer judged the exposure time from his experience and simply removed the lens cap for a period of a few seconds to several minutes, replacing the cap when the precise time had elapsed.

Making the perfect negative required immense perseverance and dexterity, especially when the plates reached mam-

118

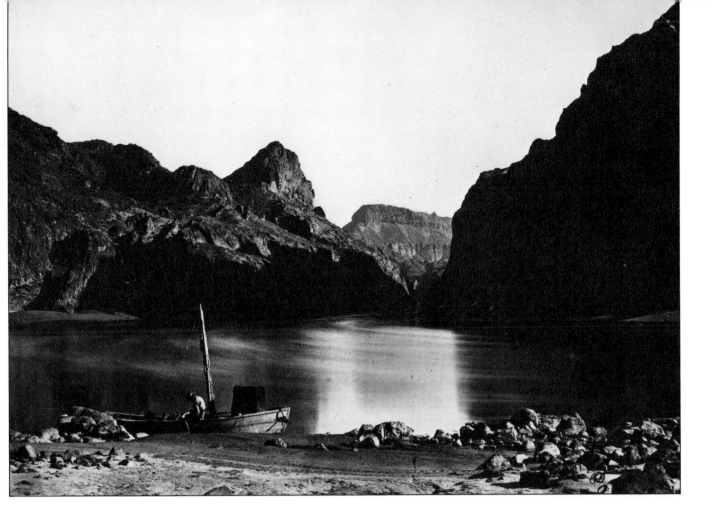

Above: *Black Canyon, Colorado River*, by Timothy H. O'Sullivan,
1871. O'Sullivan's painstakingly composed pictures gave tremendous
impact to the stark terrain. In this photo the river is blurred to a sheen
by the slow exposure. Daniel Wolf Gallery.

moth size. A chemical called *collodion* had to be poured onto
the clean glass plate and made to flow evenly over the sur-
face, with the excess pouring back into the bottle. When the
coating turned tacky, the plate was plunged into a bath of sil-
ver nitrate to sensitize it. The still wet plate was then loaded
into a lightproof plateholder and rushed to the camera. Any
drying destroyed the light sensitivity. Immediately after ex-
posure, the plate was rushed back to the dark-tent, devel-
oped, washed, and fixed. If successful, the photographer was
rewarded for all this labor with a negative rendering the
crispest detail and a full range of tones that seemed to capture
the glow of light itself.

All this occurred only after the desired viewpoint had been
obtained, which might require being lowered over a cliff on
ropes or scrambling to some of the highest peaks on the conti-
nent. William H. Jackson's efforts to photograph the Moun-
tain of the Holy Cross were not unusual. The 14,000-foot
peak was legendary because under certain weather condi-
tions snow filled the crevices at its summit to etch a perfect
cross. Jackson first saw it through binoculars at too great a dis-
tance to photograph. Further exploration led him to believe
that his best camera stance would be the summit of Notch

Mountain, northeast of the Holy Cross, at approximately the
same elevation. The ascent was rough, the trail so steep and
overgrown with brush that pack animals could not be used for
the last 1,500 feet. Three men lugged 100 pounds of equip-
ment to the peak. Before noon, Jackson exposed eight plates—
one with the 11-by-14-inch camera, the others with the 5-by-
8—and processed them on the spot.

The survey photographs were the first views most Ameri-
cans beheld of the Western half of their nation. Buried in ar-
chives, ignored and lost over the last 70 to 80 years, they were
acknowledged works of art in their day. O'Sullivan's pictures
from King's and other surveys were bound into special lim-
ited edition albums and circulated to a few key congressmen
who controlled the financing of the surveys. Jackson's images
of Yellowstone were instrumental in establishing Yellowstone
as the first National Park. His photograph of the Mountain of
the Holy Cross led Henry Wadsworth Longfellow to write his
poem "The Cross of Snow," which memorialized the striking
symbolism of the mountain.

Today these images are again being recognized for their ar-
tistic as well as their historical value. In 1975, The Metropoli-
tan Museum of Art exhibited "The Era of Exploration: The
Rise of Landscape Photography in the American West,

119

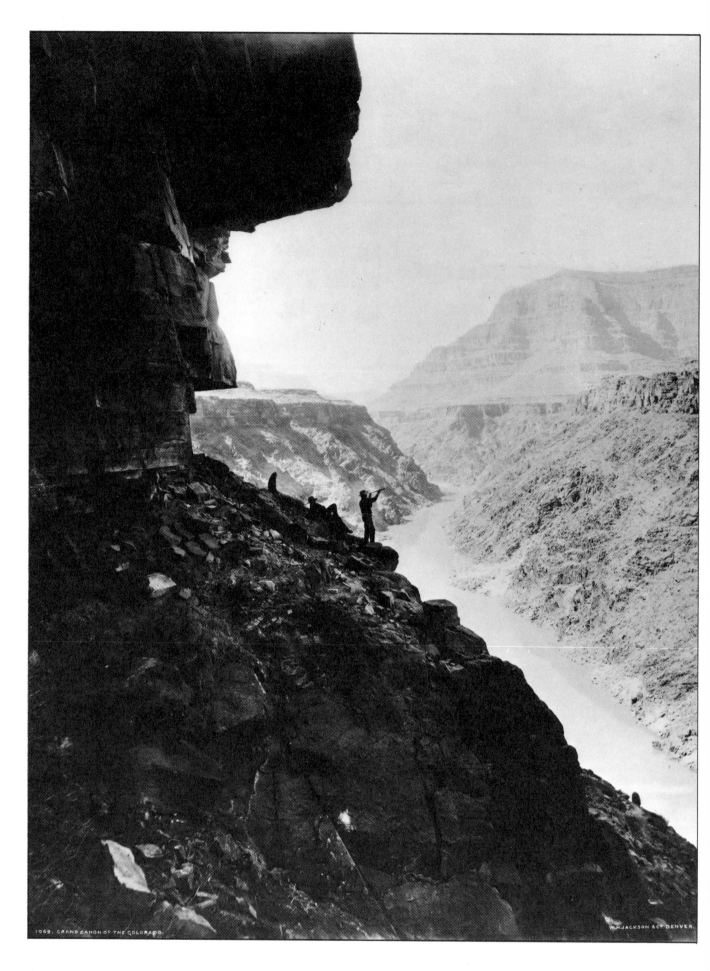

1069. GRAND CANON OF THE COLORADO.

W.H. JACKSON & C? DENVER.

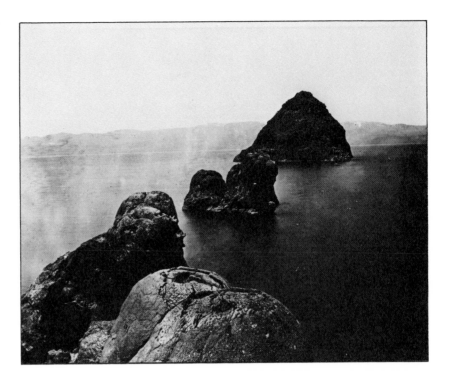

1860–1885," which brought together an unprecedented number of works representing most of the important achievements of the period and genre. Since that time, photographic dealers and collectors across the country have been seeking these images, usually to round out a wide-ranging collection, occasionally to develop an in-depth specialty collection.

John Coplans, former director of the Akron (Ohio) Art Institute, has compiled the most complete specialty collection by a private collector. He has focused on Watkins, believing him to be a seminal figure not only in the history of photography but in the history of painting as well. "Watkins was the exemplar," he says, "the major artistic sensibility" among the early photographers. His influence, Coplans believes, indirectly affected the movements in Europe toward abstraction and futurist painting.

The commercial value of these American landscape photographs seems certain to climb as the number in circulation grows fewer. Already it is extremely difficult to obtain excellent mammoth-plate prints.

Unmounted prints are the most difficult to obtain, for most prints were created for albums or for commercial publishers, who put them on their own stamped mounts. The condition of prints is critically affected by the quality of the paper on which they were mounted, the glue that was used, and the frame they were kept in. Problems of fading, emulsion cracks, torn mounts or prints, foxing (discoloration caused by the chemical reaction between the print and its mounting paper), and glue stains are pervasive. The wondrous size of these prints and the luminosity that emanates from one in first-rate condition make them unique in the annals of photographic art.

The remarkable fact is that, properly preserved, the gold-toned albumen print can project the same brilliance that was so moving a hundred years ago. On delicately thin paper coated with egg albumen that gives a slightly lustrous surface, the prints achieved their richness through the final toning process that rendered them a deep sepia or chocolate brown. This chemical process using gold brought out the luminosity and detail captured in the negative and gave the print a seemingly infinite durability.

The esthetic quality of these images seems equally durable. The popularity of landscape as a genre and the rebirth in recent years of a national awareness of the value of unspoiled nature seem to guarantee these images a permanent place in our visual education as photography expands as an acknowledged fine art. Scholarship on photography's critical role in the broader history of the arts cannot overlook these works. Some consider these images among the avant-garde of American 19th-century art.

In their esthetic richness and historic importance, the works of the 19th-century landscape photographers are unique. In them is a special blend of technological actuality and a feeling for the sublime that we will not likely see again. They derive from a moment in history when artistic ends and scientific goals coincided, when men found science and art compatible means to enhance man's understanding of God. In today's world where science and art have taken opposing directions, these images offer a strange sense of stasis, an insight into that brief moment before technological advance was put to the service of exploitative industry, when it served instead to help capture for all time the vision held by men who believed nature to be something hold. ■

The Pictorial Movement in Photography

Pictorialist photographers in Europe and America sought the spiritual, not the specific; the transcendent, not the transient. They lifted photography from literalism into the realm of interpretation and poetic meaning.

BY BONNIE BARRETT STRETCH

The pictorial movement in photography blossomed in the decades surrounding the turn of the century. It included vast numbers of amateurs and professionals from two continents. Yet it is one of the most complex and least understood periods in the history of the medium. Disparaged and ignored for the past fifty years, the movement is now being recognized as the turning point that formed the basis for modern art photography.

Although a great deal has been written about the leading photographers of the time—especially about Alfred Stieglitz and the members of the Photo-Secession—the true dimensions of the movement's aesthetic and cultural setting have yet to be fully examined. But today a major reassessment is beginning and a search for the hundreds of artists and works so long neglected or forgotten is underway.

Pictorialism was a movement that began in the mid-1880s with a sophisticated group of amateurs in England and Europe, and ended in the mid-1930s in the hands of populists and professionals in middle America. Its styles and intentions have been denounced as the worst kind of sentiment and fakery; yet the central figures in the movement were among the greatest artists the medium has known—artists who created some of photography's most enduring bodies of work. International in scope, the movement lasted for nearly half a century, involved thousands of photographers, and was supported by a vast system of clubs, salons and periodicals.

By the mid-1880s, photography was a medium stagnating in the commercial uses and conventions of earlier decades. The annual exhibitions or salons in the major European cities served much the same purposes as the Academy exhibitions in the other arts. The emphasis was on technique, equipment, and providing a forum for professionals to drum up business for their studios. A number of artistically inclined amateurs set out to change this situation and to transform photography into a significant medium of fine art. They believed that their amateur status freed them from the conformities of the marketplace and allowed them to pursue their art from a sense of love and inner need. Imbued with the romantic sensibility of the period this "new school of photographers" rejected the sharp-focus documentary aesthetic of the previous generation. The albumen prints of the 1850s and 1860s, which had captured landscapes, architecture, and people in almost reverently rich detail, were dismissed by them as mechanical, unfeeling, and actually ugly. The amateurs' concern was to

The Photo-Pictorialists of Buffalo formed one of the most prominent photography clubs of the pictorialist period. Examples from three artists in the club are shown here: Wilbur H. Porterfield (above, *Homeward*, ca. 1900), Charlotte S. Albright (far left, untitled, ca. 1906) and Augustus J. Thibaudeau (left, *The Lonely Pine Tree*, ca. 1908), who were all once internationally renowned. Courtesy Albright-Knox Art Gallery, Buffalo, New York.

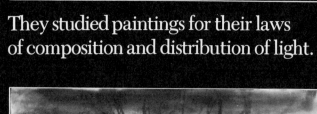

They studied paintings for their laws
of composition and distribution of light.

convey not what they saw but what they felt.

The Vienna Salon of 1891, sponsored by the Viennese Camera Club, was the first to show how far the amateur movement had come in a few short years. Unlike traditional salons such as that held annually at Pall Mall in London by the Royal Photographic Society, the Vienna Salon eschewed all prizes and awards and aimed to present, through rigorous jury selection, only the finest work by the best photographers throughout Europe.

A year later a group of five leading photographers in London broke with the Royal Photographic Society to establish their own organization called The Brotherhood of the Linked Ring, an elite group of the best photographers of all nationalities. Its annual London Salon would offer no prizes or medals; acceptance into the exclusive circle of exhibitors was to be honor enough. In 1893, French photographers followed the English lead, breaking with the Société Francaise de Photographie to form the Photo-Club de Paris, modeled on the principles of the Linked Ring.

Commitment to personal expression

The commitment was to Art and to what Art meant in the world of the 1890s. It was a time of deep unrest. Responding to the sense of cultural disintegration brought on by the accelerating industrial revolution, artists were rejecting the ancient heroic themes and classical styles of the European art academies for a more personal exploration of light, form, color, line, and space. Personal expression became the paramount goal of artistic effort: The Impressionists, Post-Impressionists, and Symbolists explored new ways of achieving it.

It was in this environment that photography sought recognition as a significant medium of fine art. Because the medium was scarcely 50 years old, there was no sense of photographic history at that time; in seeking aesthetic roots and new directions, photographers turned to the other visual media for their ideas about how a work of art could and should look. They studied paintings for their laws of composition, distribution of light and shade, and the workings of line, form, and color. The contingent, the transient, the dissociated detail, factors that today are called photographic, were seen as problems to be overcome by these photographers, who were beginning to refer to themselves as "pictorialists."

The term "pictorial" was originally used in its generic sense, meaning simply "of or relating to pictures." Used in this way the term included any photograph composed according to traditional rules of picture-making. H.P. Robinson use the word in this sense when he wrote *Pictorial Effect in Photography* in 1869. The pictorialists themselves used the term synonymously with "artistic," and often seemed to mean any photograph composed according to the traditions of painting. By 1904, however, "pictorial photography" referred specifically to the period's dominant aesthetic, which was characterized by broad painterly effects achieved through soft-focus techniques, matte-surface papers, and a variety of expressive printmaking processes.

Early pictorialists' efforts were supported by a system of clubs, salons and periodicals. In the 1890s, almost every city in Europe had a photography club whose leading members regularly showed in each other's salons—annually scheduled juried exhibitions. In 1893 there were 80 photography jour-

nals around the world, transmitting technical, topical, and aesthetic information among the great centers and backwater villages.

It was the European salons, however, that were setting new standards of excellence. By mid-decade, Vienna, Paris, and Hamburg had the outstanding photographic salons on the continent; but it was the London Salon that continued to set the standard for emulation.

The years 1890–1895 were the golden age of European pictorial photography. Buoyed by the eclectic and experimental atmosphere of the larger art world, photographers pushed their medium to achieve a technical flexibility and aesthetic variety previously unknown. Although the close alliance of photography with the other arts at the turn of the century has, until recently, been regarded as mere imitation of painting and other graphic media, essentially an aberration in the development of photography's own aesthetic, this view is far too superficial.

Perhaps the simplest way to grasp the profound difference introduced to photography by the pictorialist aesthetic is to compare the images of cathedrals by Frederick H. Evans to those of the Bisson brothers in France in the 1850s. The works of the Bisson Fréres are magnificent studies of mortar and stone; Evans's cathedrals are all light and space. It was the spiritual, not the specific; the transcendent and the enduring, not the contingent and the transient, that the pictorialists were after. They invented a vast repertoire of compositional techniques to do this. They learned to flatten or extend space, to compose with line, pattern, and chiaroscuro. Most of all, they learned to make a palpable presence of light.

It was not an easy accomplishment, for the medium's natural propensity is for the timely and the specific. In seeking to break free from photography's recalcitrant literalism, photographers tried new materials and new equipment, invented new means of exposure, developed new printing processes and refined old ones. Their methods varied from the technically simple approaches of using a soft-focus lens and matte-surface papers such as platinum, to the very complex processes such as gum bichromate, oil, bromoil, and others to manipulate the entire tonal range and texture of the print. These latter processes often simulated the effects of other media, including etching, lithography, watercolor and oil painting. Although the finest artists of the time achieved with them a surprisingly successful blend of the actual and the artistic, the immediate and the enduring, these processes were always the subject of great controversy, even among the most ardent pictorialists. Some called manipulation the "vital spark" necessary for art; others declared it a perversion of the photographic medium.

Pictorial photography in America

In contrast to the ebullient environment in Europe, the years 1890-1895 were a period gestation for pictorial photography in America. Although by 1894 there were 122 photography clubs from coast to coast, the amateur movement had barely begun. Nothing approximated the European salon system. The closest to a salon was the annual Joint Exhibition of the Boston Camera Club, the Photographic Society of Philadelphia, and the Society of Amateur Photographers of New York, which had been going on since 1887. Each year this ex-

hibition presented up to 2,000 photographs by a couple of hundred photographers, both amateur and professional. Although judged by a panel of painters and photographers, the event was a melange of technical cleverness, commercial convention, and popular notions of "art." By 1895, the Joint Exhibitions had become so moribund that Alfred Stieglitz, with characteristic fervor, proposed their abolition. A great furor erupted but the Exhibition died, leaving the United States with no framework at all for the national exhibition of photographs.

Stieglitz's prestige as a photographer was already so great that out of the ashes of the Joint Exhibitions he was able to create two new organizations that helped set American photography on a new course. The first was the merger of the Society of Amateur Photographers with the New York Camera Club to form *The* Camera Club. The second was the International Photographic Salon at Philadelphia. As Vice President and Chairman of Publications of The Camera Club Stieglitz launched a national periodical *Camera Notes*, a prototype for the later *Camera Work*, and the first publication to strive for quality reproduction of photographs and serious discussion of photographic aesthetics.

At the same time, with Robert S. Redfield of the Photographic Society of Philadelphia, he launched an annual exhibition at the Pennsylvania Academy of Fine Arts that from 1898 to 1901, brought to light such luminaries as Clarence White, Gertrude Kasebier and Edward Steichen.

Stieglitz was not the only one organizing exhibitions, however. In March 1898, the Pittsburgh Amateur Photographers Society staged a salon at the Carnegie Art Galleries with an attendance so huge the exhibition was extended. In the fall of the same year (shortly before the first Philadelphia Salon) the American Institute, a society of arts and letters, included a photographic section in its annual art exhibit at the National Academy of Design. Important photographers such as Charles I. Berg and Zaida Ben Yusuf arranged the section that saw the debut of Joseph T. Keiley.

Sponsorship of exhibitions by art institutions, the number and quality of photographs, and the amount of interest they stirred indicated the growing status and vitality of American pictorialism. Art and culture in general were undergoing profound changes in America at the turn of the century. Since the 1880s, popular aesthetic taste had been shifting from a rather insular realism to a more painterly, emotive, European mode. The movements that swept over Europe 10 to 20 years earlier were now pervading America. The pictorial movement in photography was an important manifestation of this cultural phenomenon.

Essentially, it was a democratic movement. Most camera clubs, for example, were founded as recreational organizations for well-to-do amateurs seeking aesthetic and spiritual enrichment. With the invention in the late 1880s of lightweight flexible film, small cameras, and mass-produced materials, photography became a form of popular entertainment in the days before movies or radio. Clubs organized weekend outings to scenic spots and featured lectures on technical and aesthetic matters.

The tyranny of Stieglitz

This was quite different from Stieglitz's aspirations for photography as a medium of fine art. He was looking for artists who could produce extraordinarily high quality work on a consistent basis. Thus, when he began to organize one person exhibits at The Camera Club, sometimes he featured photographers who were not even members. When he published in *Camera Notes* (" the official organ of the Camera Club") reproductions of work by the outstanding European and American photographers and articles by the noted art critics Charles H. Caffin and Sadakichi Hartmann, he soon felt the heat of the opposition. Club members, feeling excluded from their own organization, began to complain of Stieglitz's "tyranny" and the publication's "artiness."

Similar resentment arose against the Philadelphia Salon, whose jury soon consisted of some of the finest photographers of the time—Gertrude Kasebier, Clarence White, F. Holland Day, Frances B. Johnston and Henry Troth. The fact that the jury was composed of photographers, excluding for the first time artists of other media, was an additional point of contention within the photographic community. Most offensive, however, was the two-tier system that showed in depth the work of only a handful of the most accomplished photographers, and permitted others only token representation of one to three prints each.

The turmoil in New York reached a climax in 1900, and Stieglitz resigned as the Vice President of The Camera Club. At the same time, a revolt in the Philadelphia club led to the replacement of the management of both the club and the Salon. The new officers denounced the Salon's "domination" by a "clique" and declared they would seek a larger representation of the work being done throughout the country.

Stieglitz's opponents were not merely photographers of lesser achievement or more democratic leanings, however. They also included one whom Stieglitz acknowledged as an equal—F. Holland Day, who in 1900 set out, over Stieglitz's objections, to present a definitive exhibition of American work at the prestigious London Salon of the Linked Ring. Stieglitz wielded his political clout to prevent Day's collection, entitled "The New School of American Photography," from being shown through the Linked Ring. Instead it was shown at the Royal Photographic Society to enormous acclaim. In Paris, it was received with unreserved enthusiasm. Day had unquestionably scored a coup. The show established the reputation of American pictorial photography and to many it signified a shift of creative energy from Europe to the United States.

Despite Day's success in Europe, American vigor remained personified in Stieglitz, who emerged from the debacles of The Camera Club and the Philadelphia Salon stronger than ever. In 1902, he formed the Photo-Secession, the elite group that for a few years embodied the ideals he had sought for so long. Throughout the next two years, Stieglitz sent works of the Photo-Secession to salons all over the country stipulating that they must be shown as a group representing the best of American photography. In 1904 he arranged major shows at

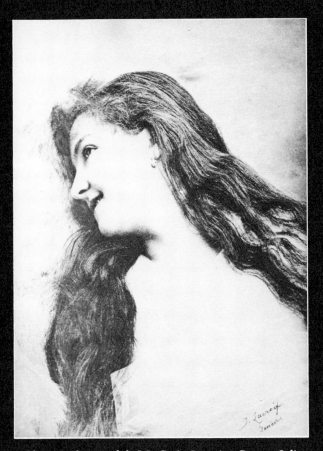

Clockwise from top left: J. LaCroix, *Sanguine*, Geneva; Julius Strakosch, *Rue de Village*, Hobenau; Hannon, *Matinee d'Automne*, Brussels; J.B.B. Wellington, *Evening*, England. Photogravures of varied tones prints by these and other little known Europeans appeared in a rare set of four souvenir folio volumes published 1894-1897 by the Photo Clubs de Paris. Courtesy Ars Libri, Ltd., Boston. Reproduction photographs by William Crawford.

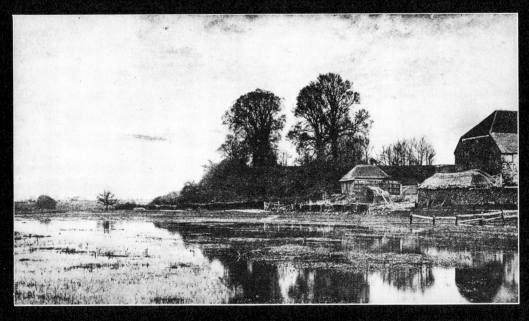

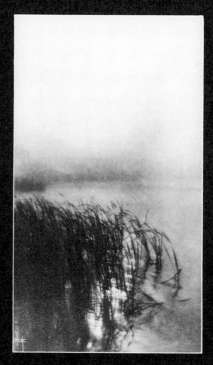

As a movement, pictoralism drew impulses from many painterly schools. The mystical impressionism of Maurice Bremard's *Crepuscule*, facing page opposite (1894, courtesy of Ars Libri, reproduction photograph by William Crawford) contrasts with the romantic realism of Rudolf Eickemeyer's *Evelyn Nesbit with Roses*, 1901 and *A Japanese Fantasy*, 1911. Eickemeyer was once ranked with Stieglitz. Together they were the first Americans elected to The Linked Ring. Courtesy the Hudson River Museum.

two prestigious galleries—The Corcoran Gallery of Art in Washington D.C. and the Art Gallery of the Carnegie Institute in Pittsburgh. At the same time Stieglitz also controlled the American participation in the London Salon and most of the major continental salons. Not surprisingly, this unparalleled monopoly generated considerable resentment.

Even the most skeptical modern eye must concede that the Photo-Secession contained many of the most original talents of the time. Nonetheless, some excellent photographers were excluded—notably Rudolf Eickemeyer, Jr., who together with Stieglitz had been the first American elected to the Linked Ring in 1892. His is a story that still needs to be fully told. Other leading names of the day, like Zaida Ben Yusuf, J.H. Garo, Adolph Petzold, Paul L. Anderson, Charles I. Berg, to name a random few, were also excluded. As more of their work becomes accessible to public view, many of these photographers may be seen as the equals of some of the other Secession members. Why some fine artists were in, and others out has yet to be explained. But this complicated issue seems to have involved questions of amateurism vs. professionalism, elitism vs. populism, and clashes of personal style and power, as much as it concerned evaluations of artistic excellence.

Stieglitz is challenged

As self-proclaimed arbiter of photographic excellence, Stieglitz could not go unchallenged. A grassroots movement of pictorialists began to coalesce around the popular photography journals, and organizations that challenged the elitist premises of the Photo-Secession began to emerge. In December of 1903, Louis Fleckenstein of Minnesota and Carl Rau of

Wisconsin organized the Salon Club of America, a national organization of 11 pictorialists whose work, according to the contemporary account of Sadakichi Hartmann, "had successfully passed the Salon juries of recent exhibitions at Philadelphia and Chicago."

In July 1904, The Salon Club joined with Curtis Bell, president of the Metropolitan Camera Club of New York, to promote two matters—the formation of a nationwide federation of clubs, and the organization of a national exhibition of pictorialism to be held in New York City. The federation, with an initial membership of seven clubs, was called the American Federation of Photographic Societies. Their exhibition, under the direction of Curtis Bell, was called the First American Salon and was held at the Clausen Art Galleries in New York City in December 1904. The jury included artists, not photographers, and the "Conditions" specified "no invited work, and all prints forwarded will be examined by the jury."

This Salon, the first national exhibition of pictorialism in New York since the 1902 National Arts Club Show, stole some of Stieglitz's thunder by revealing that there were many competent photographers not associated with Stieglitz's group. Rudolf Eickemeyer helped organize the show and presented a body of his work, as did F. Holland Day, and an important new talent emerged: George Seeley.

Partly in response to the challenge of the Salon, Stieglitz opened the Little Galleries of the Photo-Secession and settled into producing a series of international shows and publishing *Camera Work*. But as pictorialism expanded across America and the Photo-Secession consolidated its position in New York, pictorialism in Europe began to fade. In 1898, the Paris

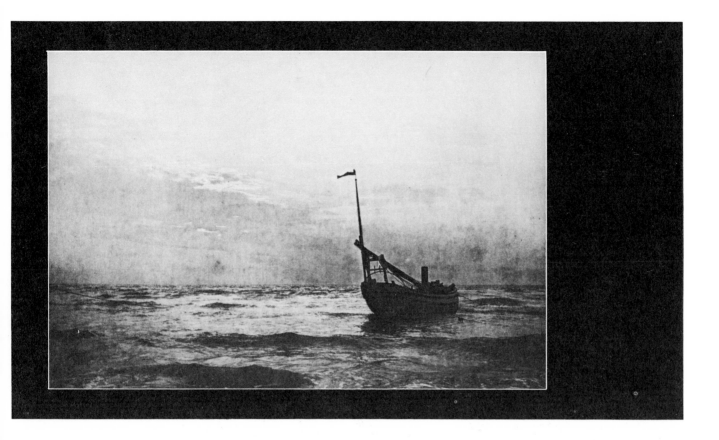

Salon ended. By 1907 the Linked Ring was on the verge of disintegration and the American members all withdrew. The 1909 Dresden Salon was the last in Europe to which Stieglitz sent a Photo-Secession section.

Long before the United States, Europe began to feel the stirrings of profound aesthetic change. Emergence of the Fauves and the start of Cubism signaled the artistic revolutions to come. Although Stieglitz sensed this and shifted his interest toward modern painting, most Americans—the photography world in particular—were untouched by it.

In 1910, the director of the Albright Art Gallery at the Buffalo Museum of Fine Arts asked Stieglitz to arrange an exhibition of photogaraphy. It proved to be both the triumph and the demise of the Photo-Secession. The show was an unparalled display of the finest achievements of the previous 10 years, and the Museum purchased a number of works for its permanent collection. Stieglitz felt his goal—the recognition of photography as a fine art—had at last been fulfilled. But, alas, the antagonism from the larger pictorial community, as well as within the Photo-Secession, finally broke the group's cohesion, and soon after the Buffalo exhibition, it officially dissolved.

The following years, however, brought rich development for pictorialism in the camera clubs, who built on the resources set mainly by the Photo-Secession. Gradually subject matter and treatment became catechized in a system of formulas; the clubs became teaching centers; their star members competed for awards and medals from the many national salons. Most of the finest pictorialists were now professionals earning their living through their work.

World War I marked the end of real vitality in the amateur movement. Materials were unavailable, and afterward hobbyists turned to a new attraction: the radio.

In 1917 Clarence White and Gertrude Kasebier joined with a few others to form the Pictorial Photographers of America, an attempt to recapture some of the old spirit. The emphasis now was not on art, but on education. Linked with public libraries, museums, and Teachers College at Columbia University, the PPA had closer ties to the progressive education movement than to the art world.

For the art world, World War I swept away all remnants of the late 19th-century romantic movements. The mystery and emotion, the aspirations for transcendent beauty, the elaborate designs and moody effects that characterized the Symbolists and Art Nouveau as well as pictorialism, all seemed false and affected.

A rich and complex period in photography's history was subsequently forgotten, to be recalled half a century later. Now, with interest in the period rekindled, there is hope of many exciting rediscoveries of hundreds of competent artists who worked with the camera. The pictorial movement has paid a high price for being bound too closely to the styles and intentions of the other arts. It has lain too long in this shadow of its limitations.

Pictorialism was a movement that enormously expanded the technical and expressive possibilities of the medium, and lifted photography out of its specific descriptive nature into the realm, claimed by all the arts, of interpretation and new meaning. It also and most importantly left us a legacy, yet to be fully explored, of beautiful and moving photographs. ∎

Alfred Stieglitz and the Photo·Secession

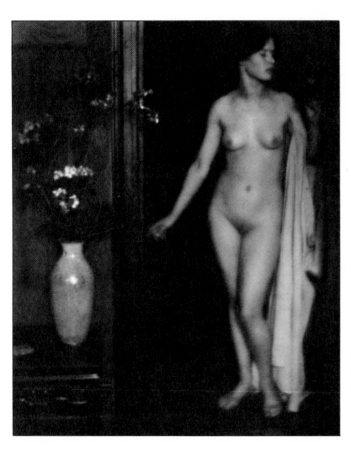

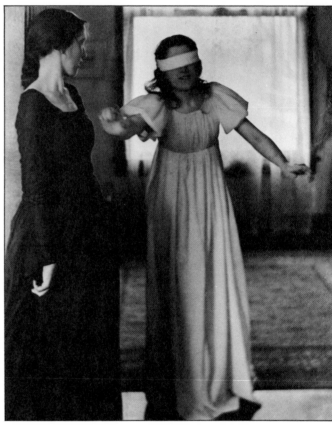

No longer the "handmaiden of art," photography during the Photo-Secessionist Movement commanded an interest previously reserved for painting.

BY HELEN GEE

The emergence of photography into the mainstream of American art—a phenomenon that appears to have developed only within the recent decade—actually began with Alfred Stieglitz at the turn of the century. Leading a small group of photographers in a movement called the "Photo-Secession," Stieglitz sought to rescue photography from its historical role as the "handmaiden of art" and to elevate it to a position of equality with painting and the other visual arts. However tenuous that position was to remain during subsequent decades, it was Stieglitz's early struggles—as well as his considerable success—that provided the base, and prepared the way, for the acceptance of photography as a serious form of creative expression, and as an independent art.

It was not that the creative possibilities of the camera hadn't been previously acknowledged or explored. As early as 1844, Fox Talbot, the inventor of the negative-positive process referred to photography in his book, *The Pencil of Nature*, as "the beginnings of a new art." Ten years later, having predicted a future for his technique of "photogenic drawing,"

Talbot wrote, perhaps with a measure of glee: "Already sundry amateurs have laid down the pencil and armed themselves with chemical solutions and with Camarae obscurae." These amateurs, most of whom had the time, the means, and the inclination (although not always the talent), were to become the mainstay of "artistic," or what was better known as "pictorial," photography.

Among these early amateurs was a highborn lady named Julia Margaret Cameron. Taking up photography to offset the idleness of her later years, Cameron tackled her "divine art" with enthusiasm. This enthusiasm was not shared by her sitters—among them Charles Robert Darwin, Alfred Tennyson, and Henry Wadsworth Longfellow—who were to remain incarcerated for long hours in her greenhouse studio in Freshwater on the Isle of Wight. Their forbearance—coupled with Cameron's considerable talent—resulted in masterful portraits in which she captured "the greatness of the inner as well as the features of the outer man." (Stieglitz later admired and revived her work, and that of another 19th-century pioneer, David Octavius Hill.)

Unlike Cameron, most mid-century photographers who were dedicated to making art only managed to imitate it. Borrowing sentimental themes from the popular genre painting of the period, they inundated the fashionable camera clubs (found in cities from London to Bombay) with entries bearing such titles as *The Last Supper, Venus at the Bath,* and *Little Red Riding Hood.*

One of the major influences on these "artistic" photographers was Oscar G. Rejlander, who combined a taste for elaborate photographic tableaux with an inclination toward descriptive moralizing. His *pièce de résistance* was an allegorical composition titled *The Two Ways of Life.* One-half of the photograph depicted figures representing Charity and Industry; the other half, which included several nudes, illustrated Licentiousness and Vice. No less than Queen Victoria herself became Rejlander's patron (and one of the early collectors of the medium) when she purchased this photograph for the Manchester Art Treasures Exhibition. (Although the "Vice" portion was covered with a drape during the exhibit, it is perhaps safe to assume that the Queen took a peek before making the purchase.)

Objecting to these hackneyed imitations of painting, Peter Henry Emerson, a physician and well-known amateur, expounded a theory of "naturalism." In his book *Naturalistic Photography for Students of Art,* he recommended the use of natural light, natural poses, and rural settings. This was a sharp break from the past and the contrived artificial images of the camera clubs. He also suggested the use of soft-focus effects, a technique later used by the Photo-Secessionists that was also a hallmark of the pictorialist style.

It was Emerson, in fact, who brought Stieglitz his earliest recognition. In 1887, judging a competition for the British magazine *Amateur Photographer,* Emerson awarded him first prize—two guineas and a silver medal—for *A Good Joke,* an unposed photograph of grinning street urchins. Emerson later referred to it as "the only spontaneous work" he had seen among the entries.

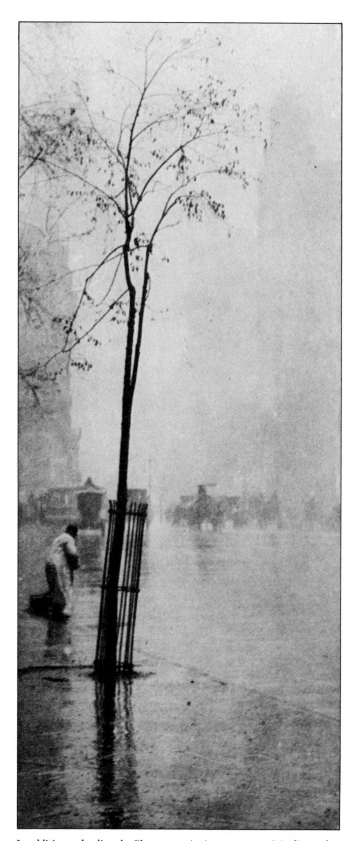

In addition to leading the Photo-secessionist movement, Stieglitz took his own pictures as exemplified above in *Spring Showers,* ca 1901. Helios Gallery, New York City. He and Clarence White collaborated in a series of nudes of *Miss Thompson,* facing page left, ca. 1907; waxed platinum, 9⅜ x 7⅝. Metropolitan Museum, Steiglitz Collection. Facing page right: *Blind Man's Bluff* 1898, by White; platinum, 7¾ x 5⅞. Museum of Modern Art.

While his major interests lay outside the studio, Alvin Langdon Coburn's reputation was built on his portrait work, an example of which is shown at right in *The Bubble*, 1909. Gelatine silver, 11⅛ x 8⅝. But Coburn really preferred to roam the world at large, seeking out the unposed, dramatic images he could find there. Below: *The Rudder, Liverpool,* 1905. Gum bichromate over platinum, 14½ x 11½. Both Metropolitan Museum of Art, Alfred Stieglitz Collection.

Still in his early twenties, Stieglitz had begun to make his mark in photographic circles. Emerson's prize was the first of 150 Stieglitz would ultimately receive; later, however, when founding the Photo-Secession, he opposed the competitive prize system in principle. Born in 1864 (just 25 years after the birth of photography), Stieglitz was sent by his well-to-do parents to study engineering in Germany. One day, noticing a camera in a shop window, he purchased it and initiated a life-long fascination with photography. His involvement with this medium led Stieglitz to multiple careers—he became not only a photographer, but also a writer, a publisher, a gallery owner, a champion of the arts, and the leader of the Photo-Secession movement.

During this nine-year stay in Europe, Stieglitz first became aware of the idea of "secession" in the arts. A group of painters in Munich reacted against the conservative establishment to form the independent "Munich Secession." Soon afterward, rebellious photographers organized groups in several European cities—the London-based Linked Ring, the Photo Club de Paris, and the German and Austrian Secessions. They were not seceding from any particular organization, but from the sterile and banal attitudes that dominated "artistic," or "pictorial," photography. It was the secessionist credo, advocating "the complete emancipation of pictorial photography," that Stieglitz brought back with him from Europe.

On his return to America in 1890, Stieglitz felt a sense of cultural displacement. After the refinements of the Old World, the dynamic aggressiveness of New York seemed harsh. Also, he attempted unsuccessfully to adjust to a new life-style. His business career (as a partner in a photoengraving firm) failed; his newly contracted marriage offered little gratification. More and more he turned to his camera. During this difficult period of his life, Stieglitz began to develop the powerful personal imagery that would establish him as one of America's foremost photographers.

But interest in pictorial photography had diminished. Membership in the camera clubs had dwindled. After the introduction of the mass-produced hand-held camera in 1888, "snap-shooting" had become a national craze. Now anyone could take a picture simply by following Eastman's dictum:

"You push the button. We'll do the rest."

Having decided to devote himself entirely to photography, Stieglitz was determined to raise the level of pictorialism. As vice-president of New York's Camera Club, he began to arrange exhibitions, often selecting the work of nonmembers. Having previously been an editor of the *American Amateur Photographer,* he now took over the club's bulletin, *Camera Notes.* It soon became an influence on photographers throughout the country; Edward Steichen read it in Milwaukee, Clarence White saw it in Newark, Ohio, and so did others who were soon to participate in the Photo-Secession.

Inevitably, however, the conservative club members, resenting Stieglitz's influence and his "radical" views, began to oppose him openly. One particularly disgruntled member wrote in a letter that Stieglitz published in *Camera Notes:* "A growing and very dangerous Tartanism has inoculated the club." By 1902 it had become clear that, if he were to affect the world of photography, he had to strike out on his own, so he resigned his positions.

Soon afterward, Charles de Kay, the director of the National Arts Club, invited him to organize an exhibition. Stieglitz accepted, but with this stipulation: he was to be entirely free of committee interference. At one point, de Kay asked Stieglitz what the show would be called. He answered, "Call it *An Exhibition Arranged by the Photo-Secession.*"

The public poured into the opening reception on the night of February 17, 1902. Everyone—including the photographers represented—was mystified by the title of the exhibition. Gertrude Käsebier, finding herself labeled a "secessionist," asked Stieglitz, "What is this Photo-Secession? Am I a Photo-Secessionist?" Stieglitz replied, "Do you feel like one?" "Yes, I do." "Well, that is all there is to it."

The public demanded a more precise explanation. Encouraged by the clamor, Stieglitz began to formulate his ideas, and made plans to act on them. In sympathy with his views, the photographers banded together, and several months later an official but informal body called the Photo-Secession came into existence. Its stated purpose was "to advance photography as applied to pictorial expression; to draw together those Americans practicing or otherwise interested in art; to hold from time to time, at varying places, exhibitions not necessarily limited to the productions of the Photo-Secession or to American work." Among its founding members were Edward Steichen, Gertrude Käsebier, Clarence H. White, Eva Watson-Schütze, John G. Bullock, Joseph Keiley, and Frank Eugene. Stieglitz was chosen director.

Because Stieglitz deplored the floor-to-ceiling clutter of the fashionable salons, he installed the photographs at eye level. But he also felt the accessibility of art should not be made too easy. "Those who love and understand . . . will find their way."

Shortly afterward, Stieglitz began publication of *Camera Work*, the Photo-Secessionists' "mouthpiece." Fifty issues of *Camera Work* were published between 1902 and 1917; it was known as the most provocative—and certainly the most elegant—arts journal in the world. Its contributors included the noted art critics Charles H. Caffin and Sadakichi Hartmann, and the well-known writers Maurice Maeterlinck and George Bernard Shaw. Even Gertrude Stein contributed a piece—the first publication of her work anywhere.

Not only did *Camera Work* serve as a forum for esthetic ideas, but, most notably, it reproduced the work of the photographers in fine photogravure. Printed on Japanese paper, and often tipped onto the pages by Stieglitz himself, the gravures were presented as works of art (and are prized as such by collectors today).

Camera Work brought recognition to the Photo-Secessionist photographers both here and abroad, creating a demand for their work. Stieglitz, who insisted that they only show by invitation and together as a group, had more requests than he could fill. Oddly enough, Photo-Secession members had not had a show in New York since the original exhibition at the National Arts Club. For three years they had been meeting in restaurants, and felt the need for a home base. Steichen urged Stieglitz to open a gallery. Reluctant at first, Stieglitz feared there was not enough good work being made to sustain an exhibition schedule, but he agreed after they both decided to show other works of art as well. Steichen, who was bound for Paris, planned to send back for exhibition some of the work being done there. This was the beginning of a collaboration that was to continue for a decade and change the world of American art.

Conveniently, Steichen had just vacated a studio on the upper floor of a brownstone at 291 Fifth Avenue. This space attracted Stieglitz because of its low rent and lack of accessibility. Stieglitz thought that the experience of art should not be made easy, claiming that "those who love and understand and have the art-nose will find their way." A modest sign read "Little Galleries of the Photo-Secession," but the gallery became known simply as "291."

Steichen designed the galleries and painted each of the three small rooms a different color—olive, tan, and salmon. He created an atmosphere of simplicity and austerity, placing the focus not on the surroundings but on the work. Photographs were to be installed in single rows; both he and Stieglitz deplored the floor-to-ceiling clutter of the fashionable salons. The only decor was a brass bowl, which became the symbol of the Photo-Secession.

The first show—which, unannounced, nonetheless drew crowds—opened on November 24, 1905, and was devoted to the work of the members. The reaction of both the public and the press was enthusiastic. Still in touch with his European colleagues, Stieglitz next presented an exhibition of French photography, including the work of Robert Demachy, Charles Puyo, and Rene Le Bégue. This was followed by an exhibition of British photography featuring Frederick H. Evans, J. Craig Annan, and the 19th-century pioneer, David Octavius Hill. Later the same year, Stieglitz exhibited the Austrians known as the Trifolium—Heinrich Kuehn, Hugo Hennenberg, and Hans Watzek, and the German Hofmeister brothers, Oscar and Theodore.

Stieglitz set aside his own photography for the time being, and devoted himself to promoting the work of the Photo-Secessionists at 291. Busy from morning to night with the details of running a gallery, he answered hundreds of letters, talked endlessly to visitors, and waged what appeared at times to be a one-man crusade for photography. The magnetic force of his personality attracted many supporters, but his uncompromising attitudes alienated others. (One hapless photographer, who printed "Member of the Photo-Secession" on his business card, was accused of opportunism and expelled.)

During the next few years, Stieglitz exhibited photography almost exclusively. Among the photographers shown at 291 were Gertrude Käsebier, Edward Steichen, Clarence H. White, Alvin Langdon Coburn, Baron Adolph De Meyer, Annie Brigman, George Seeley, Herbert G. French, Eva Watson-Schütze, Frank Eugene, Paul Haviland, Alice Boughton, John G. Bullock, and Joseph Keiley. Stieglitz did not exhibit his own photography until 1912.

Paradoxically, Stieglitz's work was least representative of the pictorialist style, and least characteristic of the Photo-Secession. His photographs were direct, his prints unretouched. Charles H. Caffin described Stieglitz's approach in his book, *Photography as a Fine Art:* "He is by conviction and instinct an exponent of the 'straight' photograph, working chiefly in the open air, with rapid exposure, leaving his models to pose themselves and relying upon means strictly photographic." Using a hand-held camera—unheard of among "serious" photographers—he would walk the streets in all kinds of weather, often waiting for hours to capture just the right moment. When he obtained misty effects, it was through the direct use of atmospheric elements—fog, rain, snow, and even industrial smoke—rather than through the manipulation of the photographic processes so often favored by his colleagues.

Steichen, for example, used various devices in order to achieve impressionistic effects, especially in his landscapes. To achieve ". . . the haunting elusive quality of twilight," Steichen would often kick the tripod during an exposure, or put drops of water on the lens. As both painter and photographer, Steichen brought to each of these mediums a veiled,

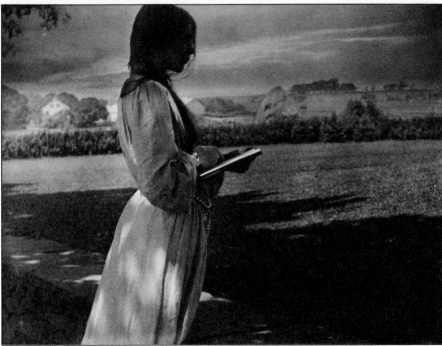

Alfred Stieglitz, photographer, collector, writer, gallery owner and leader of the Photosecessionists left little time for his own work, an example of which is shown in his *The Hand of Man*, 1902, 7⅛ x 9⅜. Princeton Art Museum. Gertrude Kasëbier, a former art student, was the first woman photographer to enter Stieglitz's inner circle. She specialized in portraiture, especially mothers with their children. Left: *The Sketch*, 1899 Platinum, 6⅛ x 8¼. Metropolitan Museum, Stieglitz Collection.

The Flatiron building in New York was a popular subject for photographers and both Steichen and Stieglitz photographed it. But while Stieglitz isolated the building in a landscape of snow, Steichen caught it emerging through a dusky evening fog. Right: *The Flatiron*, 1909 print of 1904 negative. Greenish-blue pigment gum-bichromate over gelatine silver, 18¾ x 15⅛. Metropolitan Museum, Stieglitz Collection. Opposite page: Annie Brigman's photographs have a distinctively allegorical quality. Her favorite subject was the solitary nude in a landscape. *The Bubble*, 1905. Gelatin silver, 6¾ x 9¾. Princeton Art Museum, New Jersey.

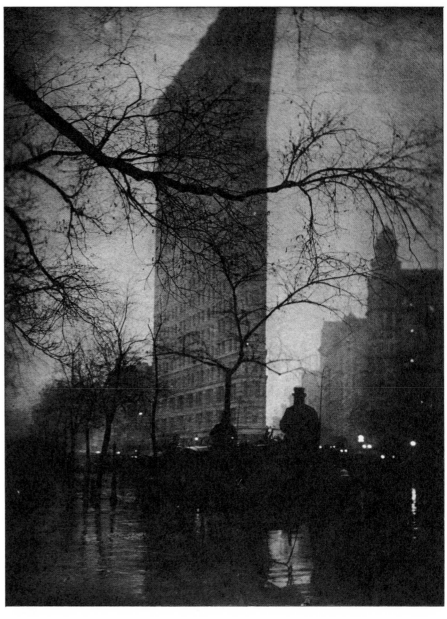

dreamlike poetic vision. It was not until years later, after renouncing painting, that he was to turn to "straight" photography.

The rejection of the stereotyped genre painting of the past had not, however, discouraged the Photo-Secessionists from drawing heavily on painting for effects. Influenced by the painters—especially James McNeill Whistler—many of the photographers went to extraordinary lengths to achieve similar atmospheric qualities. A common means was the manipulation of the print. Through the use of the bichromate process—an involved method of washing away a coating of gum and pigment that had been added to a print—the photographer could exert considerable control over light and shade, subdue detail, and even add color. Some photographers also manipulated the negative by adding scratches that resembled the marks of an etching needle.

Stieglitz himself favored the platinotype process—a method of sensitizing paper with platinum salts—because of its subtle tonalities and fine range of grays. For multiple images, such as those published in *Camera Work*, he used photogravure—a direct method of reproducing photographic images in printer's ink from etched copper plates. Despite his own preferences, Stieglitz approved of any means a photographer chose to make his own personal statement.

The pictorialists often alluded to a remark once made by William Morris: "Get the effect no matter how—empty an ink bottle over it if you like, but get the effect you want. It is nobody's business how you get it." The use of handwork—the need to add an artist's touch—was a conscious effort on the part of the pictorialists to convince a still skeptical public that photography was more than simply a matter of mechanics.

The Photo-Secessionists emphasized subjective expression rather than objective documentation. They drew upon their own feelings and found their subject matter in their personal surroundings. Clarence White posed his wife and children in dreamy landscapes more suggestive of Eden than rural Ohio. His prepubescent children, photographed in the nude, were

seen with a kind of pre-Freudian innocence.

Gertrude Käsebier's portrayal of family life was more ambiguous, and often contradictory. One of her well-known photographs, showing a woman tenderly bending over a young girl in a doorway, is titled *Blessed Art Thou Among Women*. In contrast, another image called *Marriage: An Allegory* shows two oxen, side by side, yoked and muzzled.

Annie Brigman, the wife of a sea captain and a dedicated free spirit, photographed herself either paddling in a brook or draped *au naturel* against a tree. (It is said that, after the loss of a breast in a boating accident, she continued to pose, skillfully shielding the missing part.)

Alvin Langdon Coburn, the youngest of the group and a latecomer to the Photo-Secession, traveled throughout the world, photographing such cities as London and New York. His cityscapes are impressionistic and celebratory: like other Photo-Secessionists, he sought to capture the beauty in the world.

But the definition of beauty was changing. And Stieglitz, always in the vanguard, once again led the crusade for a new art. Through Steichen (who had been working in Paris) Stieglitz discovered Picasso, Braque, Matisse, and other modernists who were shaping a new esthetic. He began to exhibit their paintings, sending shock waves through American art circles. After an exhibition of Rodin drawings in 1908, the number of photography shows at 291 began to dwindle until,

after a few years, there were hardly any at all. 291, which Stieglitz had always regarded as a "laboratory and experimental station," was no longer a showplace for photography; it was now the only place in America where modern art could be seen regularly.

But the gallery had fulfilled its early mission. In 1906 Joseph Keiley wrote a review of a Photo-Secessionist exhibition at the Pennsylvania School of the Fine Arts: "In America the battle for the recognition of pictorial photography is over. The chief purpose for which the Photo-Secession was established has been accomplished."

By 1910 Stieglitz was engaged in championing avant-garde art, and the Photo-Secessionist movement had already declined. Ironically, in that year the movement achieved its greatest, and final, success—museum recognition. The Albright Art Gallery invited Stieglitz to arrange a major exhibition of pictorial photography. The exhibition, consisting of over 600 photographs, opened to record-breaking crowds in wintry Buffalo. And as an additional feather in the Photo-Secessionist cap, the Albright purchased 13 of the photographs for its permanent collection.

Despite the acclaim, the exhibition marked the end of the Photo-Secession. But it was an end colored by victory rather than defeat. For Stieglitz it was only a beginning, a successful first skirmish in the continuing battle for the recognition of photography as fine art. ■

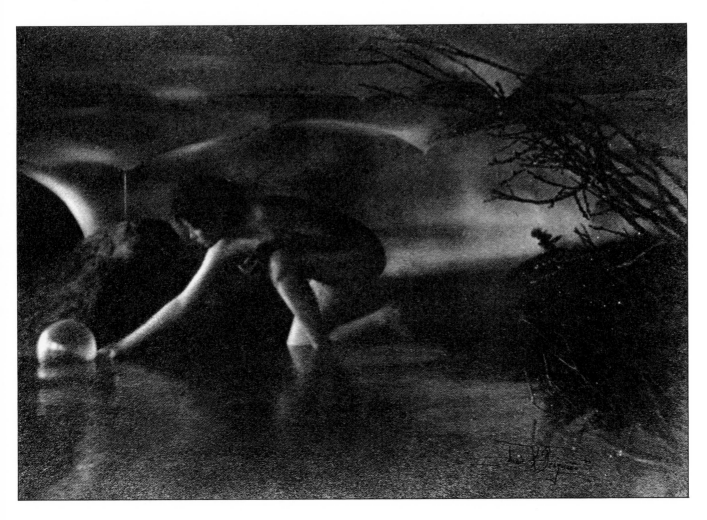

Gertrude Käsebier

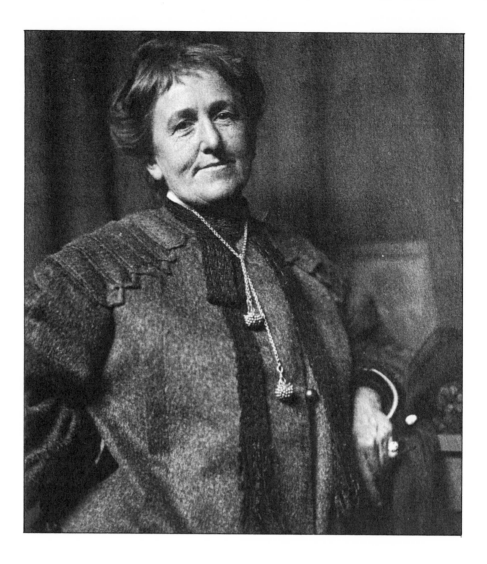

A *member of the Photo-Secessionist Movement, American pictorial photographer Gertrude Käsebier often bridged the gap between painting and photography.*

BY WILLIAM INNES HOMER

Gertrude Käsebier was one of America's most distinguished photographers. During the first two decades of this century, she was preeminent in portraiture. At the same time, she was nationally and internationally renowned as a pictorialist—a photographer who emphasizes the painterly possibilities of the medium. But with the general shift among progressive photographers away from her kind of romantic imagery toward a more direct unsentimental style, Käsebier's contributions were obscured, even forgotten by many. The recent revival of interest in pictorial photography, particularly of the Photo-Secession group, has begun to restore Käsebier to her rightful place in the pantheon of eminent pictorialists.

Käsebier's background was not typical of the average artist or photographer of her day. Born Gertrude Stanton in Des Moines, Iowa, in 1852, she was taken across the plains as a small child and spent her early years in a mining camp in Colorado. When she was 12, she was brought to New York, attended school there, then went to college in Pennsylvania. Subsequently, Gertrude Stanton married a shellac importer—Eduard Käsebier—and, as a Brooklyn housewife with three children, embarked on the study of painting in her late thirties.

Art school and photographic beginnings

In 1889 Gertrude Käsebier broke out of the mold of middle-class Victorian behavior: she enrolled at Pratt Institute in Brooklyn. Though she must have been one of the oldest students in the school, Käsebier's extraordinary dedication and talent soon won the respect of her classmates.

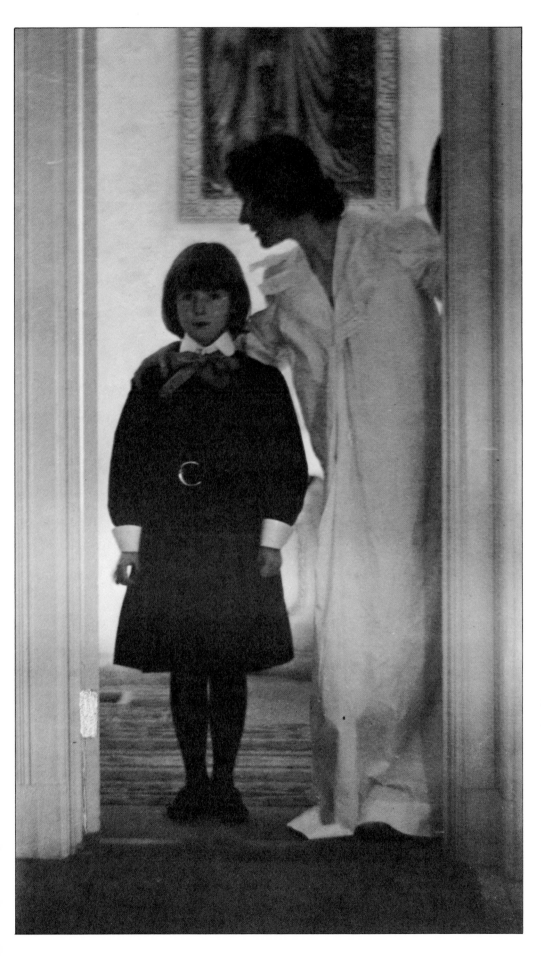

Gertrude Käsebier maintained that professional portraiture should be a fine art rather than merely a recording of visual facts. She opened her New York studio in 1897, and produced approximately 100,000 negatives until she retired 30 years later. Opposite page: *Self-Portrait*, ca 1905, platinum. Private collection. Left: *Blessed Art Thou Among Women*, 1899, platinum. By the turn of century, Käsebier had established her reputation as a pictorialist with images such as this. The theme of motherhood appears often in her work; here, in one of her most famous photographs, the biblical phrase that forms the title suggests religious overtones. The Metropolitan Museum of Art, the Alfred Stieglitz Collection, 1933.

Käsebier drew heavily from the styles and poses of Old Master painting for her photographic portraits. Above: *Flora*, ca 1899, platinum. One of several views of Cornelia Montgomery in Renaissance dress. The Library of Congress.

At Pratt, she studied to be a portrait painter. Although no record remains of her teachers, it is likely she had some contact with Arthur Wesley Dow, who revolutionized art instruction there when, in 1895, he introduced his students to flat pattern, simplicity, and a quasi-Japanese style.

Photography, the medium in which she would excel, entered Käsebier's life in a rather casual way. Like so many amateurs, she started by taking photographs of her family and children, without any professional ambitions. When she attempted to improve her photographic skills, she received little encouragement. For example, while at Pratt she entered a photographic competition sponsored by *The Monthly Illustrator* magazine and to her amazement won a $50 prize. Viewing her winning effort, her teachers chastised her for taking the photographic medium seriously, and in deference to their views Käsebier came to believe she had done something wrong. In shame, she gave away the prize money.

In the mid 1890s, Käsebier spent two summers in France with an art class taught by Frank Vincent DuMond. Initially, her husband opposed the trip, but he reluctantly agreed when she was appointed chaperone to the class. With her two teenage daughters, Käsebier spent her first summer painting from nature at Crécy-en-Brie, a provincial village and art colony rich in peasant subject matter. Käsebier brought her camera to France almost as an afterthought; on rainy days she experimented with indoor portraiture. These efforts surprised and gratified her. "From that moment," she recalled, "I knew I had found my vocation." That summer she continued to photograph local townspeople, her daughters, and fellow students. She showed these pictures to DuMond, who "was very enthusiastic and told her to give up painting and take up photography instead." With this confirmation of her own belief in her photographic talents, Käsebier began to approach the medium as a serious art form, one in which she could establish her reputation. To gain a solid technical foundation in the chemistry of photography, during the following year—while her daughters attended school in Wiesbaden—she studied under a German chemist who knew photography.

When she returned to America after spending a second summer at Crécy-en-Brie, Käsebier showed her prints to several artists and was again encouraged to continue her photographic work. It was then that she decided to take up professional portrait photography. Lacking practical experience, she decided to apprentice herself to a commercial photographer to learn the technical and business side of the trade. She approached Samuel Lifshey, a Brooklyn portrait photographer, and for a handsome fee, he reluctantly agreed to take her on.

Largely as a result of her experiences with Lifshey, Käsebier gained the necessary knowledge and confidence to embark on a series of portraits of Brooklyn socialites. She posed her female subjects in antique dresses and arranged their hair in old-fashioned styles, revealing a considerable debt to the art of such painters as Rubens, Raphael, and Rembrandt. In a bold action she thus set out to transform the photographic portrait, drawing heavily from the styles and poses of Old Master painting. In so doing, she laid the groundwork for the idea that the professional portrait should be a fine art rather than merely a recording of visual facts.

Educated by her experiences with Lifshey, Käsebier opened her own portrait studio in New York City in 1897.

The professional photographer

Gertrude Käsebier's methods of producing portraits were very different from those of most commercial photographers. Guided by her belief that a photographic portrait should be a work of art, she dispensed with "the papier-mâché accessories, the high-backed chair, the potted palm [and] the artificial flowers" found in traditional studios. She insisted on relaxed poses in natural light within a very simple setting furnished with "small colonial rugs [and] wooden clothes horses covered with denim for screens."

Käsebier dealt with a sitter much as a painter would, often working for two or three hours until she found the most appropriate pose and the best possible light. Because she favored natural side light, rather than stronger illumination from the typical studio skylight, her exposures had to be fairly

long. Her daughter recalled that Gertrude took many of her pictures by "taking off the lens cap and counting seconds." She tried to avoid retouching her photographs, a courageous policy for a portraitist dealing with clients used to having their blemishes removed. She confessed, "Generally the negatives are not satisfactory until after several trials. I never retouch them, but just keep on working until the negative is just as I want it. Wrinkles, freckles, all have to show if they are in the original."

If Käsebier felt she could not achieve a satisfactory result, she refused to do a portrait. When photographing Thomas Edison's daughter, for example, she posed her in different ways and worked with the camera for about 15 minutes. At that point, she told Miss Edison she could go home. The subject replied, "But Mme. Käsebier, you haven't made a single picture." "I know," Käsebier said. "There is nothing there."

Gertrude Käsebier matured as a portrait photographer after the turn of the century, and the period of her greatest influence in this genre extended to about 1910. In her heyday she was an extremely popular person, not only because her portraits were much admired but also because she enjoyed many friendships among the artistic elite of New York City. She knew Stanford White, the celebrated architect and socialite; she was on friendly terms with John Murray Anderson, the theatrical producer, and Ellen Terry, the actress. She made many other contacts in the world of art and society through people who came to be photographed.

Käsebier as a pictorial photographer

Today, Gertrude Käsebier is known as both a professional portraitist and as a pictorial photographer, but at the beginning of her career there was very little separation between these two categories in her work. Because she started as a portrait photographer, pictorial photography of other subjects did not play an important role in her early development. (Her views of peasant life at Crécy-en-Brie, made in the mid-1890s, were conceived mainly as records rather than as pictorial photographs.) But the artistry embodied in her portraits made them function as art photographs as well, and with these images she first entered the ranks of the pictorialists. When she began to produce photographs that were more pictorial, she tended to emphasize figures and their relation to each other, often using the landscape as a background to articulate or amplify the human message.

After Käsebier opened her New York studio in 1897, she made portraits that, in some cases, she felt were worth exhibiting as art photographs. By this time, she also began to turn out work more purely pictorial—unrelated to her portraits—that could be shown in the photographic salons. Judging from her exhibition record in 1899 and 1900, she seems to have found her stride as a pictorialist around the turn of the cen-

The platinum process uses papers impregnated with light-sensitive salts to produce subtle and delicate tones. Top: *Auguste Rodin*, 1906, platinum on tissue. By printing on tissue, Käsebier has imparted a painterly quality to this portrait. Library of Congress. Right: *Adoration*, 1899, platinum. Laura T. Shevlin and Mason E. Turner, Jr.

> "Käsebier dealt with a sitter much as a painter would, working until she found the most appropriate pose and best possible light."

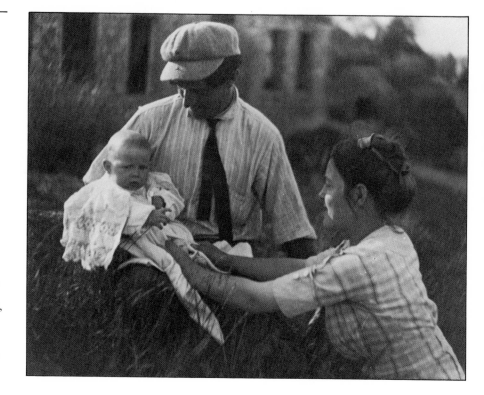

Right: *In Times of Peace*, platinum. Laura T. Shevlin and Mason E. Turner, Jr. Opposite page, left: *Portrait of Miss N.* (Evelyn Nesbit), ca 1898, platinum. International Museum of Photography at George Eastman House, Rochester, New York. Right: *Untitled*, ca 1910, platinum. Gertrude Käsebier O'Malley playing billiards. Mason E. Turner, Jr.

tury. During this time she made several of her best known images, such as *Blessed Art Thou Among Women*, *The Manger*, the views of Cornelia Montgomery dressed in a Renaissance costume (*Flora* is a typical example), and the penetrating studies of Sioux Indians, including *The Red Man*.

Thematically, she tended to favor compositions showing women with children, with the woman usually in a supportive or nurturing role. Two of her most celebrated photographs dating from this early period deal with the mother-child relationship. The simpler of these, *The Manger*, represents a seated woman in a white dress and veil, holding a baby in a protective position. Though religious overtones are unmistakable, the picture probably also symbolizes the universal dignity of all women and children of a humble station in life.

Related in spirit to *The Manger* is Käsebier's most famous photograph, *Blessed Art Thou Among Women*, of her friend Frances Lee and Lee's daughter standing in a doorway. The title suggests religious nuances, but as in *The Manger*, these are not explicit. In her thinking and visualizing, Käsebier was very much a product of the 1890s—the Symbolist era of Mallarmé and Gauguin—which preferred to suggest an idea rather than to describe things in a realistic manner. Even more in the Symbolist mode is *Serbonne*, featuring her friends and daughter Hermine seated in an open French field. The subdued tonalities and emphasis on low-keyed values are much in the manner of James McNeill Whistler and his contemporaries in France in the 1890s, Pierre Bonnard and Edouard Vuillard. This work reveals Käsebier at her most formalistic and Whistlerian moment, although she did not usually tend toward formalism for its own sake but rather preferred a more human and suggestive message couched in an

artistically significant vehicle.

This kind of suggestiveness can also be seen in *The Bat*, one of her few nudes, in which the model is photographer Clarence White's wife. It is an unusually mysterious picture for Käsebier, reflecting an extreme moment of pictorial Symbolism in her *oeuvre*.

The pictorial portrait, such as her rendering of *Clarence White* and another called *Family*, was one of Käsebier's special achievements. In such pictures, she translated the character of the person into abstract, formal terms. Like a Symbolist painter, she considered the lines, rhythms, and tones of the image as expressive devices to say something about the sitter in a nonassociational way. This is one of the secrets of her skill as an interpretive portraitist.

Käsebier's pictorial photography showed a pattern of growth from the turn of the century to about 1910, marked by an increasing fondness for solidity of mass, and more direct light which modeled the form in three dimensions. Her figures often take on an air of monumental dignity; effects of decorative flatness, so characteristic of her early work, become secondary. In her pictorial work, there are continuing references to the mother-and-child theme or to motherhood in general. In *The Heritage of Motherhood*, posed by Frances Lee—the woman portrayed earlier in *Blessed Art Thou*, whose daughter, seen in that same picture, died a year later—Käsebier strikes a tragic if powerful and compelling note, extracting the greatest expressive intensity from her chosen medium.

But Käsebier had some interests outside of the mother-and-child theme. Occasionally she produced architectural views of great sophistication, particularly those of a château in a French medieval style in which reflections in the water play

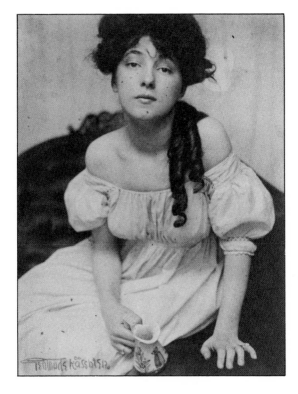

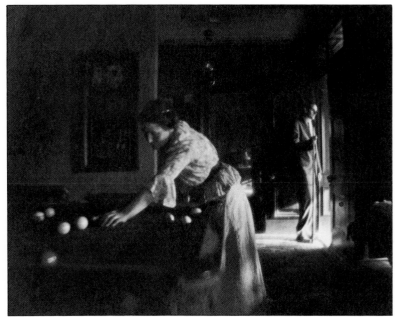

against the grandeur of the edifice. She also executed more informal landscapes, like *Bungalows*, and photographs of workmen, which sometimes glorify field laborers in the manner of the canvases of the French painter Jean Millet. Her photographs hold no hints of social criticism, however; she was a late-19th-century sentimentalist who seemed never to have come to grips with the harder realities of labor or the pressing social problems of her time.

Nevertheless, Käsebier's best pictorial work ranks with that of her eminent colleagues Edward Steichen, Clarence White, Alvin Langdon Coburn, and F. Holland Day. Her most notable photographs were made early in her career. Perhaps her portrait business drained her energies, making it difficult to concentrate on art photography. Whatever the reason, by 1910 Käsebier's most productive years were behind her.

Recognition and friendships

Gertrude Käsebier's rise to prominence in the photographic world was nothing short of meteoric. In 1897 she had just opened her New York portrait studio and was an unknown; in the following year, ten of her works were chosen for inclusion in the first Philadelphia Photographic Salon, one of the most selectively juried exhibitions in the country.

Käsebier's own efforts helped to propel her into the front ranks of the pictorialists. Beginning in 1898 she submitted the best examples of her work regularly to a variety of photographic exhibitions and salons in the United States and Europe. With the utmost rapidity, she came to the attention of the international photographic world. By 1900 her pictures were exhibited not just when juries accepted what she sent;

she was also invited to participate in several major shows, such as F. Holland Day's influential "New School of American Photography," presented in London and Paris in 1900–1901. Moreover, invitational honors of other kinds were bestowed upon her. In 1901 she was offered membership in the Camera Club of New York; and she was elected to the Linked Ring, the exclusive London-based group of progressive pictorialists who had much in common with Alfred Stieglitz's Photo–Secession photographers. (She and Carine Cadby were the first women to attain membership in the Linked Ring.)

When Stieglitz introduced his new journal, *Camera Work*, in 1902, he selected Käsebier as the photographer to be featured in the inaugural issue. Six photogravures from her pictures were published, together with supporting articles by Charles H. Caffin—the noted art historian and photography critic—and Frances Benjamin Johnson, a well-known woman photographer.

Stieglitz's high opinion of Käsebier's work, early in her career, cannot be disputed. When he founded the Photo-Secession in 1902 by mounting an exhibition at the National Arts Club, Käsebier was invited to show. And when the Photo-Secession was given formal identity later in the year, Käsebier became one of the 13 members of its governing council. Both Stieglitz and Käsebier had strong personalities, which may have accounted for this initial attraction as well as the ultimate dissolution of their relationship. At the beginning, there was a great deal of "mutual admiration," as Stieglitz assumed leadership of the pictorial movement.

But a parting of the ways soon occurred. It is well known that Stieglitz was opposed to any form of commercialism in photography, and he must have disapproved of Käsebier's use

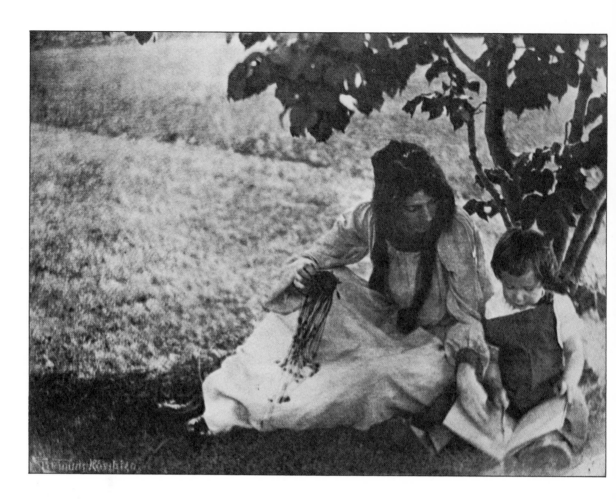

of the medium to make a living. Furthermore, as the first decade of the century wore on, the kind of romantic soft-focus imagery practiced by Käsebier and those who shared her esthetic views became unappealing to Stieglitz, who turned increasingly toward the promotion of modern artists—Cézanne, Picasso, Matisse, and their American followers—in his gallery "291." When the top leadership of the Photo-Secession was reorganized in 1909, Käsebier was not elevated to the rank of "Fellow of the Directorate," as were other eminent pictorialists of Stieglitz's circle. The disillusionment was probably mutual, for Käsebier rejected Stieglitz's autocratic behavior and felt that she could see through his pretenses. As she later confessed, "When I saw he was only hot air, I quit."

Although Käsebier's talent, gregarious personality, and keen interest in the pictorial movement made her a popular figure among the Photo-Secession photographers, she was never an important political figure within the inner circle dominated by Stieglitz, Steichen, and their close associates who produced *Camera Work* and ran the Little Galleries of the Photo-Secession.

While she had been friendly with Stieglitz—at least in the beginning—she maintained equally close ties, on a highly personal rather than "official" basis, with several other important photographers—White, Coburn, Steichen, and Day. It is difficult to evaluate the exact role that "Mother" Käsebier played within the group, but it is certain that she was an inspiring and unifying force who strengthened the ties among these talented workers.

As these photographers began their mutual withdrawal from Stieglitz and the Photo-Secession, Käsebier's role undoubtedly became stronger. After all, she was the first to leave the fold. In concert with White and Coburn (and to a degree Day) she became part of an alternative route to pictorialism, one not dominated by Stieglitz. The countermovement took shape officially in 1916 under the title of the Pictorial Photographers of America, a group organized by White with the help of Coburn and Käsebier. Stieglitz, in the meantime, was pursuing a more direct and "straight" esthetic in his own photographs. When he saw the advanced work Paul Strand was doing in 1916, he found in it—and in Strand himself—the perfect manifestation of his own current artistic beliefs. According to these new criteria, Käsebier and her friends were out of date.

Later life

After her husband, Eduard, died in 1910, Käsebier moved from her home in Oceanside, Long Island, to a new studio and residence on West 71st Street in New York City. There she was free to live and work as she pleased, without family obli-

144

gations. Käsebier continued her portrait photography, though as the years passed, she became less prolific and her popularity gradually declined. Because her style did not grow or develop in a significant way after 1910, she began to seem a conservative figure, unable to change with the times. Her adherence to the *status quo* made her increasingly compatible with others of similar tendency, particularly White and Day, who with Coburn became the defenders of the original concept of pictorialism—romantic soft-focus imagery that Stieglitz now deplored. This relatively conservative movement became centered in Clarence White's photography schools in Maine and New York, and in the Pictorial Photographers of America. Käsebier taught at White's school and, having helped to found the PPA, became honorary vice-president.

With the help of her daughter Hermine, Gertrude Käsebier continued to operate her portrait studio until 1927, although she gradually lost the circle of prominent friends and sitters who flocked to her during the height of her popularity. After she gave up portrait photography, her daughter maintained the studio, but the retired Käsebier found it difficult to stay away. In 1929 the Brooklyn Institute of Arts and Sciences exhibited 35 of her works. She enjoyed a relatively healthful old age and died peacefully on October 13, 1934, at the age of 82. With predictable simplicity, Käsebier requested cremation in a pine box, with no funeral or flowers. After a brief family ceremony consisting only of music, her ashes were taken to Oceanside and buried near those of her husband.

Other contributions

Among Käsebier' accomplishments was her ability to work creatively, often experimentally, with an unusually large number of photographic printing processes. She probably used the widest variety of any worker of her day—albumen, platinum, gum bichromate, gum platinum, carbon, silver, and so on. Only Steichen rivaled her in his range of techniques, but because Käsebier was a more prolific artist in the number of pictorialist prints she produced, the scope of her technical experimentation tended to be wider. Part of her exploration of different printing processes may have been influenced by her early experiences as a painter; whatever the reason, she was able to envision painterly and pictorial possibilities with a broader vision than most other photographers of her time. In addition, like Steichen, her painter's background gave her the ability to manipulate the surface of her photographs, particularly gum prints, with a great deal of freedom and vitality, producing expressive images that often bridge the gap between painting and photography.

Another of Gertrude Käsebier' achievements that set her above virtually all of her contemporaries was her amazing productivity. By her own count, she made approximately 100,000 negatives in her lifetime, a startling figure when we consider that she worked with relatively little assistance as an individual portrait photographer, not as the head of a large commercial studio. Volume alone is not a measure of significance; but in Käsebier's case she seems to have made a remarkably large number of successful photographs within this total count, and that is a worthy achievement. ■

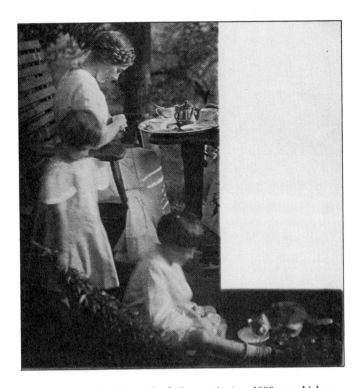

Opposite page: *The Picture Book (Instruction)*, ca 1899, gum bichromate. Käsebier often emphasized the closeness of family ties, particularly the mother-child relationship. The Library of Congress. Above: *Untitled*, ca 1911, platinum. This L-shaped family group is neither strictly formal nor a casual arrangement; it bridges a gap between portraiture and pictorial photography. Private collection. Below: *Untitled*, platinum. Käsebier stressed simplicity of design. Here the careful selection of a single accessory—the branch of flowers—adds another dimension to the portrait. Private collection.

Frances Benjamin Johnston's Architectural Photographs

Many of the buildings Frances Benjamin John-ston shot were later photographed by others, but never with a deeper sense of what architecture is, nor with more stunning results.

BY MARIAN PAGE

Frances Benjamin Johnston, who embarked on a photographic career in the 1880s, bequeathed us many windows to our past that otherwise would be lost forever. There are few historic structures below the Mason-Dixon line that she didn't photograph inside and out, not to mention several important ones north of it. From her photographs we know what many van-

ished landmarks looked like, and we can see the furnishings of the White House in the 1890s as well as the interiors of the mansions of the Astors, Vanderbilts, and Whitneys. We can see the work of Elsie de Wolfe, "America's first woman deco-rator," and we can view Admiral Dewey's quarters aboard

In the 1930s Johnston pursued the final and perhaps most important phase of her career. Armed with a $26,000 Carnegie grant, she worked in earnest to record Southern colonial architecture—not just the promi-nent homes, but the simple farmhouses and dwellings of everyday colo-nial life. She is shown, opposite, in 1936. Above: The graceful staircase in the Jacob Stigerwalt House near Concord, North Carolina. Both courtesy The Library of Congress.

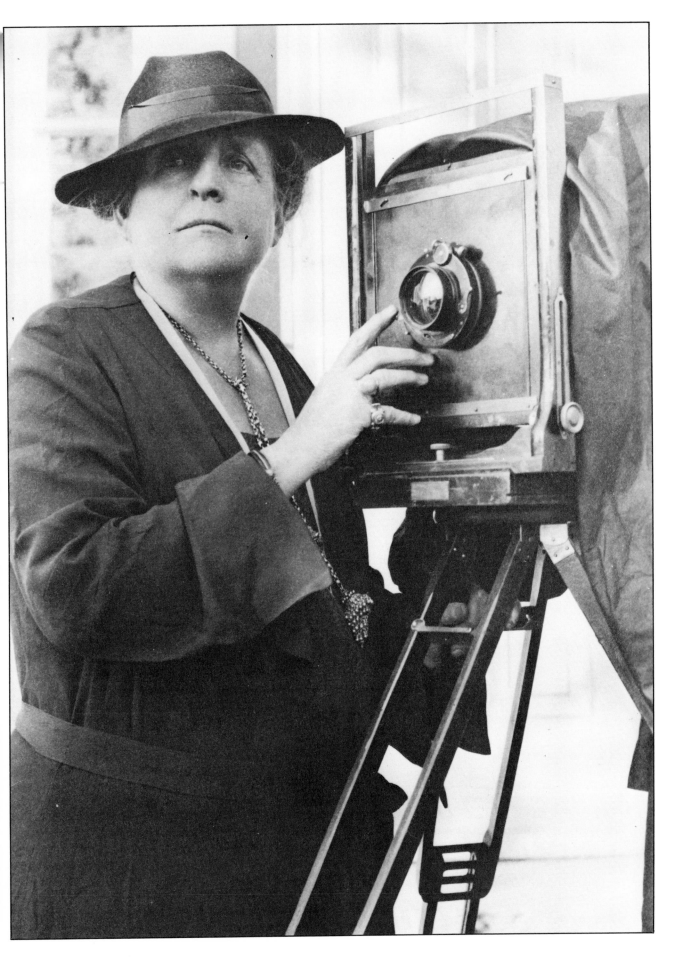

Certainly not many people in those days were interested in old buildings, let alone in their historical significance and preservation.

the battleship *Olympia.* We can follow the step-by-step construction of the Chicago World's Columbian Exposition of 1893, the fair that was supposed to have killed native American architecture with its Beaux Arts splendors, and we can see what some of New York City's buildings looked like during the first two decades of this century.

Frances Benjamin Johnson may well have been the world's first female photojournalist. She didn't concentrate on architectural photography until she was in her mid-sixties, yet she applied to the later work the same extraordinary vigor, perseverance, and high standards that had taken her into the coal mines of Pennsylvania, a shoe factory in Massachusetts, Hampton Institute in Virginia, and the White House in Washington before the turn of the century. And certainly as she got older, she exhibited no weakening of the "vivid, unforgettable personality" that Paul Vanderbilt, former consultant in iconography at the Library of Congress, recalled when he wrote an appreciation of her work in the *Journal of the AIA* (American Institute of Architects, November 1952). Architect Milton Grigg, who knew her in the 1920s and '30s, says how much he enjoys thinking back on "my good times with the grand old gal."

Frances Benjamin Johnston was born in Grafton, West Virginia, in 1864, and grew up partly there, partly in Rochester, New York, and partly in Washington, D.C. She was educated at the Notre Dame Convent in Govanston, Maryland, and in 1883 she went to Paris to study art. After returning to the United States she enrolled at the Art Students' League in Washington, D.C. (later incorporated in the Corcoran Gallery School). When a friend who was leaving town asked Johnston to take over her job as Washington correspondent of a New York newspaper, she did a series of interviews and illustrated them with her own drawings. She soon decided, however, to take up photography—because "it was the more accurate medium"—and lost no time in writing to George Eastman, who had invented the roll-film Kodak only the year before, to send her a camera that would take good pictures for newspapers.

In 1890 she opened her studio in a low brick building behind her father's house in Washington. Here, amidst tiger rugs, paisley throws, Savonarola chairs, Parisian posters, Oriental bric-a-brac, and other decorative symbols of Bohemian life in the nineties, she entertained her artistic friends. And here, under a skylight—"the finest portrait light south of Philadelphia"—she photographed such Washington notables as Mrs. Grover Cleveland, Mrs. William McKinley, and the Theodore Roosevelts. Although much of her portrait work came about as the result of her social connections, she didn't always follow the conventions of that milieu. A professional woman photographer was odd enough in the 1890s, but one

who apparently entertained men unchaperoned in her studio was practically unheard of. In this, however, she merely exhibited the self-assertive will and iconoclastic views that made her an interesting woman and a great photographer.

From 1890, when she opened her studio, until about 1910 her career embraced many facets of photography. In addition to portraiture of the illustrious and the obscure, her lens recorded such diverse bits of Americana as the living and working conditions of Pennsylvania coal miners and *A Day at Niagara.* She photographed the daily life of Theodore Roosevelt's children at the White House for *Ladies' Home Journal,* and contributed "What a Woman Can Do With A Camera" to the same magazine. For a news syndicate she went aboard Admiral Dewey's flagship, the U.S.S. *Olympia,* in the Bay of Naples to document the last lap of his triumphal return after the battle of Manila. She photographed the story of Hampton Institute and its vocational training program for blacks and American Indians for the 1900 Paris Universal Exposition—a documentary photo essay that brought her the Grand Prix and wide acclaim here and abroad. During World War I she photographed a bridge in the United States and spent the night in jail for "spying." All this is but a skimming of the early photographic achievements of Frances Benjamin Johnston, who captured on film two decades of the American scene at its most exalted and humblest points.

After 1910 she gradually drifted away from portrait work and photo-journalism (some 20 years, incidentally, before such so-called pioneer photo-journalists as Margaret Bourke-White were even heard of) and eventually devoted most of her time to architectural photography.

New York architect John M. Carrère of Carrère & Hastings seems to have provided her first architectural commission—to photograph his New Theater in New York in 1909. Probably as a result of that success she opened a New York studio with Mattie Edward Hewitt in 1913 and documented many of the private palaces and public edifices in the city during the age of elegance. She did photographic work for Bertram G. Goodhue, McKim, Mead & White, John Russell Pope, and Cass Gilbert, among other fashionable architects of the time. It is worth remembering that when Frances Benjamin Johnston opened her Fifth Avenue studio, two of New York's greatest Beaux Arts buildings were brand new—the main building of the New York Public Library (Carrère & Hast-

Precocious in her concern for vanishing American landmarks and their preservation, Johnston traveled through the old South in a chauffeur driven car from which it is said she could sniff out a colonial house five miles off the highway. One of the books that resulted from her travels, *The Early Architecture of North Carolina,* 1941, includes the architectural photographs illustrating this article. The prints used were made from the original material, purchased from the Johnston estate by the Library of Congress in 1952. Courtesy The Library of Congress.

ings), completed in 1911, and Grand Central Terminal (Warren & Wetmore), completed in 1913. The Plaza Hotel (Henry J. Hardenbergh) was hardly six years old, and The Metropolitan Museum of Art's north and south wings on Fifth Avenue (McKim, Mead & White) were under construction.

But it is in the preservation on film of the vanishing landmarks of historic American architecture, particularly of the Southeast, that Johnston may have accomplished her most valuable feat for posterity. She was commissioned by Mrs. Daniel B. Devore to photograph her recently restored house, Chatham, in Fredericksburg, Virginia, in 1929—undoubtedly the impetus for carrying out her ambition to photograph the neglected buildings of the South. Milton Grigg said that Johnston actually was aware of the dilemma of disappearing historically significant architecture as far back as the 1880s. He recalled having seen a series of photographs she had made at that time in Dumfries, Virginia. The pictures showed a town that no longer exists as it originally was.

Johnston's first intention was not to concentrate on famous houses that, as she said, "had been photographed often and well," but on structures that had to do with the everyday life of the Colonists and early Americans—the farmhouses, mills, log cabins, country stores, taverns, schoolhouses, and such. Initially she received a commission to make a photographic survey of Fredericksburg and nearby Old Falmouth in order "to preserve something of the atmosphere of an old Virginia town." An exhibition of the resulting prints at the Library of Congress in 1929 generated further commissions. "Her project was exciting, she was exciting," as Paul Vanderbilt put it.

Certainly not many people were interested in old buildings in those days, let alone in their historical significance and preservation. Not surprisingly, the dauntless Johnston knew where to go for leads when she needed them. The Williamsburg restoration had begun only in 1926, and she rightly assumed if anyone knew anything about the architectural remains of Virginia, they would be there. This is how Milton Grigg first met Johnston, although she claimed to have known him as a child. One day in 1929 she appeared where he was working in the Williamsburg office of architects Perry, Shaw & Hepburn and recognized him as the nephew of one of her girlhood friends. This association, she thought, entitled her to share the firm's research and the locations of its heretofore unpublished architectural finds. When the Williamsburg restoration was initiated, as Grigg explained it, "there was little documentation of the architectural remains in that area. Very few books contained reliable references, and competent, measured drawings were almost nonexistent. Therefore those of us who were on the staff usually spent our weekends on field trips photographing and measuring unrecorded places. Notable discoveries resulted from these efforts." It was undoubtedly due to Johnston's charm and enthusiasm rather than to her tenuous connection with Grigg that the architects "gladly agreed to share most of their findings" with her and

thereby, no doubt, greatly enhanced the value of the survey she was then making of the architectural heritage of Virginia.

By 1932 she had about 1,000 negatives of buildings, mainly in the Tidewater area. New York's Metropolitan Museum of Art purchased several hundred prints, and when the University of Virginia became interested in forming a collection, she offered to create a file of 500 selected prints, to secure additional records of buildings in the state not adequately photographed, and to perform the necessary research if funds could be provided. In 1933 she received a Carnegie grant for the job as a result of the joint efforts of Dr. Leicester Holland, chief of the Division of Fine Arts of the Library of Congress, and Edmund S. Campbell, who headed the School of Architecture at the University of Virginia. She planned to spend six months photographing but actually took three years. The more she did, the more there was to do, and the Virginia survey was extended by new grants. The success of the Virginia project, moreover, inspired its continuation into the Carolinas, Maryland, Georgia, Louisiana, Mississippi, Alabama, and Florida—entailing another five years of work.

After Johnston received the Carnegie grant in 1933 she again sought out Grigg. He had left the Williamsburg project and opened his own practice. "My area of professional activity and research had transferred to Virginia's Piedmont region, and she, having completed her work in the Tidewater area, was now surveying and photographing the unrecorded architecture of Piedmont." Recalling the informality of the renewal of their friendship, Grigg said that late one afternoon there was a knock at the door and "a disheveled, hot, tired, but no less enthusiastic F.B.J. greeted me with a broad grin." On learning that Griff had no other plans, she "placed two fingers between her teeth and let out a loud whistle to attract the attention of her boy driver," who, following her gestured instructions, "rummaged through the backseat of the car and approached the house with a case of beer." Those were Prohibition days, Grigg pointed out, and "such a house present was a highly appreciated accessory to a long evening of planning for the scholarly conquest of the surrounding hills." Since the Depression had relieved Grigg of any great volume of competing demands for his attention, he recalled, "we had a great time exploring sometimes impossible roads, becoming frequently lost, and punctuating our inquisitive pursuits with luncheons of crackers, cheese, and warm beer." F.B.J., incidentally, was then 69.

These forays resulted in many new finds being added to the list of architectural relics. The most notable was Edgemont, near Charlottesville, not then identified as a house designed

Opposite: Doorway and ceiling treatment at Montmorenci near Warrenton County, North Carolina, ca 1940. To Johnson, the play of light was as essential to architectual photography as demonstrated by the beautifully proportioned doorway and its delicate cornice. Courtesy The Library of Congress.

by Thomas Jefferson. To reach it, Grigg remembered, "we had to abandon the car and travel about a mile up a mountain trail before finally arriving at the west front of the dilapidated structure. I had not seen it and knew it only from old wives' tales in the neighborhood. When we reached it, my boldly pontificated 'there is a Jefferson building' prompted Johnston to ask how I knew it. I replied that I merely felt it but would prove my thesis before the sun set. Whereupon, I took some dimensions, returned to the office and dug out the Coolidge collection of Jefferson drawings and found the heretofore unidentified drawing of the house."

Johnston received other commissions to document buildings during these years, including one in 1936 from the Carnegie Institute of Washington. She was asked to make the preliminary survey for the restoration of St. Augustine, Florida, and when the first comprehensive survey of Mount Vernon was made in 1935, she was selected to do the photographs. Johnston continued her photographic recording of the early architecture of the nine Southern states until 1940, when she had more than 7,500 negatives. In addition to the great houses and gardens, she photographed such now-vanished structures of the American scene as mule-powered cotton presses, slave quarters, wagon sheds, and privies. She caught many a building in her lens seemingly hours before it fell completely into ruin. She inspired an interest in preservation all over the South for which she never has received proper credit. Frederick Doveton Nicols, who collaborated with her on *The Early Architecture of Georgia* (1957), notes in its successor, *The Architecture of Georgia* (1976), that a comparison between the two volumes "confirms our happy first impression: every important building of this state is better cared for now than 20 years ago. After extensive travels around the state, we can testify to the awakened interest which Georgians have for their history and historic structures." And at least some of that awakened interest can be attributed to Frances Benjamin Johnston. She was there before the prestigious Historic Savannah Foundation was formed; she was there even before the National Trust for Historic Preservation existed. Her photographs, in fact, have been of great help to many preservation organizations throughout the South.

There is hardly a book on American architecture since the twenties in which her photographs don't appear, and she herself collaborated on at least four such books: with Henry Irving Brock on *Colonial Churches in Virginia* (1930); with Thomas Tileston Waterman on *The Early Architecture of North Carolina* (1941 and 1950) and *Dwellings of Colonial America* (1950) and with Nichols on the previously mentioned *The Early Architecture of Georgia*. The series of photographs she made of the White House in the nineties, moreover, was published in a book, *The White House*, in 1893.

She was by all accounts a determined, spirited woman who knew what she wanted and usually got it. Sometimes she infuriated the owners of houses by ordering them out while she photographed. Grigg told the author that "her views were frequently composed with the aid of her chauffeur-man-of-all-trades, who had long since learned to climb a tree and saw off an obstructing limb (owner's permission frequently overlooked) or completely remove all the furniture in a room that might compete with its architectural recording. Her willful demands and often unannounced intrusions frequently resulted in temporary hostility, which usually dissolved before the imperious but always charming and ingratiating intruder departed."

At one time she was supposed to have demanded the removal of a tree which blocked her view of a church in Williamsburg. Her love of gardens and conservation, however, makes this story seem more legend than fact. In any case, you can say of Frances Benjamin Johnston as an architectural photographer what the Museum of Modern Art's John Szarkowski said of her carefully constructed tableaux when discussing her work at Hampton Institute about ten years ago: "She ordered life to assume a pose that conformed to her own standards." And, he added, "That she made this odd procedure work so well . . . demonstrates beyond doubt that she was a formidable artist."

Her early art training, said Grigg, gave her an innate sense of composition, and he considered her "a fascinating technician." To a great extent she worked intuitively and, as he put it, "Her well-schooled judgment of light rendered her a human exposure meter." In her own words, she "wore out one camera after another, and I never had any of those fancy gadgets. Always judged exposure by guess."

She never did her own darkroom work, according to Grigg. Through the years, he says, she used the services of a finisher in Washington whose long experience with her made him both indulgent and cooperative. In those rare instances when a slip of judgment resulted in a faulty exposure, all the tricks of the darkroom were resorted to and disaster avoided.

Many of the buildings Frances Benjamin Johnston photographed have been done by later photographers but never with a deeper sense of what architecture is, or with more stunning results. She understood the beauty of sunlight on clapboard and shutter; she knew what details to close in on; she understood a building's relation to its environment. Through the silence of a black-and-white photograph she could evoke the vanished life of a great mansion or humble slave quarters. She understood the poignant beauty of old bricks and weathered wood, of a sagging architrave or a crumbling chimney. She understood that sunlight and shadow are no less an architectural embellishment than a row of fluted columns, a proud dome, a carved cornice, or the lacy

filigree of a cast-iron balustrade. She appreciated the unpretentious adornments wrought by the hearts and hands of simple workmen.

During her long trek through the Southern states with her driver-assistant, this imperious photographer recorded thousands of vanishing landmarks and helped discover lost ones. There is no doubt that besides being a pioneer photojournalist she was a pioneer recorder of our architectural heritage and a pioneer in the preservation movement. If it was a document of American architecture or American life, she was undoubtedly there with her camera and her unerring eye.

In 1945 the American Institute of Architects belatedly awarded her honorary membership, citing her as "an eminent layman, distinguished citizen, having singly contributed to the advancement of the profession of architecture by her notable achievement in recording photographically the early architecture of the United States." During the presentation Grigg remembered that this "grand lady" was "attired in quiet good taste but in the garments of much earlier days which she had so well recorded."

She moved to New Orleans in 1940 but kept an apartment in the Arts Club in Washington. Grigg recalled that just before he was to deliver a lecture there he was summoned upstairs to her apartment to have "just a little nip" in preparation for the event. In 1947 she donated her prints, negatives, and correspondence to the Library of Congress and she spent many of her last days at the library identifying and indexing them.

She may not have been a good businesswoman—she rarely paid her bills and was continually at odds with the Bureau of Internal Revenue—but from first to last she was a professional photographer. "I have not been able to lose sight of the pecuniary side," as she herself said, "though for the sake of money or anything else I would never published a photograph which fell below the standard I have set for myself."

The indefatigable and remarkable Frances Benjamin Johnston was 69 when she started her photo-investigation of the architecture of the Southern states. She was 77—a grand old lady indeed—when she completed it. In 1952 she died in New Orleans at 88. ■

Johnston sought out the unpretentious. She photographed the house below, in South Mills, Pasquotank County, North Carolina, 1940.

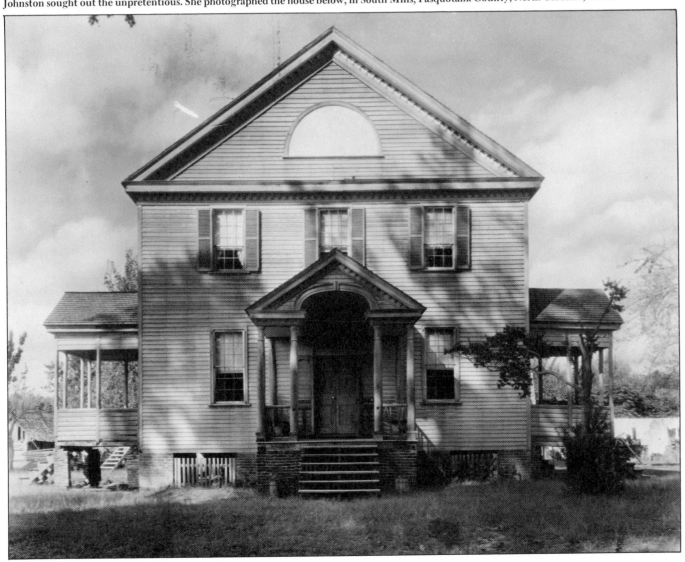

Selected Bibliography

Beaton, Cecil and Buckland, Gail. *The Magic Image, The Genius of Photography from 1839 to the Present Day*. Boston: Little Brown, 1975.

Braive, M. F. *Photography, A Social History*. New York: McGraw-Hill, 1966.

Castleman, Riva. *Prints of the Twentieth Century: A History*. New York: The Museum of Modern Art, 1976.

Coke, Van Deren, ed. *One Hundred Years of Photographic History*. Albuquerque: University of New Mexico Press, 1975.

Doty, Robert. *Photo-Secession: Photography as a Fine Art*. Rochester, New York: George Eastman House, 1960.

Eichenberg, Fritz. *The Art of the Print*. New York: Harry N. Abrams, 1976.

Gernsheim, Helmut and Alison. *A Concise History of Photography*. New York: McGraw-Hill Book Co., 1969.

Getlein, Frank and Dorothy. *The Bite of the Print: Satire and Irony in Woodcuts, Engravings, Etchings, Lithographs, and Serigraphs*. New York: Clarkson N. Potter, 1963.

Hayter, Stanley William. *About Prints*. London: Oxford University Press, 1962.

— — —. *New Ways of Gravure*. Rev. ed. New York: Watson-Guptill Publications, 1981.

Hillier, Bevis. *100 Years of Posters*. New York: Harper & Row, 1972.

Howarth-Loomes, B. E. C. *Victorian Photography, An Introduction for Collectors and Connoisseurs*. New York: St. Martin's Press, 1974.

Ivins, William M., Jr. *How Prints Look: Photographs with a Commentary*. 1943. Reprint. Boston: Beacon Press, 1968.

Lyons, Nathan. *Photography of the 20th Century*. Rochester, New York: George Eastman House, 1967.

Mayer, A. Hyatt. *Prints & People: A Social History of Printed Pictures*. New York: Metropolitan Museum of Art, 1971.

Margolin, Victor. *American Poster Renaissance*. New York: Watson-Guptill Publications, 1975.

Newhall, Beaumont. *The Daguerreotype in America*. New York: Duell, 1961.

— — —. *Latent Image, The Discovery of Photography*. Garden City, New York: Doubleday, 1967.

— — — and Nancy. *Masters of Photography*. New York: George Braziller, Inc., 1958.

— — —. *The History of Photography: From 1839 to the Present Day*. 4th ed., rev. New York: The Museum of Modern Art, 1964. Rev. ed. New York: Little Brown, 1982.

Peterdi, Gabor. *Printmaking. Methods Old and New*. New York: The Macmillan Company, 1959.

Pollack, Peter. *The Picture History of Photography*. Rev. ed. New York: Harry N. Abrams, Inc., 1969.

Reynolds, G. *The Engravings of S. W. Hayter*. London: Victoria and Albert Museum, 1967.

Rinart, F. and M. *American Daguerreian Art*. New York: Potter, 1967.

Ross, John and Romano, Clare. *The Complete Printmaker*. New York: The Free Press (Collier Macmillan Ltd., London), 1972.

Shadwell, Wendy. *American Printmaking: The First 150 Years*. Preface by Donald Karshan. Washington, D.C.: Smithsonian Institution Press, 1972.

Szarkowski, John. *Looking at Photographs*. New York: Museum of Modern Art, 1973.

Taft, Robert. *Photography and the American Scene*. New York: Macmillan Co., 1938.

Weitenkampf, Frank. *American Graphic Art*. New York: Henry Holt, 1912. Rev. ed. with Introduction by E. Maurice Bloch. New York: Johnson Reprint Corp., 1970.

Zigrosser, Carl. *The Book of Fine Prints: An Anthology of Printed Pictures and Introduction to the Study of Graphic Art in the West and the East*. 2d rev. ed. New York: Crown Publishers, 1974.

— — — and Gaehde, Christa M. *A Guide to the Collecting and Care of Original Prints*. New York: Crown Publishers, 1965.

Index

About the Authors

DIANE COCHRANE, a contributing editor of *American Artist*, specializes in writing about printmaking and photography.

CARLA DAVIDSON, an editor of *American Heritage* Magazine, is a frequent contributor to arts publications and an avid collector of daguerreotypes.

HELEN GEE established Limelight, the first gallery in the United States to handle photographs as fine art exclusively. Most recently she curated the exhibition *Photography of the Fifties*, which opened at the International Center of Photography in New York and traveled to other museums for two years from 1980–82.

ALEXANDRA HOLUBOWICH is a free-lance writer whose articles on collecting and collectibles have appeared in many business-related publications.

WILLIAM INNES HOMER is chairman of the Art History Department at the University of Delaware. He organized, and co-authored the catalogue for, an exhibition on the works of Gertrude Käsebier.

HAROLD HOLZER is a collectibles columnist for *Antique Monthly* and a specialist in 19th century prints.

MAYBELLE MANN, an art historian and museums consultant is author of *Frances William Edmonds, Mammon and Art.*

ROBERT MEHLMAN, regular contributor to *Art & Antiques* and *Art & Auction*, teaches art history at The New School and The Parsons School of Design.

MARIAN PAGE is author of many art-related publications including several books published by the Whitney Library of Design.

FREDERICK PLATT is best known for his many articles and books on turn-of-the-century American life.

BONNIE BARRETT STRETCH, a contributing editor of *Portfolio*, writes often on historic photography. She is currently at work on a book about pictorialism.

R. LEWIS WRIGHT is a Richmond, Virginia neurosurgeon who has published extensively on topics relating to southern printmakers and painters.